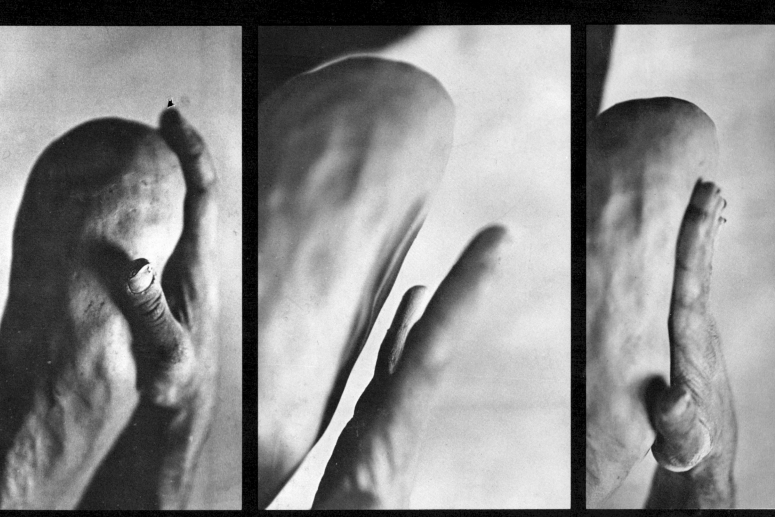

CLAY/BODY DANCE NUMBER TWO, *a collaboration between Paulus Berensohn and True Kelly*

**VISUAL ART CENTER**
ANTIOCH COLUMBIA

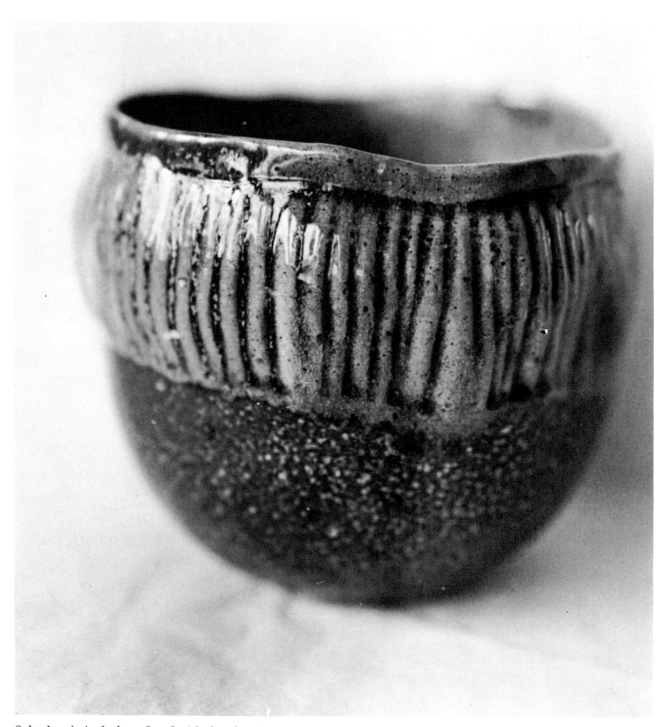

*Salt-glazed pinched pot fluted with the edge of an artgum eraser, 5 inches high*

# Finding One's Way with Clay

## Pinched Pottery and the Color of Clay

### by Paulus Berensohn

with Photographs by
True Kelly

VISUAL ART CENTER
ANTIOCH COLUMBIA

Simon and Schuster
New York

Grateful acknowledgment is made to *The New York Times*
for permission to quote from John Leonard,
"The Return of Andy Warhol," *The New York Times Magazine*,
Nov. 10, 1968 © 1968 by The New York Times Company.
Reprinted by permission.

# *Acknowledgments*

ACKNOWLEDGMENT and thanks to the National Endowment for the Arts, which, through its grant to the Penland School of Crafts, made the writing of this book physically possible, and to the Penland School itself, where I was befriended and supported by Bonnie Ford, Jane Brown, Cynthia and Edwina Bringle, Mark and Jane Peiser, Ron, Melissa and Jessica Garfinkel, and Phyllis and James Yacopino, among many others; to Deborah Miller, who read the manuscript in its early stages and was with me all the way; to Ray Blumenfeld for sharing her notes on sawdust firing; to my students at the Wallingford Potters' Guild (1964–67), who encouraged the beginnings of this work; to Shirley Tassencort, Remy Charlip, Jeffrey Carter, Larry Wilson, Bruce Marks, Sheila Paine, Judith Steinhauer, Ted Hallman, Jr., Mary Caroline Richards, Thomas Beers, M. Louise Davis, Natalie Murphy, Jack Clawson, Ellie Fernald, George Schroeder, Jane Hartsook, and many others; to Irene Friedman for suggesting and representing this book; to Rhoma Paul for editing it, to Harriet Ripinsky and Jack Jaget for producing and designing it, and to True Kelly, who was a joy to work with.

Copyright © 1972 by Paulus Berensohn
All rights reserved
including the right of reproduction
in whole or in part in any form
A Fireside Book
Published by Simon and Schuster
Rockefeller Center, 630 Fifth Avenue
New York, New York 10020

SBN 671-21324-5 Casebound
SBN 671-21763-1 Paperback
Library of Congress Catalog Card Number: 72-83911
Designed by Jack Jaget
Manufactured in the United States of America

5  6  7  8  9  10

*This Book Is Dedicated to:*

BILL BROWN
[William J. Brown, Director of the
Penland School of Crafts]

*because of what he has built
at Penland
and for his real support,
encouragement and friendship*

*and to*

MARTHA GRAHAM

*who was the first person
who demonstrated to me
the essential importance and significance
of revealing the inner man
in our work.*

# Contents

*Eight pages of color photographs follow page 96; all photographs are of author's pots unless otherwise indicated.*

# Finding One's Way with Clay

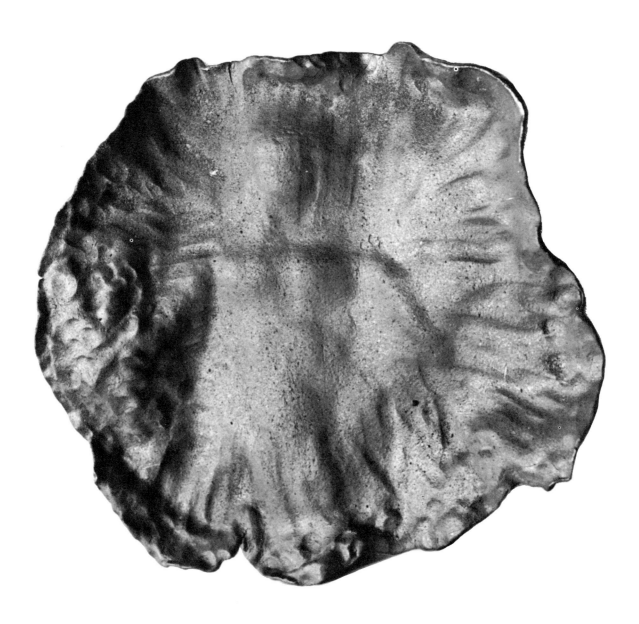

*Pinched plaque, "St. Michaël-Shiva," unglazed, wood-fired to cone 9, 10 inches across, by Mary Caroline Richards*

# Introduction

"YOU CAN take it as it comes, or you can set yourself tasks in order to develop strengths." Paulus Berensohn said this to me yesterday, while we were in the pot shop exchanging our approaches to teaching. I had asked him to share with me the way he introduces a beginner to centering the clay on the potter's wheel. Though I am not a beginner, his opening advice resonated in my inner ear. I needed to hear this. For my bias has been to "take it as it comes," to "say yes to what we behold." I have been in love with clay and nature and persons, unwilling to hear a word against any of it. But "in love" is not enough. Fuller love is commitment to seeing the process through. In this book we are inspired to set about it: an act we consciously undertake as "a way" with the help of a material. It asks us to be aware both of ourselves and of the ingredients of a process.

This book speaks to all of us, in whatever parts of ourselves we are "beginning," either for the first time, or in a new curve of the unfolding spiral. And it urges a continuing practice, which will deepen our work. There is no repetition, for each time we come to life from another perspective. We may read Shakespeare for the first time when we are ten. Each time we come to him again, our experience changes. And so with pinching pots. The first time may be when we are two. Each occasion thereafter when we come to it, we bring ourselves afresh and feel our art deepen. It is like hearing a favorite story told and retold: we never cease to thirst for living water.

My own way of pinching pots took a new turn years ago, when I began, out of personal need, to work with the tenderness and fragility of the clay rather than with its toughness. I hungered to stroke and press the clay, stretching it thin and thinner, sometimes wearing through the fine tissue like the worn elbow of a sweater. I found that these pieces were strong in the fire. My earlier conception of pinched pots as crude and spontaneous was replaced with a new experience of the stretch, the vibrancy, the response of the pinched clay to the signature of articulated touch. I like to pinch in many moods: both covering my tracks, and letting the steps show.

This book may well be a pioneer in the field of craft books, combining "how to" with human growth. We learn not only to follow the nature of the clay, but to lead it. A prodigious amount of detailed instruction is given, for which one can only be thankful, but even more thankful because it is given in behalf of each of us finding our own way, finding an experience of ourselves that feels real, with the help of this responsive and magical material, clay—and that rigorous companion to the art of pottery, the fire. To find one's way with clay is to integrate one's inner search with one's outer practice.

I asked Paulus Berensohn why he thought it was important to bring together the technique and the person. And he answered, "Because technique by itself tends to lead to dead ends. It comes alive through a person, when it is from a living source." It is the separation of object from person that he warns against. *Source* and *need* are important words in his vocabulary. They point to the vividness of his

relationship to his own life, and the seriousness with which he accepts it. It points as well to the warmth with which he affirms source and need in other persons, and helps them to awaken. His respect for the history of man's relationship to clay, and what we can learn from it, is an added resource.

*Need as source*: He needs, he tells us, to pinch from one ball of clay three bowls for three beloved friends who are to be separated. Each will have this deep link with the others, of origin. And the origin will be inscribed not only in the invisible fabric of spirit, but visibly in the inflexion of colored clays wedged into the ball to begin with. It is a human ritual in its deep creative gesture of love and forming.

*I* might need to get better acquainted with my unconscious fear and resentment. If I can see it, maybe I can find a way of changing my relationship to it. I make two grimacing faces glaring at (but not seeing!) each other, tongues sticking out. Each is furious as it feels the opposing presence. Ah, so that's it. Terrified, and furiously separate! Now I make two faces in the two loops of a figure eight, separate and yet connected: able to bear to have two opposing impulses at the same moment in the same form. Interesting. I decide to learn how to model a human head—what does a tongue really look like? I am finding my way to forming an inner capacity hand in hand with learning how to form a material. I need to bring my dreams into waking life: I dream of working fruitfully in the world. Perhaps I will put up my potter's wheel on the sidewalk of the small town near where I live, or in the schoolyard, and invite people to watch and learn, and make things for them, offering my handiwork. Crafts are not objects. They are rituals of offering, in the mysterious sheaths of matter. They are part of human ecology. Can I find my way through clay to healing and to community?

It is the pots we are forming, yes. And it is ourselves as well. The integration of this twofold realm, clay and person, is tended here with special regard. Paulus Berensohn knows that our pots are a script of our lives. And he knows that without physical practice and work done, the rhetoric of wholeness is also a dead end.

My bias has been to behold the radiant countenance of the deep in every instance of the clay. My insistence has been that we become *aware*, and sacrifice the self-will of our habits of judging and aspiring. Then I say we may move, nay must move, with equal zest into the affirmation of our needs. This kind of breathing between selfless beholding and self-full awareness tends to produce a new quality in both beholding and behavior. The eye grows free of bias wherever it looks. And the heart grows beyond its past desires. A new Being begins to form.

To help in this art of transformation, Paulus Berensohn suggests that we awaken new rhythms of working: "to set ourself tasks that develop strengths." The spirit of the discipline he urges is to equip us to do not what we may want to do, but what we deeply need to do. He suggests exercises in meditation with a ball of clay, "what if?"

exercises for the imagination, exercises in adding color as a plastic ingredient from the first moments of working the clay (colored clay, instead of color applied to surfaces).

In my book *Centering*, I stress *person* as my main concern. I might not have seen the need to write this book, had it not been for Paulus Berensohn's insistence. "Write it for us," he said. That was long ago when he was in my workshop at Haystack Mountain School of Crafts, having recently changed his direction from a career in dance. He was following his need to find new coordinations between the expressive gestures of his body and a balanced inner life. Since then we have become co-learners. His first book, to which I have the honor of contributing, carries my earlier statement to a new balance. For it is both the pot we are forming, and ourselves, in mutuality.

Sometimes I think it may be because of his dance training that he is so resolute about the need for "practice" in working the clay. He tells us not to keep all the pots we make, but to learn how to practice our pinching, coiling, throwing. Like dancers, he bids us to work so that our imaginative leaps will make a full gesture because our bodies are balanced and elastic, and the awareness in our hands is alive and continuous. The feeling of our lives will be awake in our fingers. We befriend the clay. The clay befriends us.

MARY CAROLINE RICHARDS
*Longmeadow*
*Uniondale, Pennsylvania*
*September–December 1971*

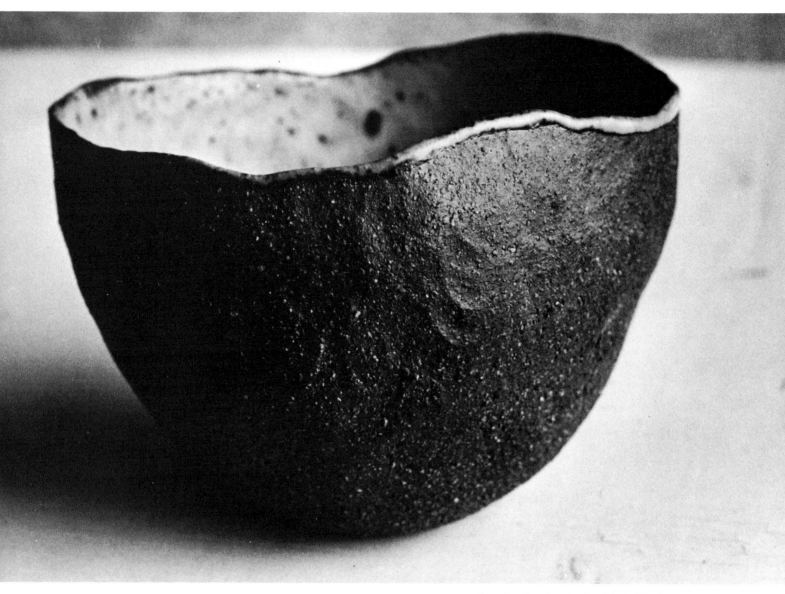

*Begging bowl, 4 inches high, black stoneware*

"And it may be that certain forms of play are an escape hatch for us from technology; a therapeutic hope . . . a little more methexis mixed into our *mimesis*. That is, participation . . . as well as imitation. Not just Warhol's participation, of course, but *ours*. If we all of us had movie cameras and tape recorders and silk-screens; if we designed our own furniture, shaped our own glassware, wove our own tapestries, set our own type, we might knit up the raveled sleeve of self. The rush of esthetic theories upon us, while we lie numb under the machines, has divided us from our experience, has stylized our responses. We do not *understand*, but *attitudinize*. Craftsmanship, the self-shaping of privacy, the health-giving labor, could be our way out."

—JOHN LEONARD,
*The New York Times Magazine*, November 10, 1968

"DESIGN: What does the word mean? DA-SEIN. *To be there, to be there.* CRAFT: what does it mean? It means *strength, power, ability.* HAND: *manus, manual, manu, mana, MAN.* Play the scale, it's the music of our spheres: *Designer-handcraftsmen.* To be there: a man in his being as man, his *mana*, his spirit-power, the power of his magic. To be there as humanized power: not nuclear power merely, but humanized power. That is the meaning of our names."

—MARY CAROLINE RICHARDS,
"Thoughts on Writing and Handcraft," *Craft Horizons*, July/August 1966

"The potter speaks of the hard silica, the softer flux, the protecting glaze, as the 'bones, blood and skin' of a pot, and there are indeed many human associations."

—SEONAID MAIRI ROBERTSON,
*Craft and Contemporary Culture*

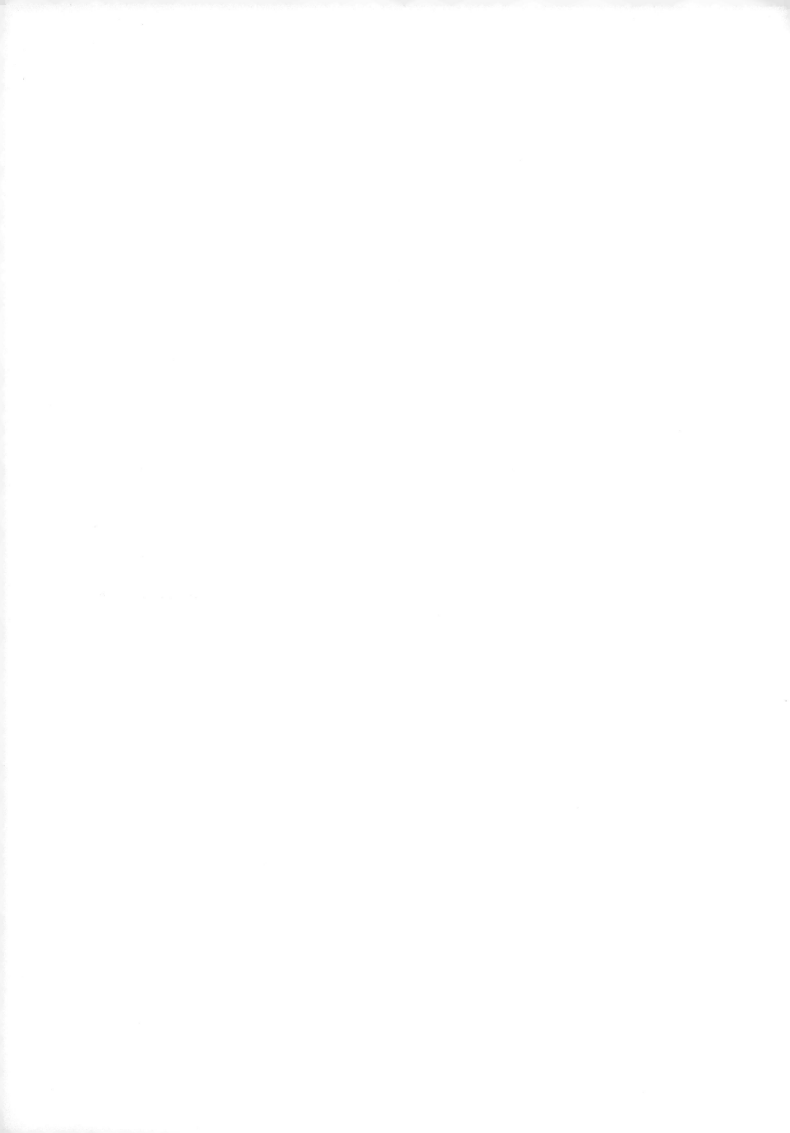

# Author's Preface

I BEGAN to teach pottery soon after I made my first pots: it wasn't planned that way, it happened most naturally. Although I go off from time to time to work alone on my pots, I seem to return again and again to sharing the experiences of forming with others; to teaching and learning. In recent years I have lived on a farm in northeast Pennsylvania, having taken a break from full-time teaching. Soon after I moved in and settled down to work I began receiving invitations to demonstrate at various schools and pottery groups. Because I was uncomfortable in the performance of demonstration and because I questioned its value at least in terms of my work, I began to design workshops in which the participants and I worked along together. This book is the partial product of three years of leading participatory-workshops. It began at a workshop for the Baltimore Potters' Guild and ripened in workshops held at the Wallingford Potters' Guild, at Greenwich House Pottery, the Craft Students League of New York, Bloomsburg State Teachers College, Penland School of Crafts, Haystack Mountain School of Crafts, Arrowmount School of Crafts, the University of Georgia, the Kiln Club of Washington, D.C., and various places in Canada. The idea to make this material into a book was first suggested at the end of a workshop at Greenwich House Pottery by Irene Friedman, who had participated in the day-long session. I started to make notes but soon found I was called away by the pressures of making my living; practicing for, planning for and leading workshops. The opportunity and time came about when Bill Brown, the director of the Penland School of Crafts (in the mountains of western North Carolina), where I had led workshops with Cynthia Bringle during the summers of 1969 and '70, offered me a small National Endowment for the Arts–Penland School grant to be in residence at Penland for up to eight months during the academic year 1970–71. "You can do whatever you want," he said. It turns out that this is what I wanted and needed to do.

I thought at first of making a large book covering all the forms of hand building I practiced and taught. When I expressed my bewilderment at so large a project to my friend Remy Charlip, he said, "Why make one large book? Why not several small ones? Write what's important to you now." It was a most propitious suggestion and one very suited to who I am. I decided to start at the beginning, to write in the first person (so as to insure that what I would say would not be mistakenly read as law, but rather as the experience, the witness, of one person working with clay), to make each book, if there were to be more than one, as much like a workshop-workbook as possible.

There were several things I wanted to write about, but clearly it was forming clay pots by the pinch method, making use of the beautiful and varied colors of clay and speaking a little about how I work, that were foremost in my mind and hands. So this book began to take shape. Hopefully I will feel drawn to go on to one or two other small books: about coiling; about working with slabs; about strengthening 17

the muscle of the imagination, using our fantasy and dreams as source; about a form of journal-keeping I've been developing with my classes that attempts to bring more of ourselves into the act of forming; and about our bodies, their rhythm, their strengths and weaknesses and health, and the part they play in concert with the clay bodies of our work. Although I wanted to include examples of other people "finding their way with clay"—friends, students and colleagues —I decided after consideration to speak only of my own experience in this first book, and to speak as clearly and in as much detail as I could. Step by step; how I may do it, what exercises I have practiced, what it may mean to me in my development as a potter, as a person. Not offered as a demonstration of *the* way; shared as a confession of *a* way, a way not yet fully shaped by any means, a way of "becoming," of "forming."

I have, by design, avoided repeating the basic technical information that is already very much available in a growing number of pottery texts. However, it was pointed out to me by one of my friends that persons with little or no clay experience heretofore may find this book and feel moved to try their hand at it, perhaps in their own homes; to experience that special aliveness of forming a simple bowl that they might then use. For such persons, I've included a "note to the inexperienced," a bibliography and a glossary at the end of the book.

The following is what I know and feel about pinching clay and its color. I offer my experience in the hope that hearing and seeing how another person is attempting to find his way with clay will spark an interest or a recognition for you that may help you toward finding your own way deeper into and with clay: toward finding our own voices.

—PAULUS BERENSOHN,
*Penland School of Crafts*
*Penland, North Carolina*
*January 1971*

18

# I

# An Approach to Working

## Finding My Work

OF ALL THE hand-forming pottery techniques, pinch pots are most often given the least emphasis, despite the fact that they are generally the first method we are taught or teach. It is difficult to make a controlled form by this method. The pots look crude, they crack in our hands and collapse. They are often heavy, difficult to glaze and frustrating. As a student I avoided attempting to pinch; as a teacher I found myself again and again unable to find a more appropriate substitute as an introduction to hand building. It seemed a good idea to pinch first, because it offered me the most direct contact with the clay that I knew. By pinching you could see and experience the texture of the clay, feel the clay as it thinned with the pressure of your fingers and be witness to the clay's moisture drying with its exposure to air and the blotting action of your fingers. With all these good thoughts, I was still unable to find my own way into pinching or to illuminate the act for my students. I would show them photographs of early Japanese pinched raku teabowls and pass around a delicate leaflike pinched bowl made by my teacher, Mary Caroline Richards. To handle this pot was like taking hold of her hand—it helped.

In my desire to encourage pinching by my students I began, more and more, to return to attempting making bowls in this way. It was, finally, a literary image that quickened my interest and brought this way of making pots alive for me personally, and in turn, for my students as my ardor became apparent. In one of his books, Jean Genet, the French playwright and novelist, speaks of his desire to roam the countryside with a "begging bowl"; a bowl, as I read it, in which to receive what he needed for the nourishment of his life, physically, emotionally and spiritually. Reading this I had an immediate response, a recognition of this image's importance to my own life, my own need. I set about to make my first "begging bowls." I found that I could not make them on the potter's wheel; that the precision and symmetry, in this case, worked against the direct feeling I was pursuing; I made some bowls by coiling and by slab, but it was not until I had pinched them out of one ball of clay each that I began to feel connected in what I was doing and what I was feeling: All of a sudden I had a need to pinch and found that pinching began to open the door into a totally new experience of clay, one based firmly in where I was in my own experience of myself.

I pinched thin, hollow, simple shells, giving them the time they seemed to require to take their form. After experimentation, I glazed them quietly with smooth skins on the inside, allowing the clay to stand clean on the outside. I have continued pinching with growing enthusiasm ever since. Starting with these small individual begging bowls, I progressed, as my skill increased and my feelings and needs necessitated, to related sets of "beloved bowls," large individual story pots, avocado planters, plates, bowls, pinched globes, etc. Because I found, in most cases, that glaze was too heavy and rich an addition to the outer surface of these bowls, I moved intuitively to a concern about the color of the clay itself and soon began using two or more  19

clay bodies wedged together to enhance the earth-connected mood. My excitement about the flexibility this gave me sent me further into an exploration of the various additives I could use to alter the color of my clays. I discovered a whole palette of color was possible in the clay itself and began firing my pots at temperatures varying from cone 012 to cone 9 in oxidation atmospheres, as well as cone 10 in "reduction fire." I use these clays wedged together, inlaid or appliquéd to the forms, to add color and texture and design; symbols of connection, signs of source. Just having this color to use from the very beginning of the forming of a pot has brought a new aliveness and a new dimension to the work.

Making pinched forms has been important in my recent life as a potter for one reason especially. My work on the wheel and in coiling, slabbing and teaching had been largely marked by productivity, high spirits, rapid rhythms and often almost breathless excitement and ambition. The more I pinched, however, the slower I seemed to move; my breath deepened and my very posture as I worked seemed to become less tense. I discovered soon that pinching offered me an alternative to my usual rhythm of work and an enrichment of it. My pinch pots asked to be formed slowly, quietly and with deep attention. New respect and interest has grown in me for the touch and the color of clay, for its perishability and its strength. I am taking more care in my selection and making of clay bodies: allowing them their own time to age. This lesson, that time is needed for both clay and potter to ripen, is a nourishing and supportive one. The simple act of pinching small bowls is for me healing and centering. These quietly and slowly pinched bowls form the core of my work, to which I return again and again for a deep breath as if in meditation and prayer.

# First Steps Toward Freedom

IT HAS BEEN my experience that students of pottery are sooner able to recognize the need for a disciplined program of study on the potter's wheel than they are in hand forming. And perhaps it is because of this very difficulty in gaining precision on the wheel that we often seek what seems to us the greater freedom of expression possible in working without the wheel. Yet I have noticed that, in most cases, working with this particular sense of freedom in hand building often leads to predictable ends: frustration at not being able to make the materials do what we want them to do; a sameness from piece to piece due to the lack of technical skill and exploration that can extend the range of possibility; and pieces that often attempt too much and result in a piece containing enough form, texture, content and glaze to enrich a host of pieces. It is because of this that I urge my students (even those with vast previous experience) to start at the beginning, if they can, and lead them through a few extremely simple and clear exercises designed to show how to control and at the same time work along with the clay—pinching open and closed forms, large and small forms, clean and textured forms, thick and thin, symmetrical and

asymmetrical—so that our freedom is equipped with power and range for expression. At the same time, and this is central to the whole point of this book, these exercises do not come out of a purely technical concern. They are concerned, acutely, with the growing relationship of the potter to his clay; with bringing more and more personality, imagination and inspiration into play; and with tapping sources deep within the experience of the potter to inform the forms he makes. In the deepest sense this is what I believe technique is—the ability to breathe the spirit of our lives into what we make. I don't believe it to be a talent that we either have or don't have. We all breathe, we are all alive, we all have unique qualities. Yet it takes hard conscious and unconscious work for most of us to connect these facts with what we make, to find *our* pot as we also seek our dance and our song.

And so I am concerned here with the questions of "How do we work?" "How do we exercise?" so that our bodies and the clay bodies come together strengthened and more articulate. The freedom I seek is not one that lets me do what I want to do but rather a *freedom that equips me to be able to do what I need to do.*

This first exercise that follows is clearly that: an exercise. It is important to remember that it is not a pot you are making, but an exercise you are performing. It's very helpful if you can engage in this exercise with as little prejudgment as possible. Don't decide if you like the exercise or don't before you do it. Try to witness what you make without declaring it good or bad, ugly or beautiful. Such declarations seem like very heavy burdens for such young work to bear. In a very real sense, in this work, failure, if there is such a thing, can be viewed as a privilege. To make something successfully on the first try leaves you, in some cases, with little but a souvenir, whereas getting lost may afford you the opportunity to stop, reexamine and begin again and again with renewed insight and perhaps even personally developed solutions to move you on with strength. These are first steps, and like those of a young child they may be uncoordinated, uncertain, and you may fall down, but they may also be enlivened by discoveries of your own and a sense of joy in a new ability opening up.

## Preparing

WHEN I return to pinching after having worked on other things, or when I have been away from my studio, I start again at the beginning with a ball of clay about the size of a small orange. The clay and its consistency is of importance to me. I like the clay to be slightly on the wet side unless it is extremely plastic and relatively grog-free, in which case a stiffer consistency will work well. Different clay bodies have different characteristics for pinching. Some bodies will pinch till they almost disappear in thinness, others will insist upon thicker walls. In most cases, fresh-made clays tend to crack on the edges and on the outside of the walls (this can be very beautiful if you choose to go along and leave the cracks). If you make your own clay body,

it is very helpful to be ahead of yourself and wedge the fresh clay and allow it to age, stored away, for at least a couple of months. Or you can add a bit of vinegar or some fresh urine to your clay when you are preparing it to help along the aging process. If you throw on the wheel, save the throwing slops in your water bucket, for this tends to be especially fine clay for pinching. Or use reconstituted, recycled clay. The ways of actually making clay vary as well. Nowadays there are several clay mixers on the market which studio potters working alone or in small groups or schools can afford. My own feeling about clay mixers is that they are fine if one works on the wheel and needs large amounts of clay, especially when one can take advantage of them to prepare and properly age sufficient clay ahead of time. Mixers have been especially helpful to schools in solving the problem of needing large amounts of clay with limited space for storing it.

The basic principle of these mixers is that just enough water is added to the clay to make it workable. I prefer, when I have the choice, clays that are prepared by adding the clay mix *to* the water. Because I usually work alone and do not have to supply great amounts of clay, when I make my own clay I prefer the old garbage-pail method. I dry-mix my clay formula in a large wooden box (or a cardboard drum), thoroughly mixing the various ingredients with a hoe or rake (or by covering and rolling the drum). Then I scoop the dry clay into the plastic garbage pails filled about one-third with water. I keep scooping till the level of the water reaches the top of the pail. This way each molecule of clay has the opportunity to drink up as much moisture as it needs till it is saturated. This tends to make for "slippery molecules" and earlier plasticity. I siphon off the excess water and dry the clay to workable consistency on large plaster bats. Bruce and Lisa Green, potters at the "Island of the Red Hood" in West Virginia, shared with me their solution to limited space for clay preparation. They first dry-mix their clay body formula and soak half of it in water, allowing it to age. When they are ready for clay they use the remaining dry mix to stiffen up the liquid clay by wedging it together on the floor with their feet. This method eliminates the need for large plaster drying bats and assures you of at least some added plasticity from the soaked clay.

If you have your clay body made, or purchase a body commercially, you can try dealing with a company that filter-presses its clay. Rather than adding just the right amount of water to the dry clay in a large mixer (the more common method used these days even by some large clay supply companies) in the filter-pressing process, the clay is first prepared in a wet-slip state and then squeezed between sheets of canvas under pressure to workable dampness. These clays are usually excellent for pinching.

And yet, almost every clay, no matter how it's made, will work for pinching to some extent. It may take a little experimentation on your part until you find a clay that has a feel that you will enjoy pinching. Try out the clay bodies you have in your studio or at the school

or class you attend. When visiting potter friends, ask for a one-pound sample ball of the clay they use. If you live near a clay supplier, it might be worthwhile to visit them or have them send you five-pound samples of the clays they make.

I pinch with a variety of clays, but the body I have been using most often is an especially plastic one, the formula of which I first used at Haystack Mountain School of Crafts when I was a beginning student. The body was developed by Karen Karnes, Mary Caroline Richards and David Weinrib when they shared a studio in Stony Point, New York, some years ago. Its firing range is cone 8 to cone 12: it is a pleasing light gray to tan in reduction and is an off-yellow-white in oxidation. For more color you can simply add from 2 to 8 (or more) percent of Ohio red or Dalton clay, or Valentine clay, Barnard clay, or Black iron oxide (or any number of other iron-rich clays).

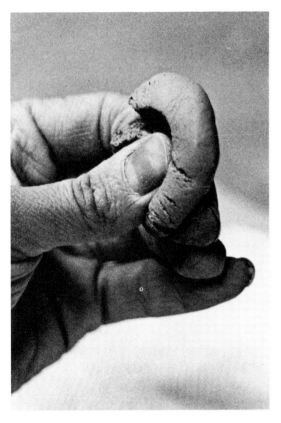

| *Stony Point Stoneware Body* | |
| --- | --- |
| Jordan clay | 50 |
| A. P. Green Missouri plastic fire clay | 50 |
| Ball clay (Tenn. #5) | 25 |
| Flint (Silica) | 13 |
| A-3 Kona Feldspar | 8.5 |
| Grog (Calamo 100) | 3 |

When I can afford to do so, I store away some of this clay in an unheated room in my barn. After two years of freezing and defrosting, this clay becomes what I like to call "vintage" clay. It seems to throw and pinch with a vigor all its own—a true collaborator. I find taking this time in the preparation of my clay deeply satisfying. It is, however, not necessary.

After I wedge the clay I try not to begin working immediately but rather to let the activity of wedging quiet in me for at least a few moments before making the initial opening in the ball of clay. I find a chair in which I can sit with a straight but relaxed back. Holding the clay in both hands, I often close my eyes or lower my focus and concentrate on the feeling of the clay in my hands: how cold it is, how wet, how it feels, now, at this moment. I try to be aware of my breathing; without forcing, to let it lower deep into my belly. (Many potters literally do not breathe when working, especially when throwing on the wheel. I had a problem with this and have to constantly return to an awareness of my breath.) When I feel together and with the clay, so to speak, I then start opening the solid sphere.

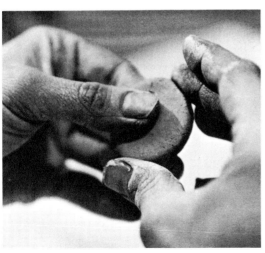

## IMPORTANT BASIC PRINCIPLE

If you take a small ball of clay with about the diameter of a quarter, and press-pinch hard into its center, chances are that the edges will crack. If, however, you rotate the ball and press firmly but gently in small pinches all over its surface while offering counter-pressure with

23

the fingers of the other hand on its edge, you will more likely be able to pinch this ball thin without its cracking.

In pinching, as in throwing on the wheel, the clay needs our support. A firm and tender touch: a pressing out by one hand or fingers, not into a void, but into the supportive, giving, and even resisting capacities of the other hand or fingers.

## Exercise One:
### Making a Small, Symmetrical, Thin-walled Pinch Pot

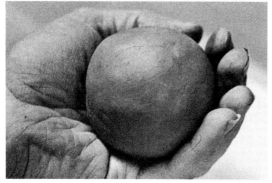

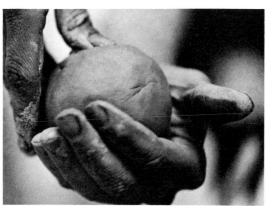

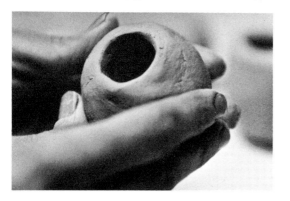

*Steps in opening*

### 1 OPENING

Hold a small ball of clay in your left palm. Rotate the ball slowly as you press slowly into the center of the ball with your right thumb. Start with the lower joint of your thumb bent forward horizontally. As you go deeper into the heart of the clay, straighten your thumb out and down into a vertical position. Keep going until you are almost one-fourth of an inch from the bottom of the ball. All we are trying to accomplish here is making the opening. Try not to make the opening wider than the size of your thumb. If you combine the act of opening with the act of widening, you will more easily lose control. To hold to symmetry, be sure to have a rhythmic relationship between your pressing thumb and the rotating ball. If you do not rotate, the shape of the thumb will immediately set up variations in the thickness of the clay around your opening. Just how much clay you leave at the bottom of the ball will affect the final shape of your pot; leave one-fourth inch of clay this time and experiment with more or less in future practice.

### 2 SPREADING THE FLOOR AND SETTING UP THE WALLS

Using the right thumb on the inside of the pot and the two middle fingers of the same hand on the outside of the pot, slowly spread the bottom wider by lightly pressing your thumb toward your two middle fingers. Press and rotate the pot: After each press-pinch of the thumb, rotate the clay about one-fourth of an inch with the other hand. Go all the way around at least once using the same pressure for each pinch and the same degree of rotation. I generally perform this act with the pot upside down on my thumb. After spreading the bottom, I move up (or down—if working upside down) the wall and repeat this gesture of press-pinching in the middle of the pot and then move to just below the rim, taking care that I press lightly enough and supportively enough that the rim does not crack open. If it does crack, I smooth over the top of the rim with the thumb of one hand while supporting the pot in my other hand. Leave a little extra clay at the rim. This will allow for greater flexibility when, in later steps, you come to shape the piece.

When working for symmetry or near-symmetry, it is important to understand that once you pinch the pot in one place it is necessary to repeat this pinch for at least one complete revolution of the pot in

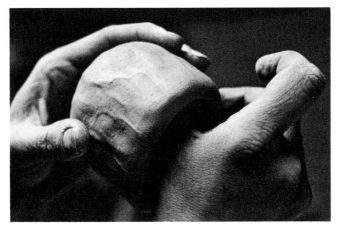

*Steps in spreading the wall*

*Ribbing the inside*

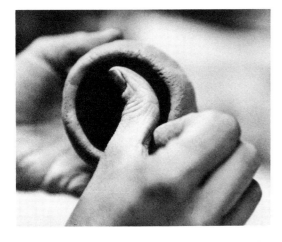

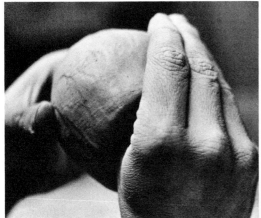

your hand or you will begin to develop an unevenness in the walls. In other words, once you make a gesture upon the clay you are committed to repeating that gesture all the way around the ball of clay, if it is symmetry you are working for.

When working on *step 2* it is possible to exert some control of the eventual shape of the finished pot by the pressure of the two outside fingers. Should you want the pot to result in a bowled-out form, do not resist the pressure of the thumb with the two outside fingers. Bowling out will happen naturally, as the thumb tends to be stronger. For a higher, rounder bowl the pressure of the thumb and the two middle fingers can be more equal. For a more lifted, more cylindrical form the pressure of the outside fingers becomes stronger than the thumb as well as moving slightly up the wall as you press (or down, if working upside down). A cylindrical shape is the most difficult one to make, and from what I know now, this last step is most important in aiming for a cylinder. Two other helpful suggestions: one, start with a ball of clay that is longer than it is wide and open it at one of the ends. Two, shift from an equal pressure between the thumb and the outside fingers to a slight sliding motion that has the thumb moving slightly down into the pot while the outside fingers slide up bringing a bit of clay up with them. For really tall cylinders it appears to be helpful, while performing this step, to hold the pot sideways in your hand. Then as you press the clay, the holding hand gently squeezes. This encourages the clay you are shaping to move up toward the rim rather than out.

## 3 RIBBING THE INSIDE

The front of the thumb is an excellent tool. When the thumb is bent as far back as it can go, it resembles the curved wood, metal or rubber ribs that some potters use in shaping bowl forms on the wheel. Place the right thumb, bent back as far as possible, as near the center of the bottom of the pot as you can reach. Use the two middle fingers of the same hand and the fingers of your left hand to rotate the pot. Slowly describe a long spiral to the rim. The thumb slides, supported by the middle fingers, which lift to rotate and to press gently to support the clay that is being described and stretched by the thumb. I find this a helpful technique for making a symmetrical form. While the continually and slowly spiraling thumb "rounds out the inside" it also checks and evens out the walls as well as thinning them very slightly. This is an especially important step for pots with a round bowled-out feeling.

Up until this point, I usually work with the pot in my hands. If  25

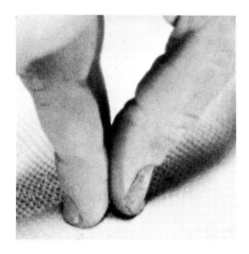

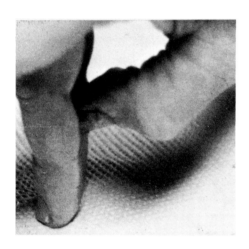

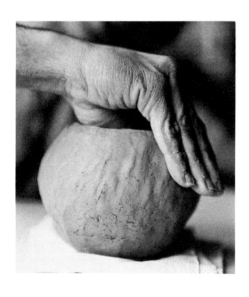

*Demonstration of finger positions in stroking*

the clay is fairly stiff, I can go on with the pot still held this way. When the clay is softer, however, I will put the pot down before or just after going on to *steps 4* and *5*. I always place a small piece of paper between the pot and the table, bat or turntable so that the pot does not stick. It is not necessary to have a bat or a turntable, as a small piece of paper, cardboard or paper toweling works very well and rotates freely with a slight movement of the fingers. If you do not use paper between the clay and the table you work on, the wet clay may stick and pull the pot off center. Also it is often the case that the table or bat may dry out the clay at the foot area too rapidly.

## 4 REINFORCING THE RIM

After *step 3* the rim may possibly open in cracks, but even if it does not, it is helpful to reinforce the rim. Much as in throwing, where the potter tends to press down on the rim after each pull up the wall of the cylinder, in pinching too, the pressure of the fingers on either side of the rim, without counter-pressure on top, is likely to leave the rim weak. Press-smooth down on top of the rim with your thumb while supporting both sides with the fingers of your other hand.

## 5 STROKING

Starting in the center of the floor or at the place where the floor flows into the wall, or as far down as you are able to reach, press and stretch (a smoothing motion) with the thumb up the wall against the outside fingers. The thumb starts vertically and continues till it is bent back at the knuckle in an almost 45-degree angle. This gesture should move you one-third, one-half, or two-thirds up the wall (depending on the size of the pot). *Stroke and rotate*, stroke and rotate until you have gone all the way around at least once. Repeat this same motion again, this time starting just below that place on the wall where you finished your first rotations. If you do not reach the rim with this rotation, repeat the stroking, starting where your second stroking rotation ended. End just under the rim, rather than continuing past it.

## 6 WORKING THE RIM AGAIN

*Step 5* tends to bow out the form so that it is wider at the middle than it may be at the bottom or at the rim. If you want to keep this shape, reinforce, thin and smooth: rotate the rim by pressing with the outside fingers down onto the thumb; the thumb cooperates by pointing to the direction you want the clay to move toward. Should you want the form to be open or straight at the rim, press-rotate with the thumb on the outside of the pot, supported now by the two middle fingers on the inside. The shape will very much depend on how much clay there is at the rim. If there is less clay at the rim than at the

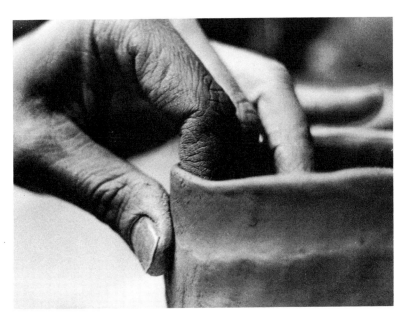

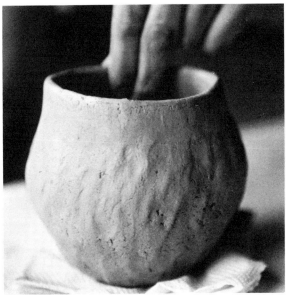

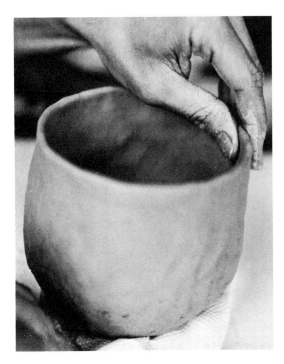

middle of the walls, pinching the walls to an even thickness will result in a shape that closes in. For a straight-sided wall there should be a little extra clay at the rim that can be pinched out to make a straight profile. For a form that opens out at the top, more clay must be left at the rim, so that when the walls are then pinched even, the form will open out.

Note that whenever a crack appears at the rim you can close it by stroking or pinching or bringing up a little softer clay from just under the rim to act as a sealer. It should not be necessary to use water if you act to close these cracks soon enough. It has been my experience that using water weakens the pot, but that a supportive caressing, pinching and stroking will actually seem to release moisture from the clay itself. However, some people have skin that seems to act as a blotter, drinking up the moisture. In such cases, it can be helpful to have a bowl of water nearby to wash any dry clay off the fingertips, leaving them slightly moist. If the cracks at the rim prove especially difficult to heal, you could place the pot upside down on a damp cloth for a few minutes. This will soften the rim enough to press-smooth the cracks closed.

If you wait to close cracks at the rim the thin edges of the cracks may air-dry and be difficult to heal, or they may seem to heal, only to open in the bisque or glaze fire. Surface cracking on the side walls of the pot does not weaken it as long as the inside is smooth. You can either leave these patterned cracks or smooth them over gently with your thumb, trying not to lose the symmetry of your form. If the cracks are fine enough, they can be scraped or sanded later. There is, of course, no law about the rim of a pinched pot. Often the rim will crack in such a rhythmical and naturally patterned way that you may decide to leave it as it is.

*Important Note*: As your pot is now on the table and the clay plastic and moist, the bottom will tend to flatten out. You will be unable, also, to thin out the clay at the bottom of the walls and at the floor without the pot collapsing further. *Don't worry about that at this point.* Continue working the top two-thirds of the pot until finished, leaving the floor and lower walls as they are. This particular approach to pinching is based on the finishing of the top two-thirds to one-half of the pot while leaving the floor and lower wall to be completed later.

27

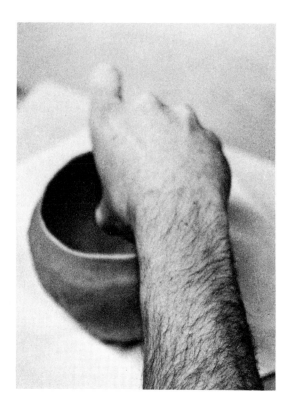

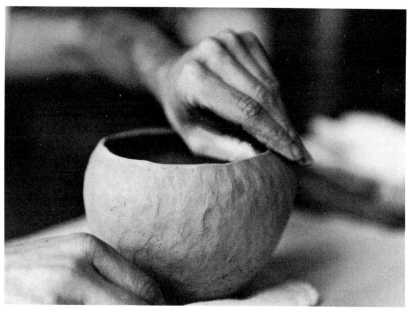

## 7 THINNING

At this point the pot should be approaching an evenness and a roundness. To thin the walls further repeat *step 2* (pinching with the thumb) and/or *step 5* (stroking). Or use any pinching gesture that feels comfortable or seems appropriate—as long as you repeat such a gesture all the way around the pot so as to maintain the symmetry and evenness.

You may at this point find it helpful to reverse the pinching gesture of *step 2*: that is, using your thumb on the outside of the pot with your two middle fingers on the inside. If you use small consistent and shallow pinches, especially on the top one-third of the pot, you may be able to even out the unevenness and bring the pot more toward round.

There is no special virtue in thin-walled pinch pots, but for the sake of this exercise it would be important to experience pinching the clay as thin as you and the clay are able: to an eighth-of-an-inch-thick wall, a sixteenth, or a thirty-second of an inch; paper-thin. How far can you go before the clay disappears? If we are able to pinch thin and even, then we can stop, by choice, at any point of thickness we feel to be right for the forms we will pinch in the future.

### Two Important Principles for Small Round Pinch Pots

(1) Pinch with one thumb at a time. However, at some time you might try using both thumbs with a larger amount of clay and see if you can keep them moving either together for symmetry or in separate rhythms for asymmetry.

(2) Move *slowly*, steadily and rhythmically. Try not to jump from one place to another. Once you make a gesture with a pinch on the wall, you commit yourself to repeat the gesture all the way around, if you practice this exercise. Don't rush: take it *slowly*. Most people experience difficulty with pinching when they work too fast and when they work unrhythmically. It's helpful to work in a rhythm related to one's breathing.

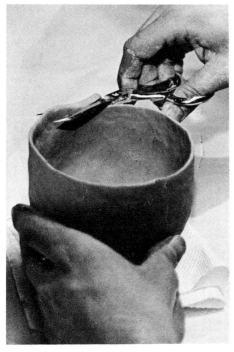

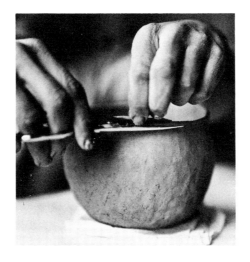

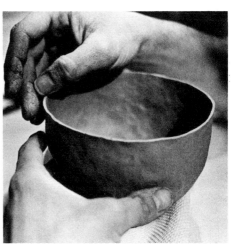

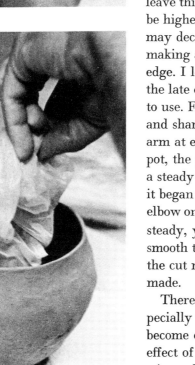

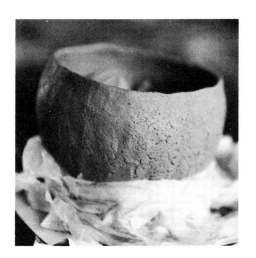

## 8 FINISHING THE RIM

Even when you have the ability to make a perfectly symmetrical form there is often a waviness at the rim. In most cases I prefer to leave this slight and natural flow; on occasion, however, one side may be higher than another, or part of the edge lower than the rest, and I may decide to alter it so that it will be even and level. In the case of making a pinch balloon (*see* page 50) it may be essential to trim the edge. I learned an especially useful method of trimming edges from the late extraordinary French potter, Francine Del Pierre, that I like to use. Find the lowest point of the uneven rim. Hold a pair of small and sharp scissors in your hand, keeping the elbow of your working arm at exactly the same horizontal level as the scissors. Rotating the pot, the paper, or the turntable, begin to trim the rim by cutting in a steady rhythm. Keep checking that your elbow is remaining where it began and has not fallen or risen (you can practice by resting your elbow on a pile of books while trimming). If your elbow has remained steady, you should end up where you started cutting. Now you can smooth the cut edge with your thumb and supporting finger or leave the cut marks, if it feels as though it's in the spirit of what you have made.

There is another reason why I may trim the edge. On occasion, especially when I may be working from a specific source, the pots may become complicated in their form. Trimming the edge often has the effect of pulling the piece together so to speak. The less complicated trimmed edge can serve a function similar to a frame on a painting: that of focusing the attention.

## 9 THINNING THE BOTTOM

When you have reached the desired shape and thinness in the top two-thirds to three-quarters of the pot and have completed the edge, it is necessary to wait before thinning the bottom to the thickness or thinness of the rest of the pot, especially if the pot is thin and moist. If you were to lift the pot now and pinch the bottom, the form would distort and the bottom flatten when you set it down again. What I do to avoid this is to wrap the bottom and lower wall of the pot with some light plastic (the kind used to cover dry cleaning) and also place a piece of plastic inside the pot, on its floor. In a few hours (depending on the drying conditions of where you work), when the rim and top are almost leather-hard, or at that point where the form will 29

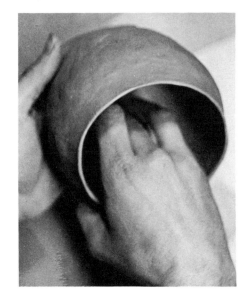

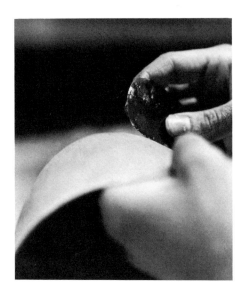

not distort when lifted, I unwrap the pot and hold it in one hand. I then use the thumb or middle finger of the other hand to stretch out the wet clay, which has remained moist because it's been well wrapped in the plastic, from the inside. Depending on how much clay is left, the lower sides will widen and the bottom will drop. The inside thumb or finger that is stretching can feel the other hand through the clay, so that one can feel and control the thickness. The holding hand also acts to support the pressure coming from the inside, checking that it does not press out too far. You can either start at that point on the wall where the clay is moist and work down or start at the floor and work up. The former will lengthen your pot, the latter will widen it.

Instead of a flat bottom there will now be a bowl-round curve. To avoid the wet bottom flattening again when I set it down, I dry the pot on its rim. When the bottom has stiffened enough to hold the weight of the pot, I either add a raised foot or usually I turn it over and tap it lightly on the table so as to form a small flat area on which the bowl can sit unwobbling. It is possible, in this way, to change the shape of a bowl with a wide flat floor and only an inch or two of wall into a much higher form. It would depend on how much extra thickness of clay there was in the floor: almost no extra clay would still round out, lifting the shape; one half inch of clay could raise the pot several inches.

This step of wrapping the lower part of the pot is, I believe, what makes it possible to (1) make thin forms and (2) make pinch pots using more than the amount of clay you can hold in the palm of your hand. Sometimes this step is not necessary, especially when you are leaving walls of more substantial thickness. In such cases, finish the pot in your hands, and so as not to lose this bottom curve, rest the pot on its rim, until the pot is stiff enough to hold its shape right side up.

Lift the pot in both hands and close your eyes. The feel of it is very important. How does it feel? In the name of this exercise in evenness and symmetry, it should feel of-a-piece, so to speak. Where is the center of its gravity? Does it feel bottom or top heavy? Open your eyes and look inside. The inside shape should be uncomplicated, one smooth curve holding air. Imagine what the inside would look like if the air could be frozen and removed. Does the outside shape relate to the inside shape?

In descending order: *Dropping the bottom; Drying the pot on its rim; Scraping the pot with a flexible metal tool when the pot is leather-hard; and* (right) *Finishing with sandpaper*

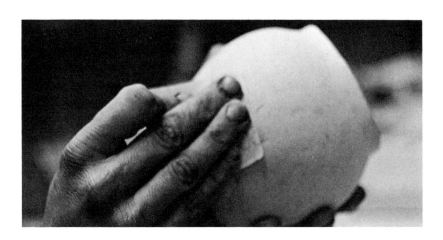

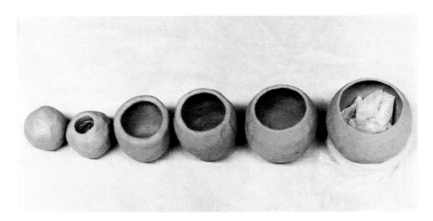

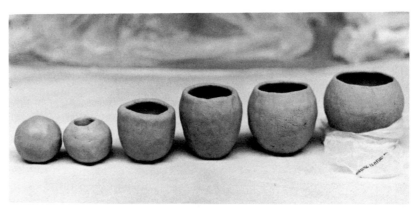

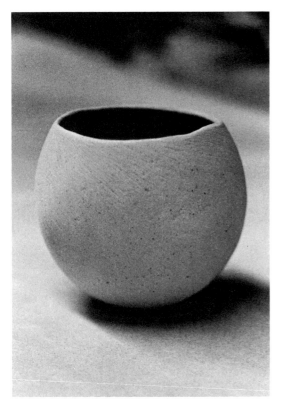

## 10 FINISHING THE OUTSIDE

The finished pot will show your finger marks. Because they are your fingers the pot will have a unique texture and you will probably want the marks to remain. There may be a network of fine or strong cracks on the surface caused by the strong pressure of the thumb pressing the clay out from the inside. This texture, too, you may find pleasing and natural and earthlike, like the shells of some nuts.

Should you want the outer walls of the pot clean and uncomplicated you can scrape off the finger marks and texture with a flexible spring steel scraping tool when the pot is at the leather-hard stage or just past it. If the clay has heavy grog the scraping will pull at the grog and make an even but scratchy surface. You can either leave this or use sandpaper, when the pot is totally dry, to smooth it over. You can add texture by using very coarse sandpaper that will scratch many small lines, like cross-hatching on the surface. After bisquing you can glaze the outside or just the inside, leaving the outside to show the clay and the texture. You can use engobes or slips and paint on the walls of the pot as if it were a canvas waiting for an image or a brush stroke. You could write a letter on its surface or tell a picture story or make designs. Or you could rub thin slips or oxides with water into the walls to darken the surface color or highlight the texture.

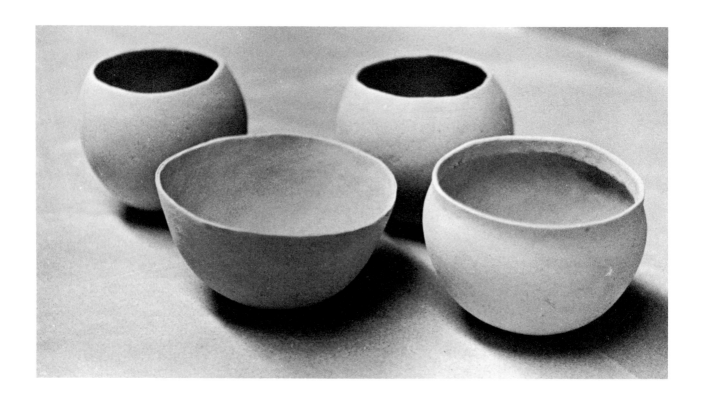

The steps of this exercise are merely suggestions for achieving a thin symmetrical form, a point of departure. Try the exercise a few times to see if you can achieve this goal of simplicity, roundness and evenness. Along the way you may find a more suitable or comfortable way of handling the clay and achieving this same goal. Keep watching and feeling what's happening: what *your* fingers are doing; what *your* clay does. If you can, practice until you are able to make a simple round bowl as described. Then you may find that you like the look or feel of your hands on the clay and may want to exaggerate the marks your fingers leave by deepening your pinch-bite on the clay. Or you may want to open the clay purposely off-center and see where the clay's unevenness leads you. Or you may want to make thick-walled but even pots, or thick and uneven pots textured by carving or by pinching out spines. Or the shape may be determined by your mood or a story you wish to tell or a fantasy you have had. Or the shape can be the result of what the pot is to be used for or whom it is being made for, or why. It may show the anger you have been feeling or the tenderness, or the sensuality or the anxiety or the quietness, or all of these. You have more freedom to show what you feel or want to now that you have gained some strength in practice. To work off-center, it is important to know where center is. I feel richer in my asymmetry because of my knowledge of symmetry; not a victim of the clay's will, but a participant.

Practice this first exercise many times. Even after you feel you have mastered it, return to it again and again, like a pianist returning to his scales. Notice the shapes that your touch on the clay seems to produce, and see whether you can add other shapes by altering your touch and by leaving sometimes more, sometimes less, clay at the floor or the edge of the piece, so as to be able to exercise control over the shapes you achieve.

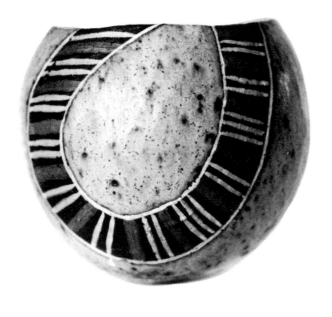

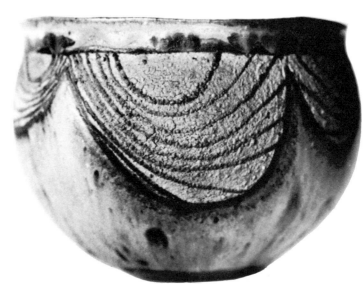

*From the series "More Than One Man Deep: An Homage to the Potters of the Past," stoneware with glaze and slips*

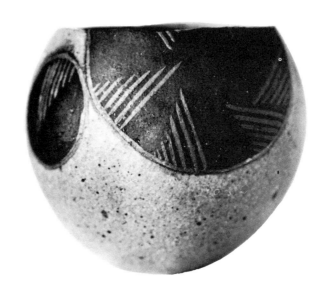

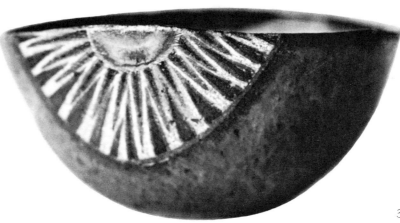

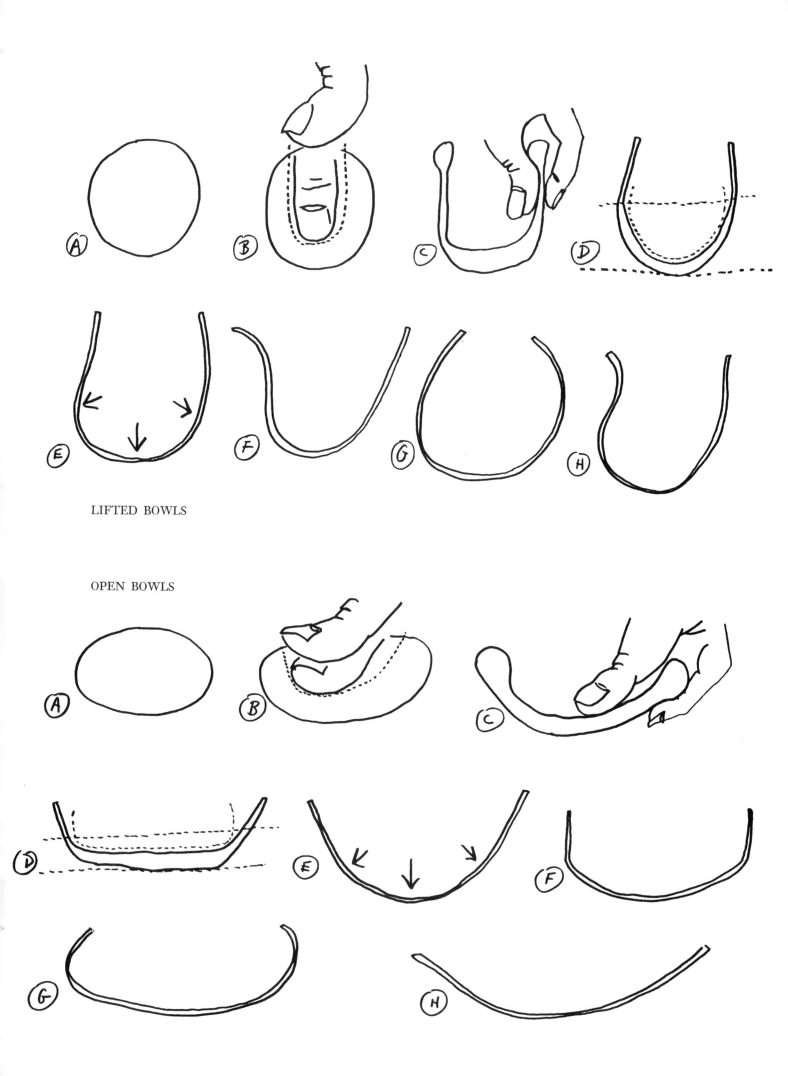

LIFTED BOWLS

OPEN BOWLS

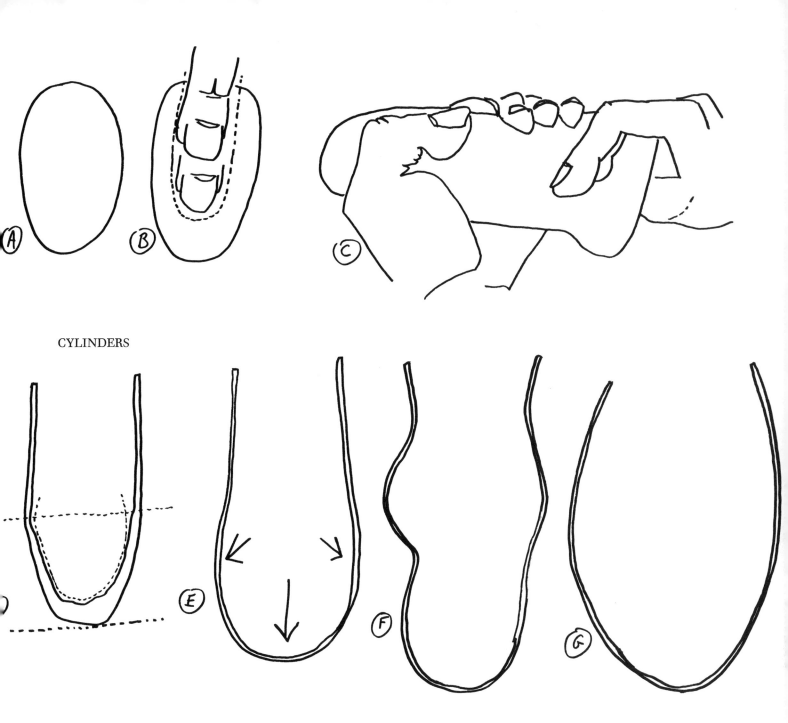

CYLINDERS

## LIFTED BOWLS

A Starting with a round ball B Thumb starts flat and
ends straight C Stroking up with even pressure D Bottom
and inside wrapped in plastic until unwrapped portion
"sets up" E Bottom pinched and pressed out F,G,H Three
possible shapes

## OPEN BOWLS

A Starting with a flatter ball B Thumb stays flat through-
out opening step C Stroking out, with the thumb stronger
than the outside fingers D Plastic wrap E Bottom pinched
and pressed out F,G,H Three possible shapes

## CYLINDERS

A Starting with a long ball B Opening with a straight
thumb C Pot held sideways in left hand. Left hand col-
lars in while right fingers stroke up toward rim with
greater pressure from the outside fingers D Plastic wrap
E Bottom and lower sides thinned out by pressing and
pinching out F,G Two possible shapes

## TO ARRIVE AT A VARIETY OF SHAPES
Change—
   the shape of the ball you start with
   the way you hold and move your thumb in opening
   the direction and pressure of your thumb and fingers
     in the initial pinching
and vary—
   the amount of clay you leave at the bottom of the ball
     of clay when opening
   the amount of clay you leave at the rim in the early
     steps of pinching out the pot

Overleaf: CLAY/BODY DANCE NUMBER ONE, *"Morning Raga"*    35

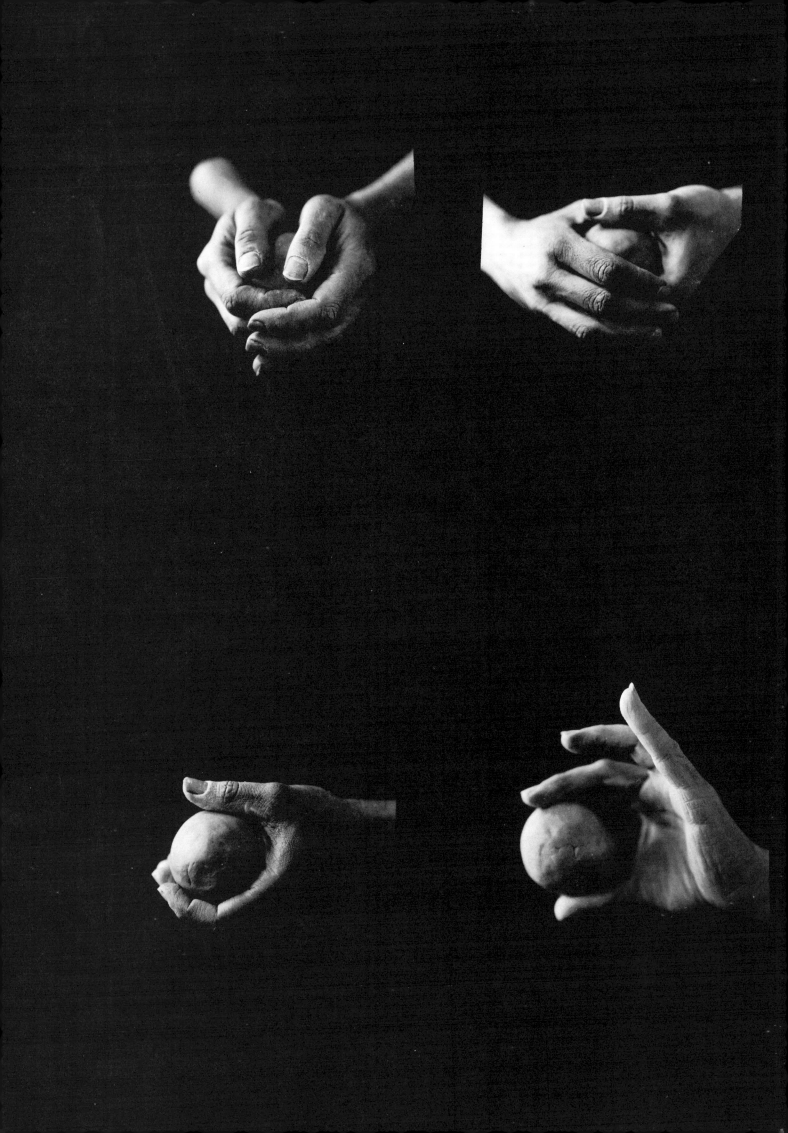

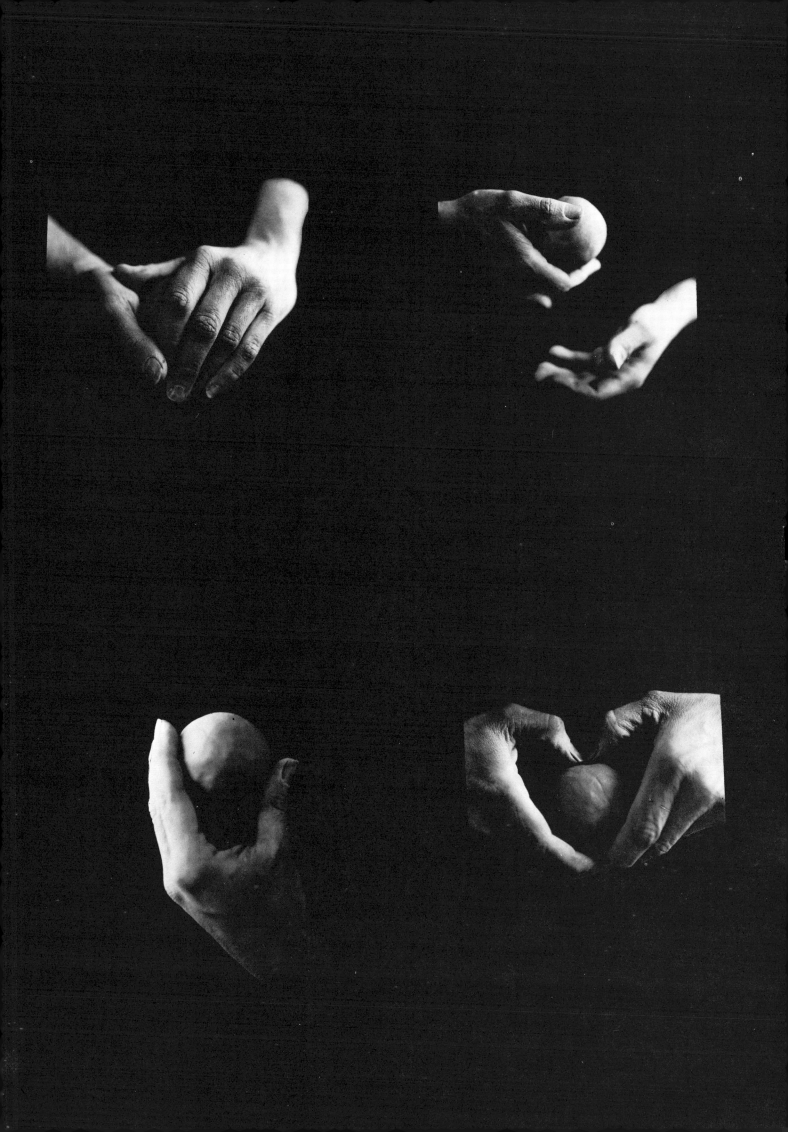

# Exercise Two:
## A Way of Being with Clay

## A Way of Attention: Being in the Here and Now

## A Way of Practice

IT ALWAYS takes time, when starting in a new discipline, to learn a way of working that helps us build strength, be it dancing, playing the violin or working with clay. Often we skip about making this and then that before we come to a time when we may feel the need to find a way to practice that will both strengthen our abilities and at the same time deepen our connection to our material. I find it clearer, and in a real sense easier, to learn how to discipline myself for dealing with the technical problems of forming: how to raise a cylinder, to make a cover fit, to add a foot, etc. These are important questions and I know that there are numerous avenues that can lead me to my own solutions. But it is not techniques I am concerned with here; my concern is, rather, in that intangible area beyond techniques that few others are able to help us with. It is something that we have to find our own way into relationship with. How do we quicken and enliven our connection to our own work so that we feel connected, feel the touch, feel the relationship, work from a deep personal center? It is also a question of concentration, of focus, of being in the Here and Now with our clay. How do we practice for this?

The following exercise is one that I do often, sometimes daily, usually first thing in the morning. It brings me to the clay and to myself in a very simple and moving way. It is a way of preparing and a way of practice for me. This exercise developed out of a bringing together, in a way suitable to my personal need and my need as a teacher, two recent experiences in my life.

One of my former students at the Wallingford Potters' Guild, Shirley Tassencort, whom I grew to admire, respect, and love, is a serious student of various practices of meditation. I noticed her special quality of attentiveness to both the clay and the work in the very first class she attended. Her person and the pots she made were special and alive for me. Over the following two or three years as we became friends and then colleagues, I began to question her and slowly discovered more and more about her commitment, her center in her practice. I became interested and asked her to recommend books that I might read and soon sought her help in entering the practice of Zen meditation. By this time I was living at my farm, some distance from the nearest Zen center, so I had to practice alone with only the rare help of a teacher. I did not fare well. One morning, however, after attempting meditation, I went immediately to my studio and found myself working with the clay in a new quieter and more concentrated way. Soon I was bringing small balls of clay to my practice and the practice moved away from attempting the form of Zen meditation into a simpler practice more specifically related to what I seemed to need.

During the summer of 1969, a friend, who was living and working there, invited me to visit her at the Esalen Institute in Big Sur, California. While there I participated in a group led by Bernard Gunther in sense awareness. He led us through a simple exercise which increased our awareness of the sensations, energies and feelings in our bodies. When I returned home I found myself repeating this exercise and similar ones often. Soon, to bring this experience deeper into the

center of my life, I began practicing this exercise while holding clay in my hands. It seemed logical to move from the experience of my body into the experience of the clay body. It made the exercise somehow especially alive and real for me.

These two additions to my daily life came together to form a way that I now practice in my own work and in my teaching. I almost always introduce this practice soon after beginning a workshop with new students. I lead the whole class through this exercise once and often repeat it with smaller groups of persons specifically interested and wishing to go on.

Before beginning this exercise read through the directions a few times so that you will not have to break the flow to consult the text. Try it the way it is outlined, if you can, a few times. If it doesn't speak to your need, abandon it. What is your need? Can you find a way to practice that will nourish that need in a way that this exercise has deepened my feelings of connection to my clay experience? If you work on the potter's wheel try this exercise throwing. Try it with wood carving if you carve wood, with yarn if you weave, with sewing, knitting, with any material with which you work in close relationship.

During this exercise it is important to breathe as deeply and with as little force as possible. Check to make sure that your stomach is relaxed and that your shoulders are without tension.

Prepare a small ball of clay—about the size of a lemon or a small orange.

Prepare a piece of paper or a turntable on the table next to where you will sit.

Sit in a comfortable chair that will allow you to sit straight, but not rigid, with both feet on the floor.

Hold the clay between the palms of your two hands and place your hands on your lap. Do not move or fondle your hands on the clay during the first part of the exercise.

CLOSE YOUR EYES: Keep your eyes closed throughout the exercise.

## PART ONE:

With your eyes closed spend about a minute following your thoughts. Then let the words go and become aware of how you feel—not what you think you feel or how you would like to feel but your actual feelings and sensations as they are in the next minute. Be aware of your breath and where it is.

Now shift your attention to the soles of your feet. Without moving them in any way become aware of what they are resting on. Concentrate all your awareness there, as if you exist at no other place at this moment. Keep your mind's eye in the soles of your feet for from fifteen to twenty seconds. Then take fifteen to twenty seconds or longer, or however long it takes you, to feel-experience (rather than

think or imagine) the following areas of your body in the following order. Take your time and keep your concentrated *mind's eye* as focused where you are as possible:

Your toes (without moving them)
Your ankles
calves
knees
thighs
genitals
Move around to your buttocks
    and the chair that supports you
the small of your back
Move around to your stomach
your chest
the base of your neck
your chin
mouth
nose
eyes
the place between your two eyebrows
forehead
your whole face
the top of your head
the back of your head
the back of your neck
your shoulders
upper arms
elbows
lower arms
wrists
hands
your fingers (without moving them)
and THE CLAY (your mind's eye in the clay)

Pause for fifteen to thirty seconds or longer with your mind's eye in the clay.

### PART TWO:

With your eyes still closed breathe deeply and lift one hand holding the clay and proceed to open the clay with the thumb of your other hand. Slowly and in rhythm with your breath make a symmetrical pinch pot in much the same manner as in Exercise One. The important task here is *at that place where your thumb or whatever finger or fingers you are working with meets the clay*. Bring your *mind's eye* and all your inner focus *there* for as long as you can. This is difficult and it will take practice even to hold your attention deeply there for a minute or so. When you become aware that you have begun to think again or that you have shifted your attention, just stop all activity for a moment, breathe deeply and then try to return your mind's eye to your thumb and the clay at the point where they meet. Don't punish yourself with reproaches when you find your head full

of thoughts: Just stop, breathe, and try to let your thoughts go and return your focus to your work.

Work as long as you can with the pot in your hands; when you can no longer do so without the pot collapsing, place it on the paper you have prepared and continue on until either the pot feels finished or you feel that you have had enough. Work slowly in rhythm with your breath. This entire practice may be as short as fifteen minutes or you may be able to remain deeply concentrated for up to an hour or more. When you have finished, pause, breathe and slowly open your eyes and look at what has happened. If you have difficulty working with your eyes closed, try working with them opened but turned away from your work.

Now do the exercise.

The pots that result from this practice are of less importance to me than *the quality of the act of the practice itself* and so I often do not save what I make in these sessions. However, they are consistently the most symmetrical pots I make and the least complicated (except for very troubled days when the pots often show my inner activity). It is as if the fingers were more informed about roundness than the eyes —something I've noticed to be true for the participants in the workshops as well. What is special about these pots for me is that criticism is irrelevant. When I open my eyes I am always surprised by what I see and feel: this pot is *this* way, and that pot is *that* way. I feel that *they* are as my practice is. Judgments such as good-bad, right-wrong, better-best are out of place here.

The experience is different for me almost every time. Sometimes I become flooded with sensations from the clay body spilling into my body. Sometimes it is as if I were giving energy to the clay. Often it is a quieting time. On occasion, it has been a deeply sensual experience.

One young man in a workshop was so concentrated in his trip of awareness through his body that he was unable to open his ball of clay in fear that he would be causing himself bodily injury. He presented me with his unopened ball of clay at the end of the session. "I would like you to have this pot," he said, and I accepted. A very special woman who sat near me on another occasion had a similar experience, only she chose to open her clay and encountered acute physical pain. When she came to the place where she was spreading the floor of her pot she felt as if she were in her own lungs pressing against the asthmatic constriction she has suffered there for many years. Some hours later she told me about it and remarked that she was able to breathe with more ease and deeper for two hours following the making of her pot. Occasionally the exercise has made people laugh or weep.

Do not be surprised if you are unable to keep your attention on the mark. It takes hard work and lots of practice to extend these periods of bull's-eye focus. And often just what does pass through your head can be of interest. For a time, I kept a jar of slip and a brush nearby so that when I opened my eyes I could write the first thing that went

through my head onto the walls of my pot or I could write a thought that may have seemed strong during my practice.

Try this exercise alone—give it several serious tries if you can. You may find it helpful (supportive) to do it with a group of friends. Have one person call off the names of the parts of the body so that you are together during the beginning stage. It would be important that the participants have the experience of doing Exercise One at least once before attempting this so that their attention will not be too diverted by questions of what to do next. You may want to share with each other what happened, following your practice together or you may want to simply be together in silence.

Recently, I have added a variation of this exercise to my practice. During the year that I lived at Penland, I participated in daily early morning yoga, led by Phyllis Yacopino. I had a great deal of difficulty, at first, in freely and deeply breathing that early in the morning. Rather than letting go, I seemed to be tightening up my stomach muscles. For a while I just waited as my friends breathed deeply. But tenderly, Phyllis urged me to try it again and again, knowing as she did how basic this breathing practice was. Finally, through experimentation I discovered that if I would stand on my head first thing, my breathing came easier. So much easier that I began to really enjoy doing yoga and I found that it made the practice of all the "positions" less straining and more fluid, more from the inside. So I tried to adapt this to clay. Holding the clay in my hands, with my hands in my lap, I precede the pinching by a period of deep breathing. I start with a three-count breath: breathing through my nose into (1) my stomach (2) my lungs and (3) my throat and then exhale (1) from my throat, (2) from my lungs, and (3) from my stomach. Then I direct my breath into various parts of my body. Into my feet, my genitals, my shoulders, my chin, my arm, etc. When I begin to work the clay, my attention is deeply focused on following my breath as I experience it, flowing through my nose, down my arms, and out my thumb into the clay. When I exhale it is as if my breath were coming out of the clay itself. The pots that result from this practice are often not symmetrical and very much a surprise for me when I open my eyes. They often look breezy—full of air, full of spirit.

It is not necessary that you take this practice as is: you can adapt it to your own needs. Robert Sherman, a young actor from New York City, who attended a one-day pinching workshop and then two longer ones, has taken off from the basic premise of this practice, enlarging it into several extremely interesting and helpful group exercises. He uses them in classes with acting students and colleagues and has led a few of them on a couple of occasions in my pottery workshops. This "crossover" between the questions and special abilities of actors and potters is especially thrilling to me and makes me wonder about what we might all share as persons with unique gifts, say in botany or dance or physics or music. The insights of all our experience individually and communally: opening up as fertile ground for the pots we make, the songs we write, the questions we explore, the lives we grow into.

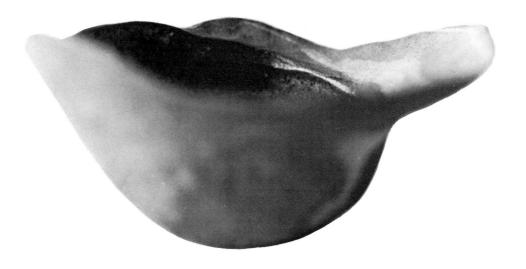

## Moving Off Center:
### Six Possible Approaches

I'VE NOTICED that when people are new to clay and attempt to work asymmetrically, they tend to push the clay about, this way and that, until either they are satisfied with the look of it or, at best, it suggests something that carries them on until they're finished. It often is especially difficult to get going when there is no specific theme or idea that has engaged the potter. The six approaches to asymmetrical work suggested below are technical in nature and based upon departures from the steps and approaches to handling the clay used in the first exercise. They are designed to introduce the hand and eye to ways of experiencing asymmetry as a part of the process of the work itself. Although the forms that result from these six ways may be similar for you, the feeling of working may differ. It is one thing to feel one's thumb stroking the outer wall of a pot and quite another feeling to dart from area to area on a piece of clay with quick and incisive pinches. Try all or any of these ways, paying attention to the feel, the touch, the form. You may find one of them suited to where you are now, or you may combine two or more of them. Or you may discover on your own an approach that is nourishing to your spirit and need. The only way to find out is to do it, and one of these six approaches may set you off.

And yet ultimately, the approaches we use will arise out of concerns beyond the technical. As we work more and more and get more "into" our work, the ways we'll use will arise out of the issues or themes that propel us to form. And what about working from our own experience of being off-center, of being asymmetrical?

43

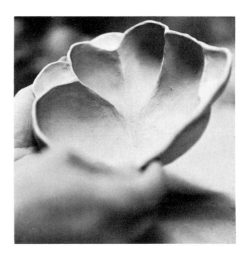

## 1 CHANGING RHYTHMS

Since making symmetrical forms depended upon a steady rhythm and slow working—a consistency—it is most logical then to begin to exercise for a form less committed to roundness by altering the rhythms of the pinch-bite on the clay, speeding up and/or slowing down as you work about the form. The pinch-bite itself can vary in its strength as well as its rhythm, so that in some areas of the piece the pinch-mark traces of your fingers may be deeper than at other places. When working this way, I keep watching what's happening; how each series of pinches on the clay seems to suggest the next. I may be working in one area only to have to skip to another. One area may suggest the need for a balancing area, or a shadow, or an opposite, or an echo.

Working in this way the rim tends to take on a life of its own, dependent upon what I've been doing in the body of the piece. I may leave the rim as is, or exaggerate it, or trim it even in contrast to the movement of the body of the pot. In pots made from this impulse, I tend to leave the finger marks clearly visible, unless the shape that results has a gesture that will speak clearer when scraped or smoothed clean.

## 2 USING THE STROKING THUMB ON THE OUTSIDE

In making symmetrical forms, I almost always work with my thumb on the inside of the pot, except when working about the rim. Reversing this procedure, I find it difficult to keep to a roundness, especially when using a stroking gesture with the thumb. Using a stroking thumb motion on the outside of the wall, the pot almost always begins to take on an asymmetrical form. I keep watching for areas to work. I work slowly, exaggerating and realizing areas that seem to be coming alive. The stroking thumb often leaves brushlike strokes on the clay and the rim seems to rise naturally from the body of the piece. I tend to work with my thumb on the outside when I want a piece to rise more cylindrically: pressing the clay in and up with my thumb while I work. I find working this way a vastly different experience from working with my thumb on the inside. The feeling and the forms appear to be a different story.

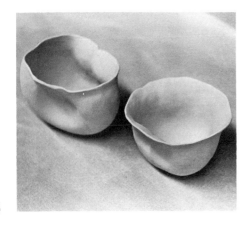

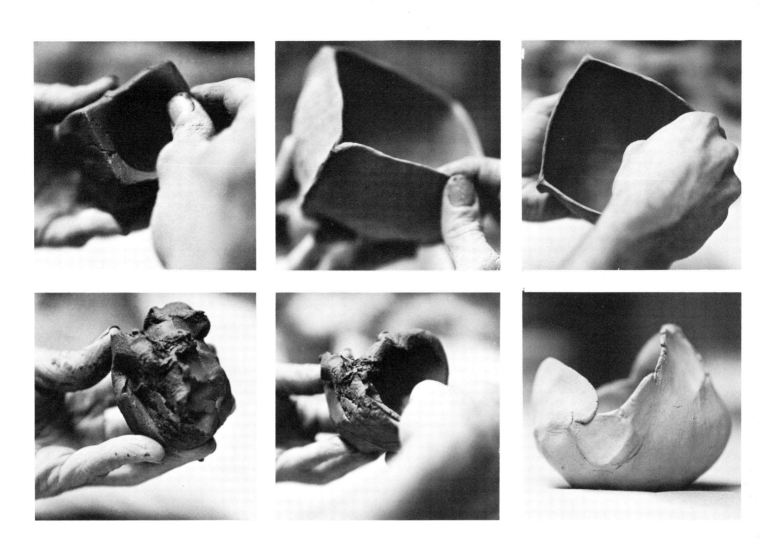

## 3 STARTING WITH A NONROUND BALL OF CLAY

So far we have been making pots from round balls of clay: What if we were to prepare our clay in other shapes? What if we were to start with an egg shape, a square, a rectangle?

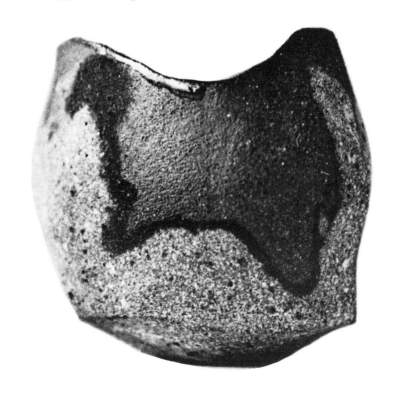

Right: *Stoneware pot of inlaid colored clays, pinched from a rectangular ball of clay, 3 inches high*

45

## 4 FOLLOWING THE CLAY

What if we were to start with clay in the shape that we cut or pull from a larger amount of clay? We could then pinch this out, letting the asymmetry of the piece of clay itself guide us to its eventual shape. Or we could look carefully at the clay itself and choose to leave as much of its natural quality untouched as we can, by pinching around it to bring out and enhance what is already there. This way of working has proved an especially helpful way of practice for me and for some of my students. It is necessary when working this way to keep one's focus riveted on the clay and on what's happening. It often serves to deepen the potter's appreciation for what is already there in the clay.

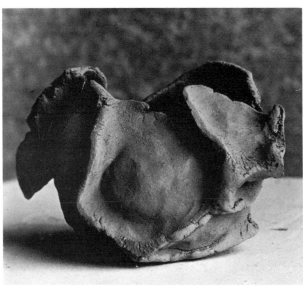

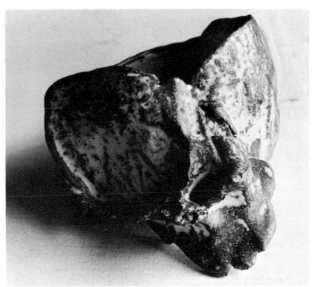

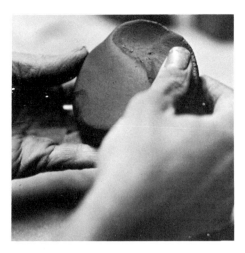 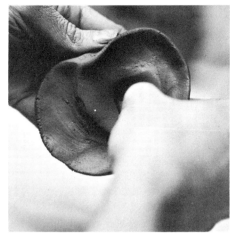 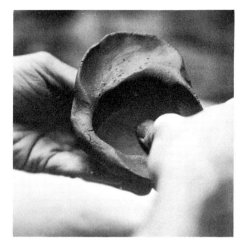

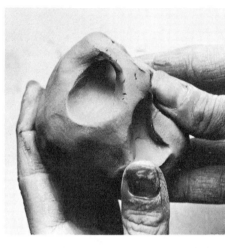 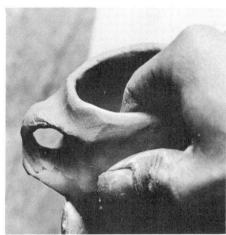

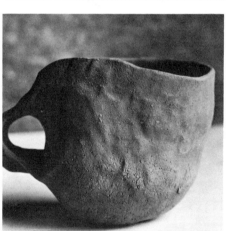 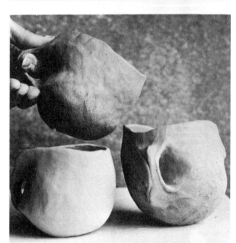

## 5 PINCHING BEFORE OPENING

The rim is usually the result of the pinching we have done, but what
if we were to form the rim before we were to open the ball of clay?
You can start by modeling the ball of clay into a shape before open-
ing. You can pinch out your rim leaving just the amount of clay you
want there for later. You can also pinch out ledges or handles, then
make your opening and work around these ledges or rims or handles.
Especially in the case of handles, when the handle is formed before
the ball is opened, the resulting form appears more integrated than a
form to which a handle is attached. I often start by rounding the ball
of clay on the table to make it thinner in one area and then pinch
that area out before going on to open the body of the clay itself.

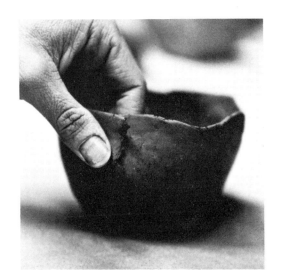

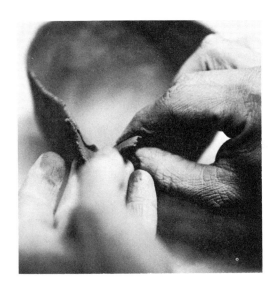

## 6 OVERLAPPING AND CUTTING

As in sewing, clay can be darted and gusseted and overlapped. For instance, if you have a form that opens wide, and the clay is soft enough, you can cut out a pie-shaped wedge and then bring the two edges together, working the clay well so that it won't open again. If you wanted to make a pitcher spout or have an area of your pot move out, you can cut a slit-like opening in the wall, open the edges of the cut and add a gusset pinched out to fit in this space. Or you can simply overlap your clay and pinch it into the body to bring the wall in or you could leave the overlaps visible.

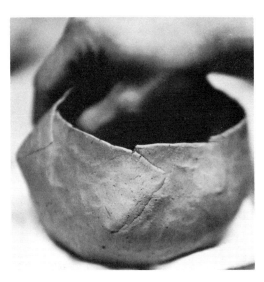

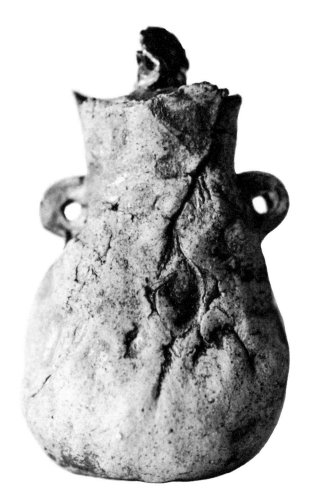

*Covered pot by Cynthia Bringle, pinched and overlapped*

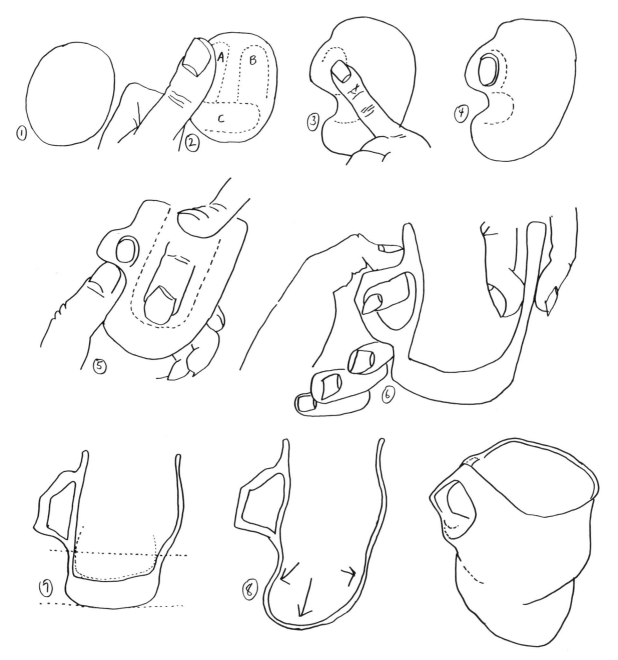

## INSTRUCTIONS FOR MAKING A "BODY MUG"

1  Start with a round ball of clay
2  Make two vertical (A & B) and one horizontal (C) deep impressions with your thumb
3  Use your pinky to dig a tunnel from imprint A to imprint B; side view
4  Side view with tunnel
5  Opening the ball of clay to form the mug
6  Pinching out the mug and handle. Whenever possible, hold the handle in your hand while you work: look less, listen more, feel what's happening in your body.
7  Wrap the bottom and the floor of the mug in light-weight plastic when the upper part of the mug is finished, and allow the unwrapped portion to dry to almost the leather-hard state.
8  Pressing and pinching out the lower part of the mug.

Spend a great deal of time observing the way you hold a cup or a mug. How does it feel in your hand or hands? How does your body feel? What will the mug be used for? Think of this mug being used at a time when you are alone: a personal time, an intimate mug. If the mug is to be for someone else, take time to watch that person move, hold something, drink. Start your mug with a solid ball of clay about the size of an orange and form the handle first, before opening the ball itself. Mold the handle to fit and conform to your way (or a friend's way) of holding. When pinching out the mug with one hand, hold the handle with your other hand, as often as possible, so it feels right.

I prefer holding a mug with my first finger through the handle, with a place for the thumb to rest at top and a ledge for the middle finger underneath, for support. I generally hold my mug next to my left hip, in my right hand with my left hand cupped below it. When I told Howard Shapiro about body mugs, he made one with a round bottom, so the mug could not be set down; when he drinks his tea, he drinks it all at once. What kind of mug do you need?

Remember that clay shrinks: the handle must be *larger* than you intend, if it is to fit after firing. The drawings on this page show how I make my mug. Proceed in any way you need to make yours.

*When you lift my mug, it should feel as though you were taking hold of my hand. When I lift yours, it should feel as though I were dancing with you.*

49

# Closed, Near-closed and Necked Forms:

## Three Approaches

### 1 PINCH BALLOON

If you wish to make a hollow sphere (to make a bottle, rockweed holder, a series of round forms to attach together, a teapot, etc.) one possible way would be to make two pinch pots with even walls and the same circumference at the lip. When the pots have "set up" a bit, use an old toothbrush (or fork) and clay slip to scratch and dampen the edges, and join the two pots lip to lip in a slight screwing motion. Add a coil of damp clay all the way around the joint and work the excess clay into the walls above and below it. Because air is now trapped in this sphere it is possible to alter the shape by slapping it with your hand, rocking or rolling the form on your table, or using a paddle; you can let it get leather-hard and scrape it or carve into it; or you can add any number of things to it (*e.g.*, neck, necks, feet, a pinched shawl). If when you put the two pots together you find that not enough air has been trapped inside, add a small bead of clay at the top, making sure you work it into the body of the form; then puncture this bead with a pin tool that opens a hole all the way into the sphere. Now blow gently into the sphere by placing your lips over

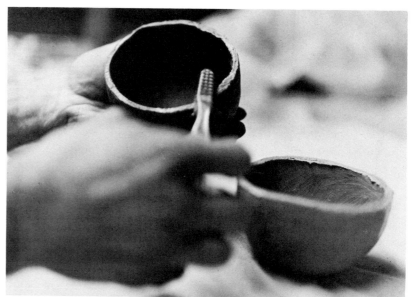

(1)

(2)

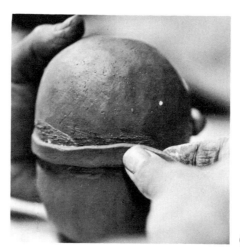

(3)

Facing page, bottom: *Un-fired rock form made by Cynthia Bringle* Extreme right: *Raku balloon weed form by Charlie Brown of Mandarin, Florida*

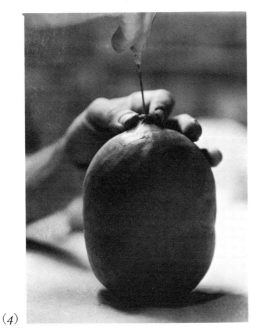

(4)

(5)

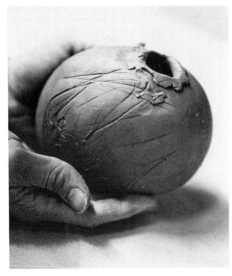

(6)

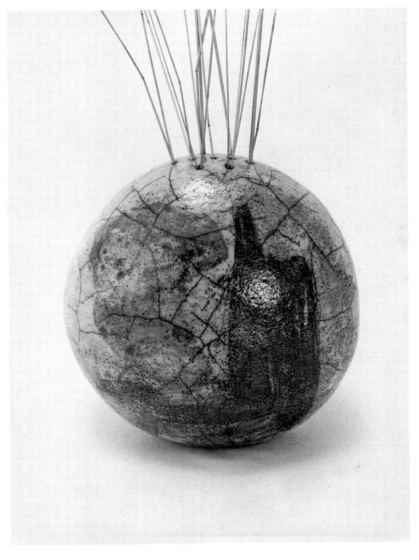

the small bead of clay. When it has enough air (feels full), press your lips together to seal the hole in the bead. You can either now work the small bead of clay into the pot or scrape it off later at the leather-hard state. The air, now swelling the inside of the sphere, will act as a support as you work further—the pot will not collapse. If, however, you press the sphere too hard, there is a possibility of bursting the balloon.

It is important to remember that you cannot fire a totally enclosed sphere. The air inside will expand when heated and either crack or blow up the pot during firing. A pinhole is sufficient to allow the air to escape and should be added to the sphere before it passes the leather-hard stage at the latest. Using the principle of this method of joining two pinch pots rim to rim does not limit you to making spherical forms. Starting with a sphere, however, one can cut out covers, make teapots, rock gardens, vases, etc.

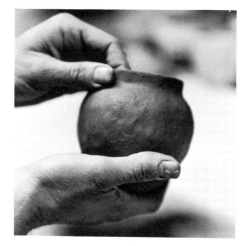

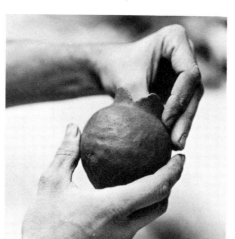

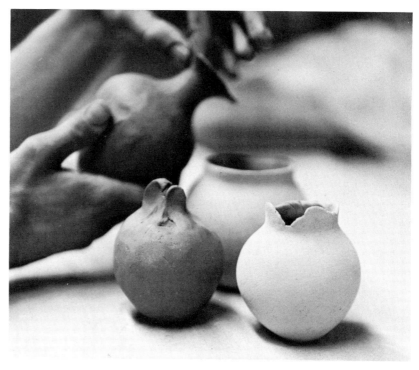

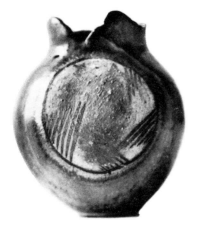

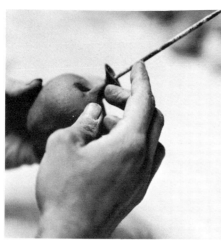

## 2 SMALL, NEAR-CLOSED AND NECKED FORMS

Start as if you were making a pinch bowl (it can't be too large, as you will have to finish the walls and the floor in this first step. *See* page 59 for making larger spherical forms). If you work from the inside of the bowl, your thumb will swell out the form. *Steps 3* and *5* of Exercise One are the methods I use to accomplish this. *Leave a generous roll of extra clay at the rim.* The amount of clay you leave will determine how closed you can make the pot and/or how tall you can make the neck. When the walls are to your liking, place your thumb inside under the rim and stroke the clay toward the center with your two middle fingers of the same or other hand on the outside. Try to stroke in, not up. It is impossible to completely close a pot this way unless there is enough extra clay left so that you can pinch it closed from the outside; or you could work in a little pinched disk of clay to cover the opening and then blow air into the sphere as with the pinched balloon. For a necked form, pinch in the clay as far as you want it and then pinch up the remaining clay to form a collar. If you leave enough clay it is possible to trap a pencil in the hole and press the extra clay up the pencil (or dowel, or toothpick) to make a neck and rim at the top. Be certain to remove whatever you have used to form the neck before the clay begins to dry, or the shrinking clay will crack. If you have difficulty removing the pencil, dowel or toothpick, try wrapping it in one layer of paper toweling; this should allow the tool to slip freely out of the clay neck.

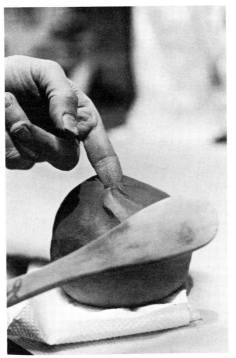

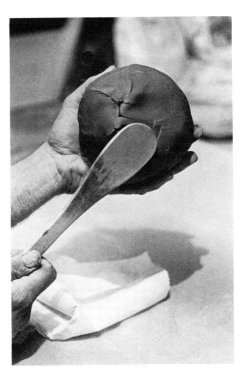

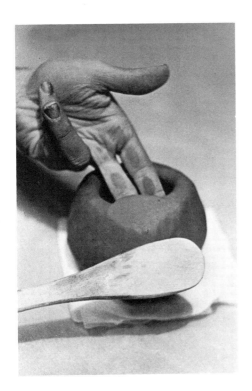

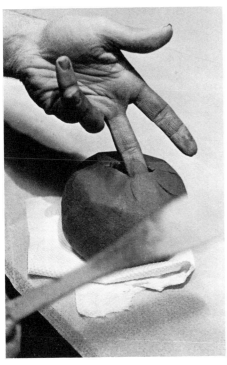

### 3 CLOSED FORMS USING A PADDLE

A way that I especially enjoy making closed or near-closed forms is to begin as on the previous page by making a pinch pot with extra clay at its rim and then, instead of closing it with my fingers only, I use a paddle. I insert my two middle fingers as near *horizontally* as possible inside the mouth of the pot, and, using a small or medium-sized paddle, I begin to paddle the clay along my fingers *into* the center of the pot. I paddle lightly and rotate the pot in a steady rhythm. When I get nearer to the center I may paddle more unevenly to take advantage of the natural and beautiful way the paddle stretches out the clay in tongue-like pulls. When there is no longer room for both my fingers, I remove one and work up as well as in with the paddle. I usually will stretch one area longer than the rest. I then remove my fingers and paddle down the longest tongue to cover and seal the pot, or to leave small natural openings. The size of the opening or openings will depend on how much clay is left at the rim to make the closing. It will take some practice to determine exactly how much clay you'll need. Again, because you cannot reach into this form to work the floor later, you should, at least the first few times, work only with an amount of clay that can be handled easily. (For an approach to making large forms in this manner *see* page 59.) Should the pot settle too much after you have closed it—or set it down on the table in a nest of plastic—allow the top half or so to dry a bit and then paddle the bottom area lightly to drop the bottom and raise the profile of the piece. Then set it upside down in your nest, until the bottom is stiff enough to stand.

53

*Completely closing a paddled form*

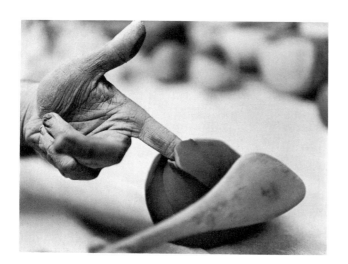 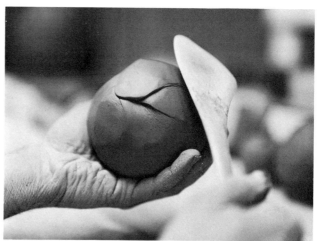

Using the paddle in this way seems to have special advantages and special qualities. It pulls, stretches, and folds the clay in a way the fingers can't. Nor can you achieve quite this quality in throwing or coiling or slabbing. If using a paddle to stretch clay interests you, try some small pots by holding some flattened clay in one hand while paddling along it with the other hand. Try different sized paddles and different shaped ones and use differing rhythms. A good source for purchasing paddles is a Japanese import store where you can often find sets of rice paddles that work beautifully. Or salad-server paddles can be found in most kitchenware departments. Or you can cut and sand one out of wood yourself.

Paddling a form closed is tricky. It very much depends on the angle at which you hold your inside fingers and the nature of your paddling. The paddling is less a slapping gesture than it is a skimming. The paddle should not come down straight and stop when it hits the clay; it should rather meet the clay on a diagonal and continue on a follow-through so that it stretches the clay along your inside finger or fingers. Often attempts at closing turn out to be necked and bottle forms. Doing it "wrong" may lead you to a propitious discovery. It would be a severe limitation of what was possible with a paddle if you were to assume there was a "right" way.

# Making a Large Pinch Pot

THE PINCHING method of making pots seems to be most suited to small amounts of clay, but I have found that it is possible with care to pinch larger amounts of clay into thin spheres, bowls and cylinders. Similar shapes can probably be more easily achieved by an add-on pinch method (*see* page 64) or by coiling. However there is a certain tactile quality to larger forms pinched from one ball of clay that I find worth the difficulty. I like the slow journey of watching and assisting the form to take shape; a shape that depends so much upon the clay, my attentiveness, the rate of drying in the room in which I make the pot, and the quality of my mood.

Building a large bowl by pinching has always been, and still is, a new experience for me each time. I have to move slowly, work gingerly, and be, as it were, in dialogue with the clay. I feel very much both in service to and served by the clay when I form in this manner. I have yet "to know" before it happened, what was to happen. I am always excited and anxious when I begin to feel what *may* be (so different an experience from working on the potter's wheel where my aim is often to know what *will* be). Despite my points of control, I have to bend or be bent by the clay, not as if in combat, but rather as if in relationship.

Start with a ball of clay the size of a grapefruit or larger and open it in much the same way you do for a small pinch pot, reaching as far as you can with your thumb. The next step is to widen the opening enough to be able to put your whole fist into it. I do this by pressing my thumb on the inside against all the other fingers on the outside (or vice versa), again keeping the ball rotating so that it will remain fairly even.

When you make a fist, with your thumb *under* your fingers, the lower part of your thumb, just below the lower joint, hardens and puffs out to make an excellent tool, like a combination curved rib and plaster hump. It is this part of the hand that I find most useful in making large pinched forms. Place your left fist into the opened ball of clay holding the ball upside down in front of you. Using your right hand on the outside of the ball, slap the clay, aiming at the lower part of the thumb of the hand inside the clay ball. Slap, not only in, but down; allowing the slapping gesture to reverberate. Not SLAP, but SLAP-p-p-p. Do not strike the clay too hard, and keep rotating the clay on your fist so that you thin the walls evenly. Slap-p-p-p rotate, slap-p-p-p rotate, doing a little at a time, paying attention to the consistency of the clay and to your rhythm. This will take some practice. You may be timid and not thin the wall enough or you may go too far and open the walls. Be cautious and leave enough clay at the base of the pot to allow it to stand when you place it down on your work area. Some people find that their kunckles go through the base clay. You can avoid this by adjusting the clay so that it does not lean all its weight on the knuckles, but on the softer cushioned skin just below the knuckles as well.

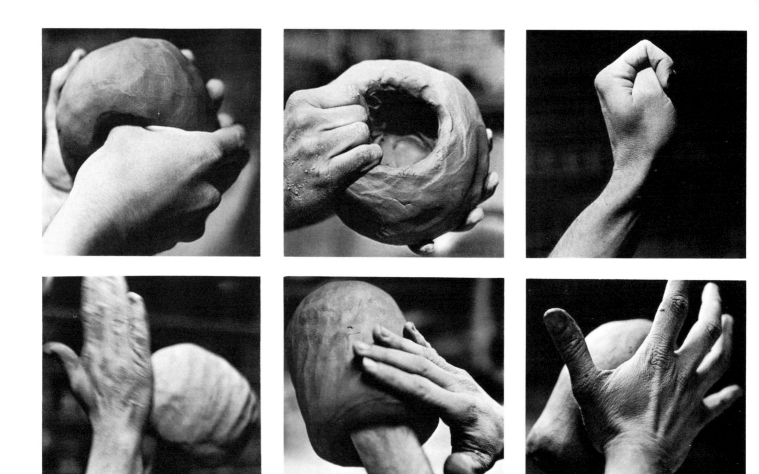

*Steps in making a large pinch pot*
(photos read left to right consecutively
for each page, pages 56-58)

There are four points of control you can use in determining the shape the clay will hopefully pinch out to.

(1) If you want the form to be taller than it is wide—cylindrical—keep your fist up and your arm vertical to the floor.

(2) Should you want the form to bowl out, or be wider than it is tall, hold your clay-bearing arm parallel to the floor. In this way the clay will hang from your arm, and gravity as well as the slapping will widen the form. For further control of the shape you can combine both (1) and (2).

Points (3) and (4) have to do with whether your piece closes in at the top or opens out:

(3) Slap so that the slapping ends just shy of the rim. This will result in extra clay at the rim that will pinch out to open out the form.

(4) Slap so that the slapping continues past the edge of the rim. This will tend to leave less clay at the rim than in the wall above it. When you then pinch out the clay evenly the walls will swell out and the rim appear to move in.

When you have slapped enough, or as much as you can, set the pot on a sheet of paper. Before you begin to go further look at what has happened. Very often the slapped clay suggests alternative continuations. You may desire not to pinch at all, but, say, paddle the lower part of the form when it has set up a bit; or you could add a hand-formed or thrown top to make a bottle. Often, especially when the slapping has been inconsistent or when you have had to twist the pot to get it off your fist, the gesture of the clay is so plastic, liquid and fresh that you may want to go no further. Several of my students have made strong vase forms and lamp bases by this slapping method.

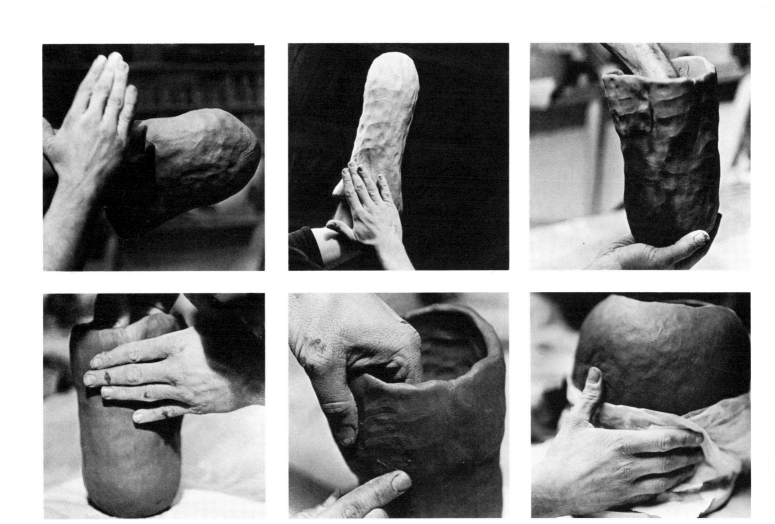

It is possible to use a large lump of clay and slap it all the way down your outstretched arm, until it reaches your shoulder.

## PINCHING OUT THE SLAPPED FORM

I have found it important when pinching out a large slapped form to go slowly. I generally work in a direction opposite from the one I would use with a small pot, by starting at the rim and working downward a little at a time. I don't try to bring any portion of the wall to its final thinness but work it a little and move down to even up the walls before thinning it a little more and so on. I pinch and stroke down as far as I can reach. Every once in a while in order to reach further down and into the form, I use both hands as if the inside hand were my thumb and the outside hand my two middle fingers. Not only will the floor of the pot remain considerably thicker than the walls, but it may be necessary to have a considerable amount of extra clay in the first third of the walls up from the base to support the form while it is still wet. Often if you thin the lower walls too soon the pot will collapse, sway, or crack open. Establish the thickness or thinness of the walls in the upper two-thirds to one half of the pot, paying attention to just how much clay you have left in the lower third and base. Finish the top two-thirds of the pot as you want it to be, allowing in your mind's eye for the change of shape and height that will occur when you are able to work on the lower walls and floor. Then wrap the lower third of the pot well with thin plastic and place a piece of this plastic inside on the floor of the pot and up the walls a bit. Allow the upper, unwrapped portion of the pot to dry to 57

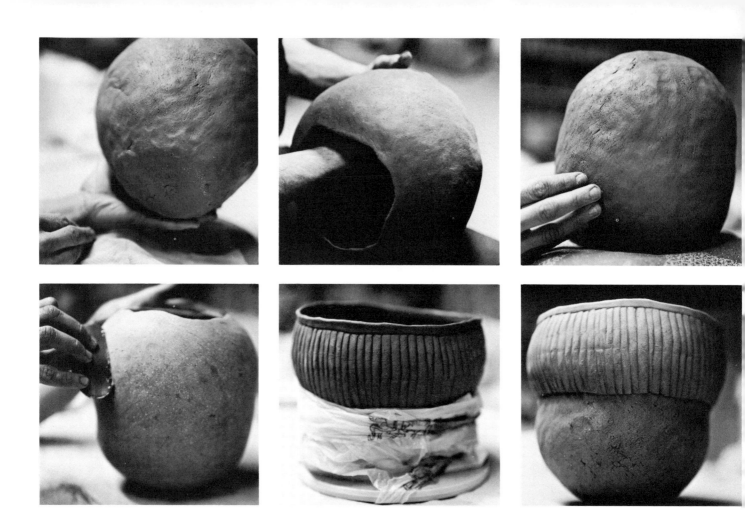

Last two photos above: *14-inch pinch pot fluted with edge of artgum eraser* (see page 73, middle right)

the leather-hard state, or until it is dry enough for the shape of the top half of the pot to hold without altering at all when you lift it.

When it has reached this point, unwrap and lift the pot gently and proceed to thin the lower walls and floor by pressing the clay out from the inside. This activity will always drop the floor, thus making the pot taller by whatever amount of clay you have had to leave there. It will also swell out the lower side profile of the form. Just how to hold the pot while you are doing this will best be established by you and the size and nature of the piece. It is very easy to crack the drying top of the pot if you do not take caution and again move slowly and attentively. Don't try to thin out too much of the clay at once. Do a little bit all over, then a little more, and so on. You might even let the clay dry a bit between thinnings. If the pot is not too large I hold it in a cupped hand while stretching and turning the pot with my other hand. Most often I rest the part of the pot that has hardened or "set up" on my lap, which frees both my hands to work on the thinning, one hand inside, pressing and pinching, the other hand outside, supporting and resisting. On a couple of occasions for extremely large pots I have used a large masonite bat with a six-inch hole in the middle. I place this bat on the edges of two chairs, place the pot upside down on the bat and then, kneeling, I work through the hole in the bat with one arm stretching the clay out and up and the other hand supporting the outside. When you have completed the lower walls and floor, allow the pot to dry upside down so that it does not collapse or settle as it would were you to place it right side up. Should your rim be uneven you can rest the pot upside down on a pillow or a sheet of foam rubber. When the bottom is leather-hard, I either tap the pot down on the table to form an area for the pot to sit on or I plan to leave enough

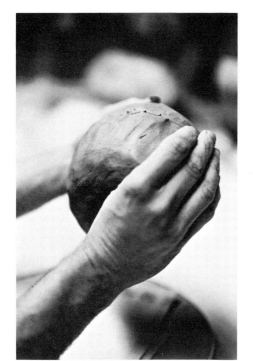

*Ball of clay opened halfway and pinched out*

clay at the floor so as to be able to scrape or sand a foot area. It is possible to pinch out a foot from clay left at the base while the clay is still moist or add one when it is drier. If you wish, you can keep the floor rounded and fire the pot on its rim much like the Mexican pots you see that are either hung or set in a basket ring. You could even throw a foot onto the leather-hard base, taking care to join the new clay well with slip to the pot; use little water when throwing, and dry the piece slowly so that the new clay will not crack away from the body of the pot.

When the entire piece is at least leather-hard, you can place the piece right side up and finish it off in any way you choose—sanding, scraping or letting it be. You can carve into it, draw on it or paint it with slips, or bisque and glaze it.

## Another Approach to Larger Forms

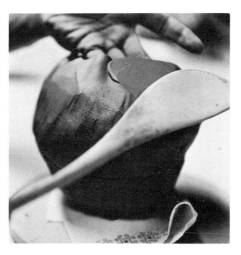

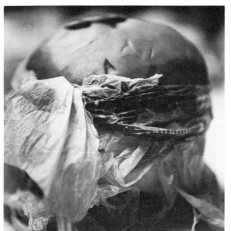

HERE IS another way to form larger pinch pots, based on the exercise on page 53, using a paddle to make a closed form.

 1 Start by opening a ball of clay no more than halfway.
 2 Spread the opening.
 3 Pinch out the clay leaving extra clay at the rim and just below the rim. If you are using a great deal of clay you can open the ball wide enough to slip your wrist in and slap the clay out, making certain, however, that you leave that extra clay at the rim. Make sure the walls are the thickness you want the finished piece to eventually be.
 4 Using your fingers and a paddle, completely close the ball to form a hollow bubble.
 5 Wrap the lower, heavier, unopened part of the ball of clay very tightly with plastic and allow the hollow bubble to stiffen up to the leather-hard state.
 6 When the upper balloon is stiff enough to hold the weight of the rest of the pot, turn it upside down and open the remaining clay that is now at the top. Open all the way down until you reach the hollow area below. You may not want to chance placing the pot upside down on the table, finding it safer to hold it in your hands and lap or to place it on a pillow.
 7 Now pinch out this clay to follow the walls established in the completed bottom bubble.

*Or:* you can repeat *steps 3* and *4* and close the walls of the form to make a large sphere. Or what if you were to . . . ?

*To form foot:* remove from pillow when top is pinched out and set and tap on table to establish an area on which the pot can sit unwobbling. Should the pot, when it is dry, still not sit strongly, there are two things you can do. The first would be to glue a piece of coarse sandpaper onto a level piece of wood and gently move your pot in a circular motion on it until the base of the pot flattens evenly. The sec- 59

Top: *Top hollow paddled closed*
Bottom: *Unopened portion of the ball of clay wrapped in plastic*

ond method would be to place a few drops of water on a piece of glass, marble, or formica and move your pot, again in a circular motion, until the water has softened the higher spots on your base and leveled them off.

The advantage of this "double-opening" method is having the foot area of the pot dry enough to support the rest of the pot as you work on it. It works well and has a special bonus in that the inside of your original closed bubble is visible at the bottom of the bowl—like a belly button. Yet it would be a mistake to think of this only as a method.

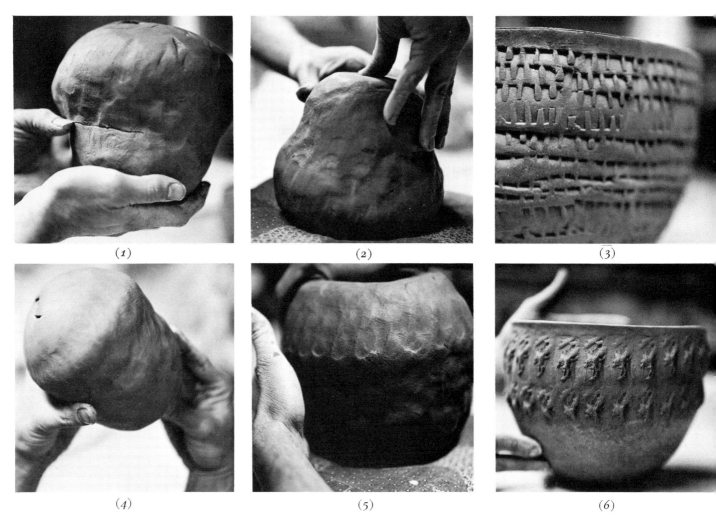

(1)   (2)   (3)

(4)   (5)   (6)

(1) Pot is unwrapped when top of pot is almost leather-hard
(2) Pot is reversed and set on soft pillow and reopened   (3) Pot textured with artgum eraser   (4) Hands opening solid clay at bottom; top of pot has already been opened, pinched, paddled closed and dried   (5) Pinching out   (6) Pot textured with artgum eraser

It seems to me to demonstrate a basic principle: Clay will remain moist when well wrapped. So this method is not limited to making large bowls, but can be used in forming anything where you may need the support of stiffer clay while working with soft clay. It is possible to make goblets this way, by pinching out the stem and wrapping the remaining clay. (When the stem has stiffened sufficiently, stand it up and pinch out the remaining clay to form the bowl of the goblet.) It is also possible to make boxes this way, to form the foot of your pot before you make the rest of it, to make egg cups, etc.

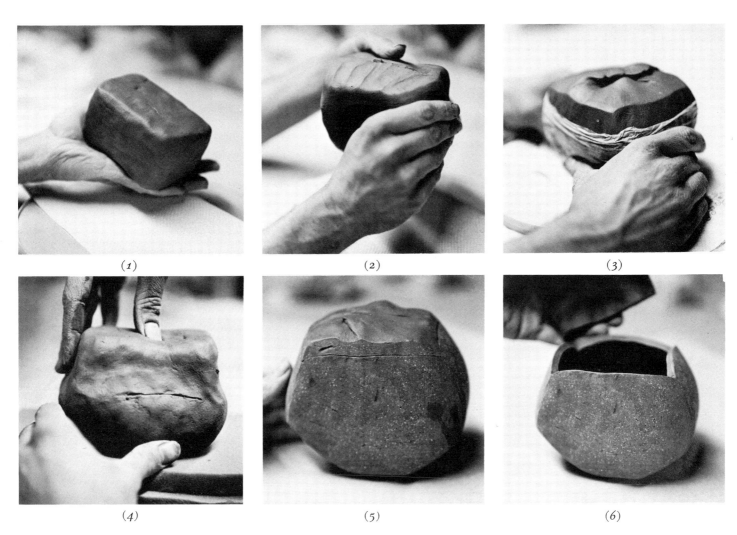

*(1)* *(2)* *(3)*

*(4)* *(5)* *(6)*

*(1) Solid bar of clay   (2) Bar opened halfway and pinched out*
*(3) Top half paddled closed, bottom half wrapped   (4) When top*
*is dry, pot reversed and second half opened   (5) Second half*
*paddled closed and line of cover indicated   (6) Cover cut open*

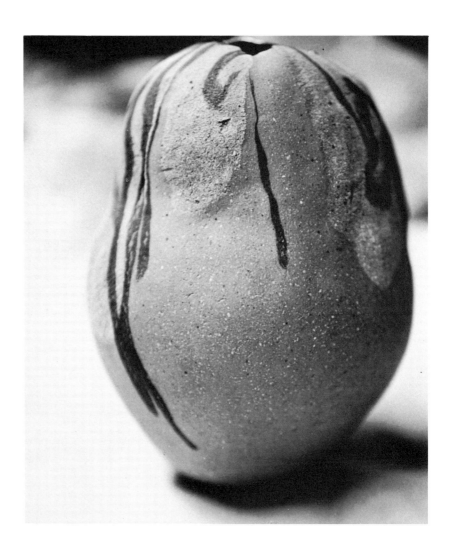

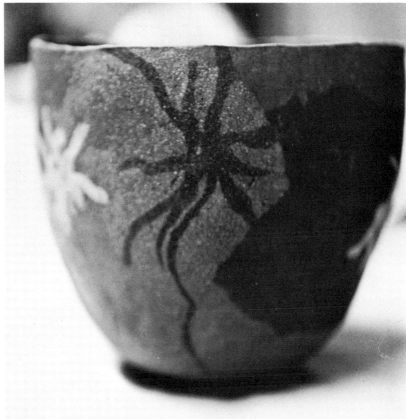

*Four forms made by the double opening method with appliquéd colored clays
Right: Stoneware reduction   Far right:*

62   *Two planters, stoneware oxidation*

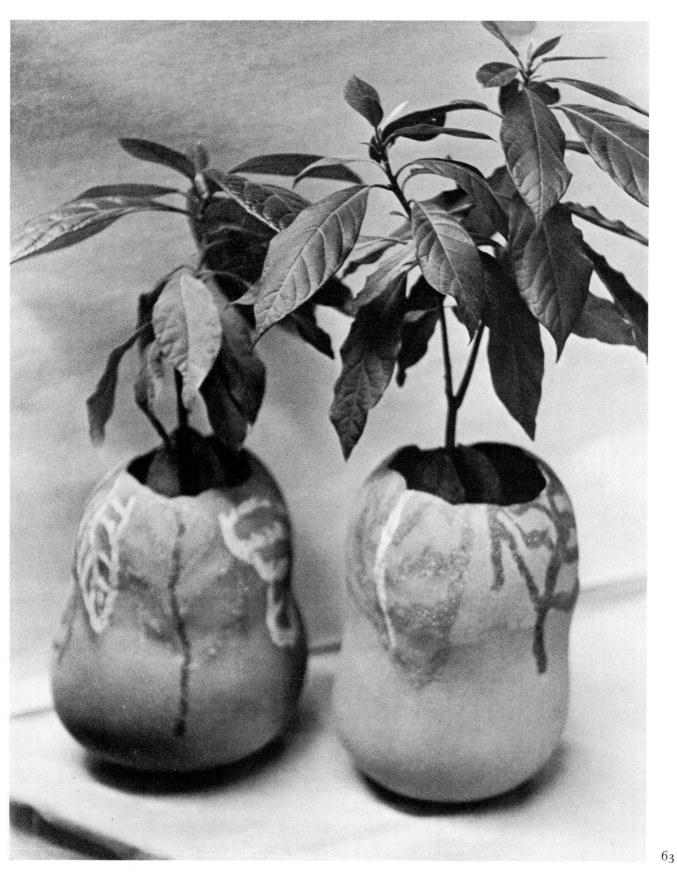

**VISUAL ART CENTER**
ANTIOCH COLUMBIA

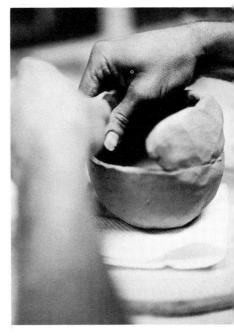

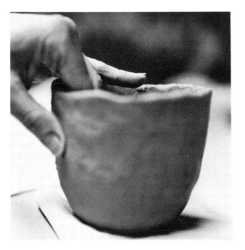
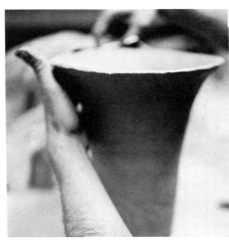

Steps read left to right across

## Putting Together and Adding On

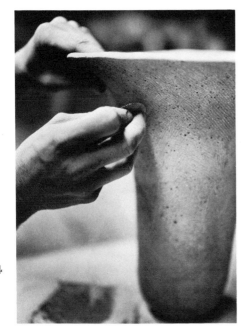

THUS FAR we have been talking about working from a single ball of clay that is pinched out to make the final shape; but what about building by adding pieces of clay where we may need or want it? The possibilities are as varied as our imaginations and our needs.

### SEAMLESS BUILDING

*1* Start by pinching a base bowl about the thickness you want the walls of the piece to be.

*2* Dry the bowl upside down with the rim wrapped in plastic, so that the foot area sets up or hardens enough to take the weight of the added clay, while the rim remains soft enough to be able to receive the added clay. This is a very basic and important step—one that allows you to work without fear of your base collapsing.

*3* Turn the bowl right side up and add pinched hunks of clay around the edge. These additions should be a little thicker than the walls to allow for the thinning action of the next step.

*4* Smooth the joints of these added pieces into the walls of the pot until they are no longer visible. Pinch the clay into the shape desired. For control you can paddle the form and/or scrape it while you work. Do not add too much clay at a time or the walls will buckle. If you are working for a symmetrical form you can trim the edge before adding more clay. If need be, allow the piece to set up with the edge wrapped before continuing.

*5* Add another layer and work it in, pinch, paddle or scrape it.

*6* Keep adding clay until you arrive at the form you want. *Note:* For added control or for especially thin walls, do not add hunks of

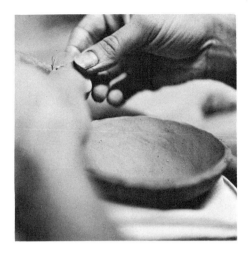

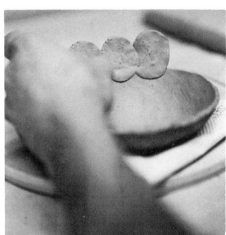

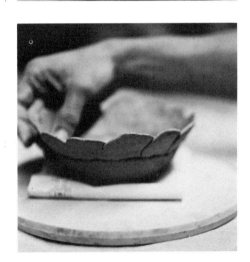

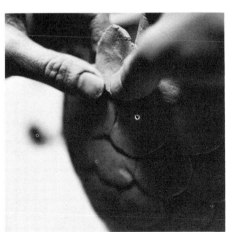

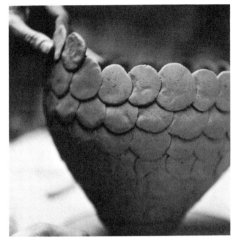

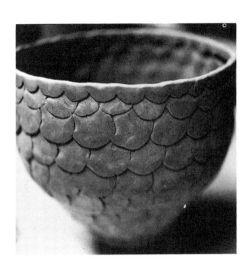

clay directly following the profile of the pot. Rather, point these hunks in toward the center of the pot. Then work in the joints and pinch out the clay until it meets the desired profile of the pot. By the time you reach this profile the walls of the newly added clay should be as thin as the wall below it. I use this method for making very large thin pots and for large thicker-walled planters, the walls of which I build up fairly freely. I depend on scraping to refine the shape.

## BUILDING WITH MODULES

*1* Start with a small pinched bowl as a base and dry it upside down with its edge wrapped as indicated on the previous page.

*2* Roll out a coil.

*3* Slice the coil as if to make cookies and pinch them out thin; or just pull small amounts of clay from a lump and pinch out.

*4* Add these modules to the bowl and then to each other to build up a form. Pinch the edges of each module well so that they will hold together. The piece can be paddled for added strength and for simplifying the surface image.

The shape of these modules can be consistent as in the above photos. Or you could combine two or more shapes of module. Or, for a rhythmical pattern, you could roll out three or four coils of differing thicknesses—slice, pinch and add them. Or you could build up a form in which the variety of module size will create its own rhythm and story. When working this way I usually work on two or more pieces at the same time, adding one layer at a time on each pot. This allows the first piece to set up a bit before I add another layer. Sometimes I wrap the edge so that clay there will remain soft and therefore easily able to receive the joining of the next layer. I have found it unnecessary to use slip as a glue in joining these modules, especially if I pinch each joining firmly.

65

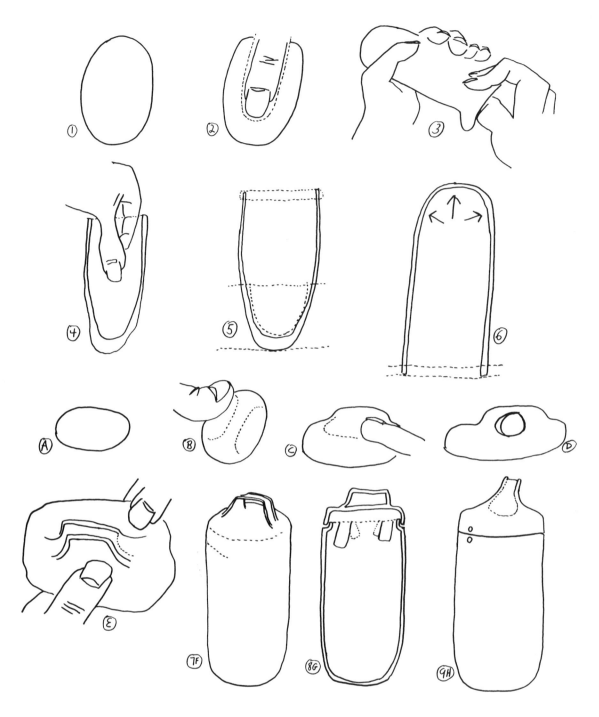

## INSTRUCTIONS FOR MAKING
## A COVERED VESSEL

### MAKING THE POT

1 Start with a tall ball of clay 2 Open with a straight thumb while rotating the ball 3 Hold the pot sideways in your left hand while the right fingers stroke the clay up toward the rim. At the same time the left hand acts to collar in the clay, pressing it narrow and long 4 Pinching out the top of the cylinder 5 Wrap the bottom one-third to one-half with lightweight plastic inside and out. Also wrap the rim. Allow the unwrapped portion of the pot to "set up" 6 After pressing and pinching out the bottom of the cylinder by working with one hand inside and the other out, allow the bottom to "set up," upside down. To keep the rim soft, wrap again in plastic or set it on a slightly damp cloth

### TO MAKE THE TOP

A Use a smaller, flatter ball of clay B Press with thumb to indicate finial or handle C Turn ball sideways and use pinky to dig a tunnel D Side view of unpinched ball with tunnel E Pinch out clay into a disk and pinch-form handle or finial

### PUTTING THE POT AND THE TOP TOGETHER

7F Place the top on the moist rim of the pot, trim a bit of the excess top clay and paddle down the overlap into the wall of the pot 8G Cut pot open when it has set up, and add a coil flange to the pot or the cover. Place three or four small pieces of paper towel over the rim before putting the cover on again so that cover and pot don't stick together. If the fit is not perfect, paddle lightly 9H Side view of finished covered pot with two little buttons of clay to indicate placement of cover on pot

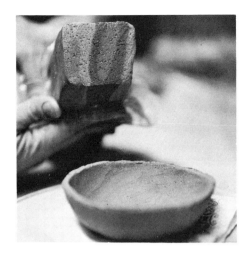
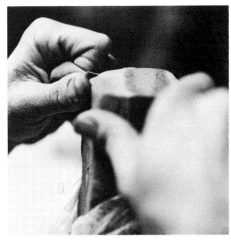

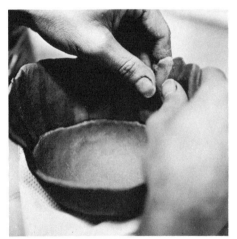
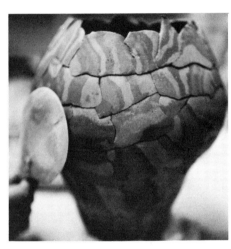

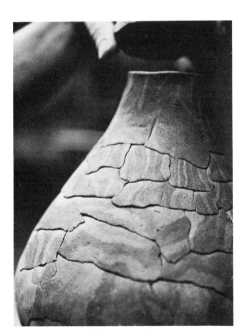

*Steps in building* (left to right across)

## A WAY OF BUILDING

Many of the methods of building I am describing here can be just that, methods. For me a method comes alive when some part of me makes a connection to it so that the very way I'm using to build is expressive of some relationship I feel or some need I wish to explore. Here is an example of a very simple connection that has grown between this modular way of building and my need for directly felt involvement in the very process of building.

Some time ago a friend came to visit bringing me a collage she had made out of pieces of a wasps' nest. She said she had made it for me because of my interest in papermaking and paper-weaving. The collage did look like some incredible paper tapestry, with its layers of gray moving in every direction. As I looked at it carefully and admired the earthlike striations of color, two things came to mind immediately. First, that I could use my experience with coloring clay to make similar clay layers of closely relating colors, and second, that the fragility of the wasps' nest itself reminded me of my thinnest pinch pots (several people had actually described these pots as being "paper-thin"). So an excitement began to grow in me to make a paper-thin pot in layers of color, the form of which would be based on the theme of a wasps' nest. This way of working proved to be very slow. I could add only one layer of clay at a time, and I had to wait for just the right moment to build further. If I added too much too soon the pot would collapse. If I waited too long the edges would be too dry to add to.

I prepared my clay in layers of color(*see* Part II, page 112), making · 67

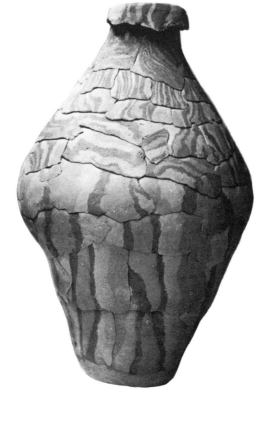

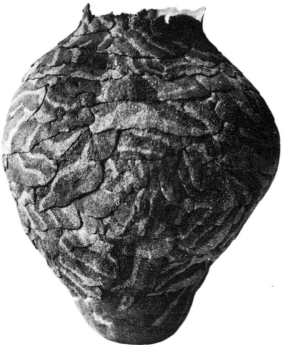

a multi-layered bar of clay like a many-layered cake. Using a fine wire I would slice off bits of clay from the layered end and pinch out these pieces to make sure the layers would hold together and then I would add them to the form.

I found that I soon began to get into the rhythm of adding, waiting, and attentiveness. I began to feel what I thought an animal must feel while building his nest. It was this feeling that opened it all up for me. I was not just making a pot but experiencing a connection to a way of working that was deeply satisfying. I began to notice nests all over the place and did some research into nesting animals. The pots themselves no longer resemble nests, as the experience of the color has grown and the form taken on a life of its own; but the feeling of "building my nest" remains, to nourish and bring me further into the act of building. The clay and I together build a place in which a part of us lives.

*Three forms made in nest-building spirit; top photo is of completed pot shown being built on previous page*

## WHAT IF I WERE TO PINCH A . . .

What if I were to pinch a bowl and add a pinch shawl or collar to it?

What if I were to pinch out long rectangles of clay individually and then pinch their edges together and keep doing this until I had made a large pinched platter?

What if I were to pinch out squares of clay, paint them with colored slips and pinch them together to make a pinched clay quilt?

What if I were to put together pieces of pinch clay and make clay envelopes that could stand or hang or open and close?

What if I were to establish a chance structure that would designate the size of the piece of clay to be pinched out? What if I then tossed coins to determine how many, and what sized, pieces for each form and then put them together?

What if I were to make a study of cacti and do a series of pots or sculptures based on a pinched response to this study?

What if I were to combine a piece of pinched clay with one or two other materials or things?

What if I were to pinch a sculpture by putting pinched-out pieces of clay together?

*Sculptural form made by attaching several individual pinched forms*

# Texturing, Surface Enrichment and Signs of Source:
### Endless Possibility

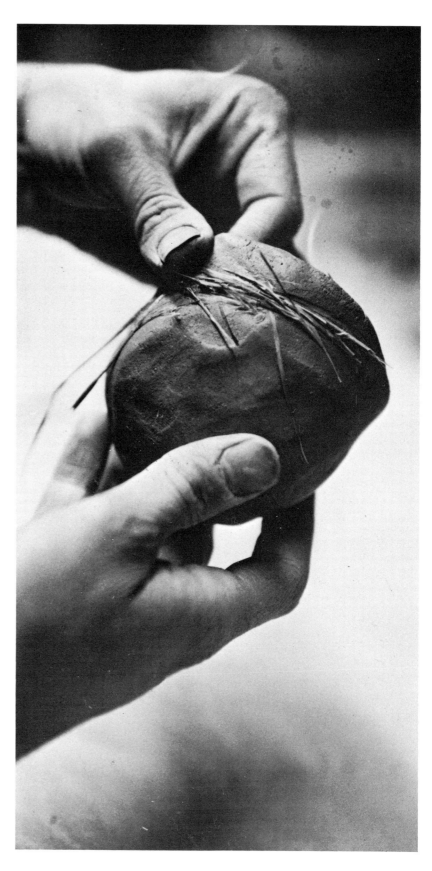

Top left: *Using fresh or non-plastic clay that will naturally crack on the outer surface*    Top right: *Slip is brushed on all over a bowl and then sponged off so that the slip remains only in the cracks to highlight them*    Bottom: *Deep finger marks made by pressing with the thumb on the outside. What if I were to wrap the thumb in lace, or burlap?*

71

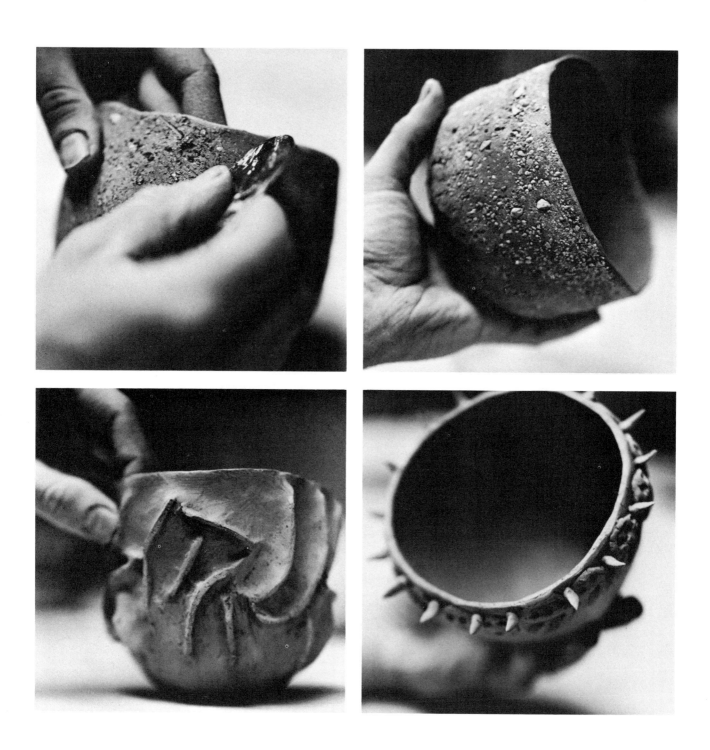

Top left: *Extra coarse grog wedged into the clay and then scraped when the pot is leather-hard. The pot is scraped with a steel-flexible rib tool.* Top right: *Coarse grog pressed into the finished but still wet piece to give a pebbly surface. What if I were to use two or more grogs of different color clays?* Bottom left: *Pinching out from the walls of the pot to make ribs.* Bottom right: *Adding on bits of clay to make thorns*

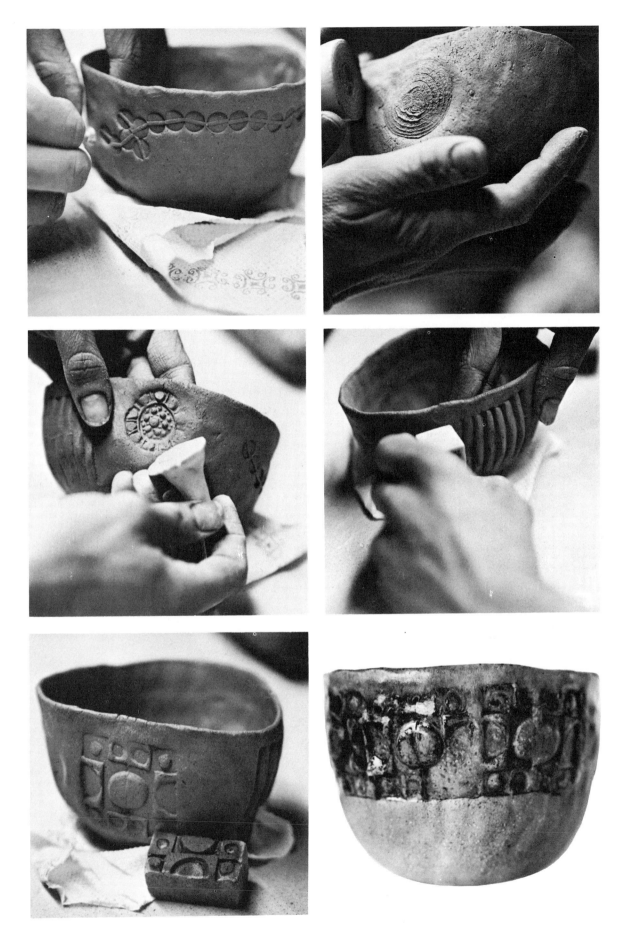

Top left: *Pressing in the head of a screw*   Top right: *Pressing in an onion half left from my lunch*
Middle left: *Pressing in a bisque stamp*   Middle right: *Repeated pressings of the edge of an artgum eraser to create a fluted effect*   Bottom left: *Pressing in an artgum eraser into which I have cut a design with an X-acto knife*   Bottom right: *Finished and glazed pot based on the design cut into the artgum eraser*

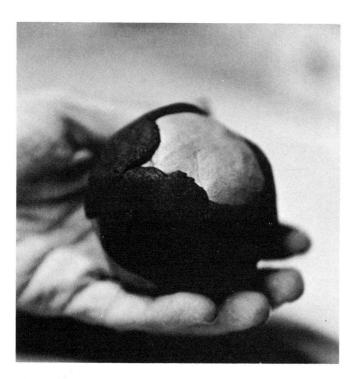

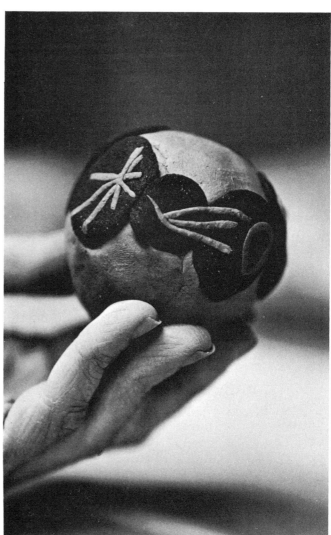

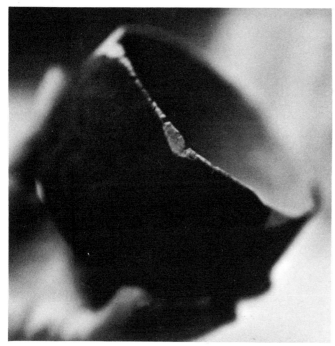

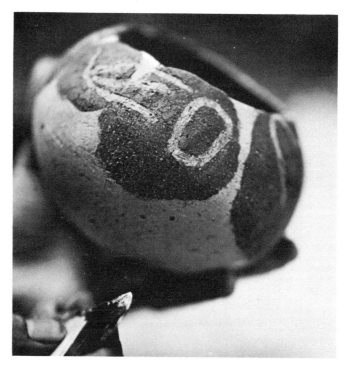

Top left: *Wrapping shawl of darker clay around unopened ball of clay*    Bottom left: *The pinched-out, two-toned bowl*
Top right: *Appliquéing design of two other clays on unopened ball of clay*    Bottom right: *Pinched-out, appliquéd bowl*

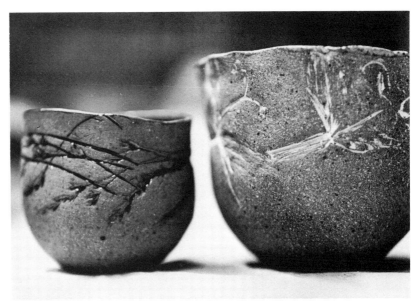

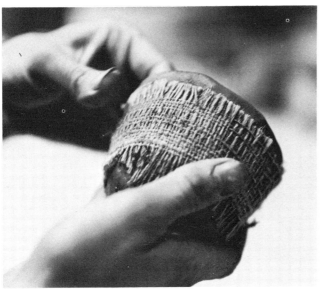

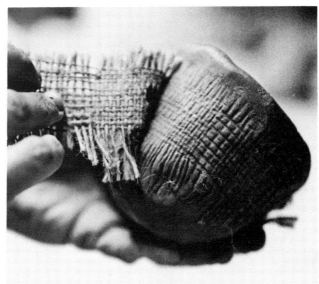

Top left: *Pinching in other materials to the surface, such as weeds or grasses*
Top right: *Finished pots—slips were painted on bisque and then sponged off surface to remain only in surface indentations* Others: *Pressing in burlap*

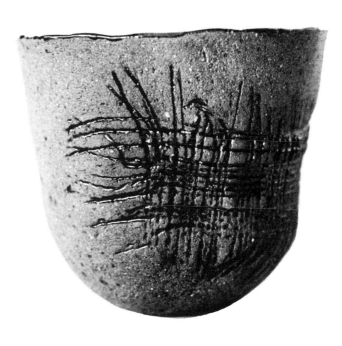

Top: *Painting with slips on leather-hard or bisqued pots*   Bottom: *Two slip-decorated bowls by Cynthia Bringle*

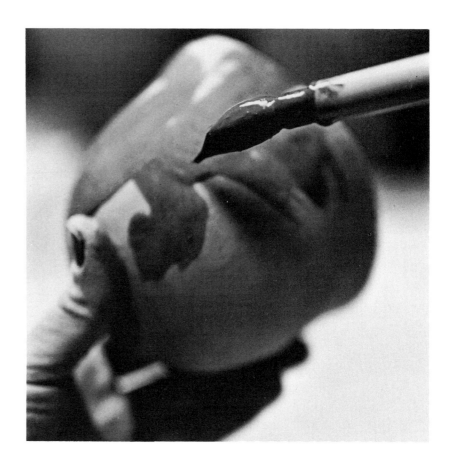

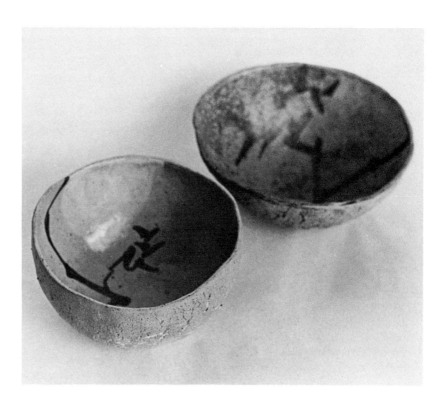

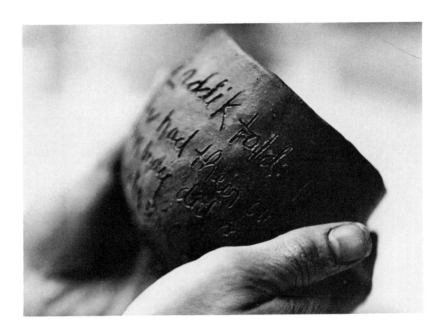

IT IS very easy for surface enrichment and design to be just that: a decoration and on the surface. What I try to evolve in my work is a felt reason for the designs I'm using that will deepen the surface and enliven the form with signs of my person, my interests, my life. At the moment I feel most connected to the last example: that of writing on the pots. It seemed most natural to use as design on these pots the events and thoughts in my life at the time, or to remember something someone else said or did in a special way. Or to make a pot as a celebration of a specific event, or as something I wanted to say to someone. Or a series of pots decorated with entries from my journal.

What is suggested in this section is just that—suggestions. Try any or all of them, individually or mixed. Don't be afraid to learn by imitating: only be certain to watch for and listen to how *your* clay and *your* experience and *your* fingers change what's happening. If you paint or have knowledge of and enjoy using a brush, try bringing that experience together with your clay experience by painting on your pots with slips. For many years I've kept art gum erasers, an X-acto knife and stamp pads on my desk. I would cut designs into the erasers and stamp them to make greeting cards and decorate letters, or to give first lessons in design. One day it seemed very natural to press one of these erasers into the clay I was pinching. It was a familiar, friendly, and joyous thing to do. It felt fine. All I had to do was cut off yesterday's mark from the eraser and make a new one for today. To celebrate today. Or to perhaps repeat an old favorite out of loyalty, nostalgia, laziness, tradition, or keeping the covenant? If the designs we use come from some place in us, from some concern, interest, sense of relationship, sense of humor, we may be able to breathe the quality of our persons into our pots, giving them at least the authority of our own experience.

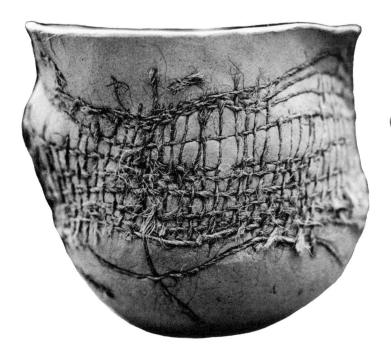

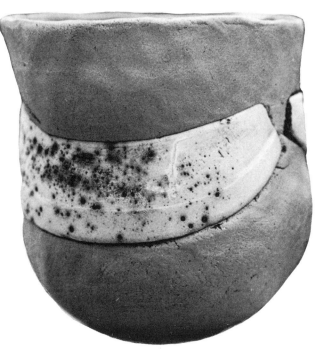

Pots above and above right, facing page: *Unfired*  Two pots lower right, facing page: *Slip inlaid*

## PLACE BOWLS

During the summer of 1971, I was contracted to lead two- and three-week summer sessions at four craft schools in four different states. As the time came near to begin this journey, I grew nervous and beset by doubts. I left early for the first workshop, which was at the Greenwich House Pottery in New York City, and began to feel easier as I worked in the studio for a few days before I began to teach. It occurred to me then that I would be in many "places" that summer and that each place would have its own character and texture. Since I usually pinch a pot as my first activity when coming into a new studio situation so as to become familiar with the studio's clay, wouldn't it be interesting, I thought, to texture these first pots in each place with a sign of that place? And that's just what I did. I would walk about the studio and in the area outside it picking up what looked like its characteristic textures. In most cases it was the leaves and branches of the trees outside the studio that most invited my imagination. In New York City, I found some onion grass gone to seed. In North Carolina I found some old vintage burlap. In three of the places I found different kinds of pine branches.

Now, these pots do not look that different from many other textured pots I've made, nor do I make them in a manner that differs much. What's thrilling to me and makes them unique in my experience of forming is the intention they carry out. My place bowls are experiences of unfamiliar clays and unfamiliar flora—records of first days in new places. I look forward to more travel, inner and outer!

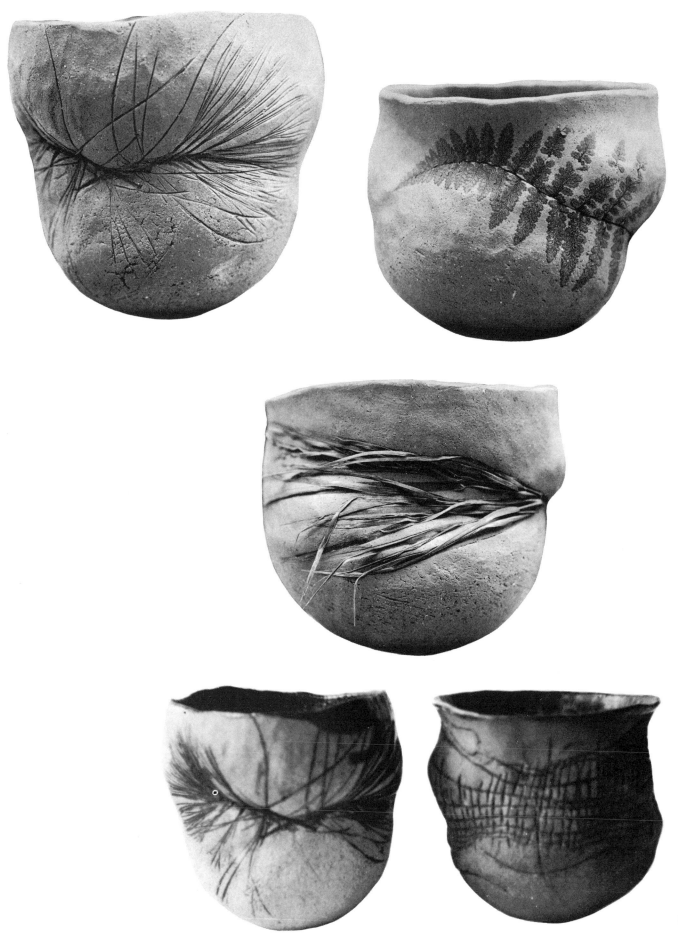

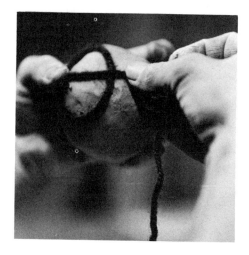  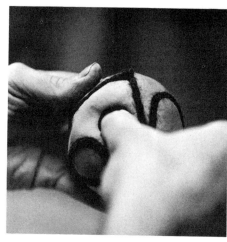

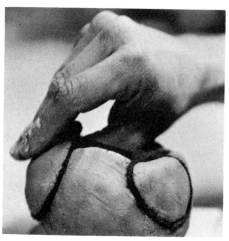 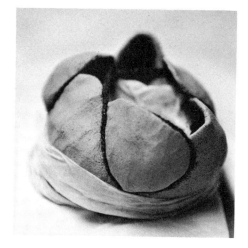 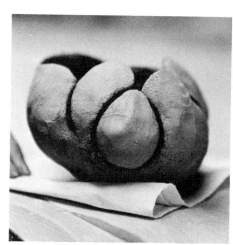

## New Ground:
### A Demonstration of Finding One's Way with Clay

FOLLOWING is an exercise with clay that I developed originally for myself, when I felt myself to be in need of refreshing my impulse into pinching clay. It worked well, serving to reawaken me to more of my range, which in turn reinitiated me, as it were, into all the clay work I was doing. I share it with you here, and you may want to try it, not so much as an exercise in itself—although it is exciting and fun to do —but more as a witness of how it is possible to practice for movement: how by making exercises for yourself you can move on from a temporary rut. You may or may not share my particular reasons for needing to work out this particular exercise, though you may at some time experience in yourself a need for a new approach.

This exercise came about when I needed to develop a way of practice to help counteract two traits I experience in myself and observe

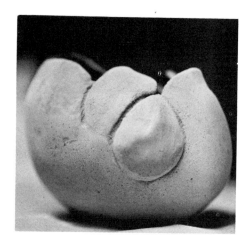 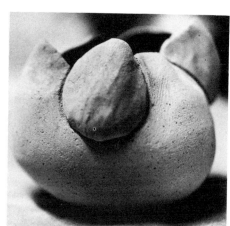

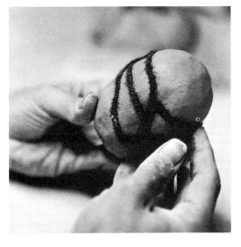 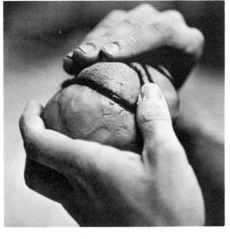 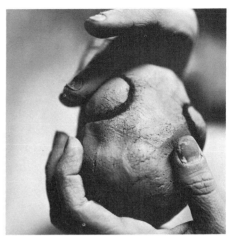

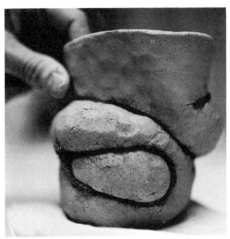 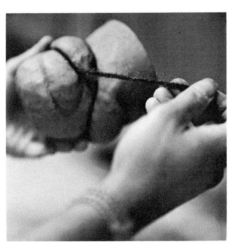 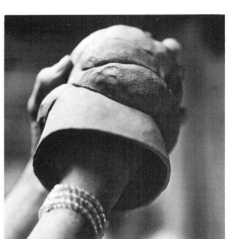

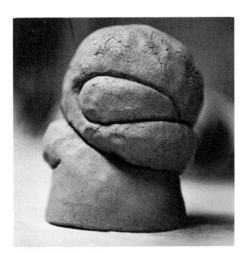

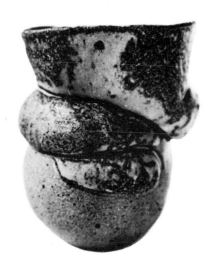

in some of my students as well. The first trait I would liken to a form of addiction. I come to a way of working that I like and enjoy and find important for a time, and find myself continuing with it well past the time that the light and life in this way have gone out of it. The way of handling the clay, the source I am working from or the forms I am making become so familiar and so pleasureable that it is difficult to imagine any other way, any other touch, any other source. Even at the point where my way of working is no longer as alive for me, or has even gone sour, it is at least known. I know the way to do it; I am familiar with whatever difficulties might be involved. This for me, with clay, as in my life, may be less anxiety-producing, less fearful than the next unknown step. It is at times like this that I feel 81

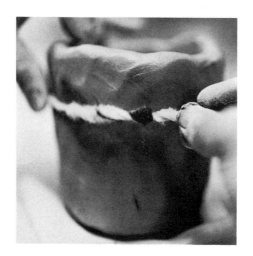

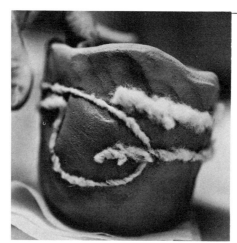
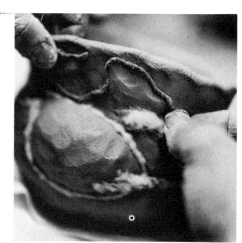

the need to change the rhythm and touch of my hands on the clay, not in this case by some major turnabout, but rather by doing a simple related exercise that might call upon other qualities and produce fresh insights.

The second trait is one that I believe I share with many students of pottery. It has to do with a quality of willfulness. Often I work with a predetermined vision of what I would like to make, and while this, in many instances, seems to work fine for me, there are many other instances when this way of working produces a kind of deafness and sightlessness and lack of sensitivity to what is actually happening. It does not always take into account the clay—which may be stiffer that day—or accidents, or sudden insights. It's like getting up in the morning and deciding exactly what I am going to do that day and doing it no matter what. But I'm finding the "what" to be terribly important. Something unplanned might happen that day that is essential to follow.

It is as much a discipline to learn to follow what happens as to plan what happens. This is certainly true for me. I need both to lead

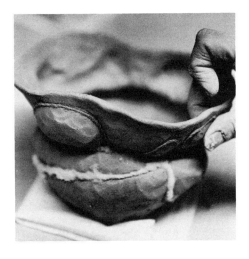

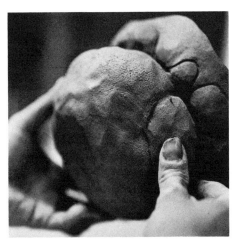

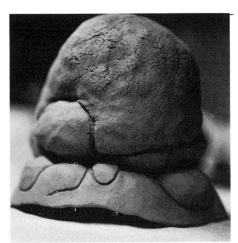

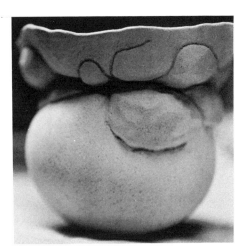

and to be led and I seem to be heavy with leadership impulses with clay as well as in other elements of my life. It is easier for me to see this happening in others than to experience the feel of this in myself. Very often it is quite obvious to me when a student, for instance, has made a decision that lacks the quality of consultation with his clay. A side of a bowl is moved off round, not because it was natural to do so, but because of what on occasion appears to be a kind of strong-willed violation of what is actually happening in a particular piece.

So I had been thinking about my own immobility at certain times with the mobility of my clay, and I had been thinking about my need to practice how to be a follower. At about this time I was working on the texture section of this book. I was making pots by wrapping burlap or other fabrics around the clay and pinching into it. I observed the simple fact that the clay would stretch above and below the material but that the relative lack of stretch of the burlap held the clay in like a corset. It occurred to me then that if I were to use a very open piece of fabric it might be possible for the clay to have *more movement* in and out: some of the clay might be able to move    83

through the spaces in the fabric. I even thought of cutting holes in a fabric by some kind of chance structure and seeing what would happen then. I wrote and drew about this in my journal and, as is often the case for me in journal keeping, my mind and imagination raced faster than I could write. One of the things that occurred to me on this occasion was that I could wrap the clay with yarn in some kind of free design.

So I set myself this task: to take a small amount of clay and wrap it freely and simply with soft yarn and then to pinch out the clay, moving only where the yarn allowed me to move. I would follow what the yarn design established. If there were an open area the clay would move out; if it were a bound area the clay would have to move up or down. I didn't seem to have to make any decisions. What resulted were forms unlike any I had ever made or seen before. It gave me great joy and a real sense of discovery to see clay moving in such extremes of in and out. After I had made several I began to make observations, to draw from these pots in the sketchbook section of my journal, and to find my imagination following with fresh images and associations. What encouraged me the most was to have moved into a new area of form and to have done it in so simple and "led" a way: to have worked myself from a difficult place onto new and fertile ground.

How fantastic it is to feel it demonstrated in one's hands and body that clay work and life work are even more plastic than one had imagined: a very simple but powerful demonstration for me that I can work for my own freedom.

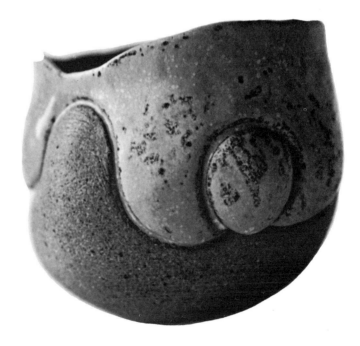

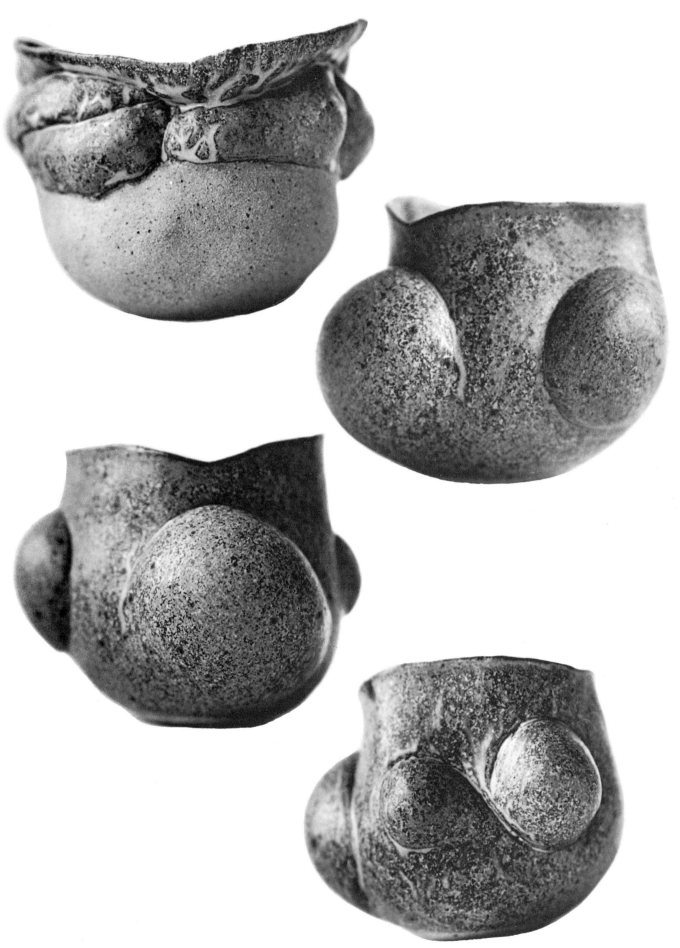

# An Exercise for the Imagination

WE RARELY HAVE the opportunity to practice for such things as imagination or originality. I think about this a lot: one method I have been practicing myself and using in my workshops is to spend a few minutes now and again doing a series of exercises designed to make use of what I like to think of as the muscle of the imagination. For some of us this muscle is active and flexible; others of us, having been educated out of using it, are stiff and shy and must work hard and be encouraged to stretch this muscle out to bring it back to the life it had when we were children. Following is one such exercise related to our work in pinching.

Do you know what gesture drawings are? In many life drawing classes (croquis classes), the model will take a number of one-minute, thirty-second, or shorter poses. The students, not having the time to make a detailed and finished drawing, attempt to capture the essential information, the gesture, in fast sketchy drawings. The finished sketch often resembles scribbling, yet the act is captured. One can do a similar thing with clay.

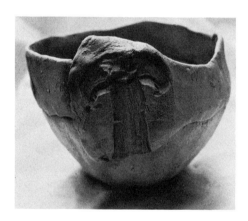

Begin by preparing ten or twenty very small amounts of clay. Round balls, squares, egg-shapes, or just pieces pulled from a larger ball of clay. Determine an allotted amount of time, say somewhere between twenty and fifty seconds or so, and begin to pinch rapid-gesture pots or sculptured forms. Let your fingers work fast and try not to repeat yourself. As soon as your time is up, put down what you are working on and start another. Don't stop to criticize what you have done, just keep going. It doesn't have to be beautiful, it can be ugly. It doesn't have to be round, it can be square. It doesn't have to be good, it can simply *be*. There are no laws, no precedents, just keep going. If you don't know what to do next, try doing the opposite of what you have just done; or look around the room until something hits your eye that you can translate through your fingers into the clay. If you don't know what to do, ask your clay: What does it say?

Try doing this exercise out of doors where many forms may catch your eye. Try repeating what you have done upside down or putting two similar or dissimilar forms together. What if a pear were before you? Could you make a quick three-dimensional gesture sketch in your clay of *those* lines of *that* pear? Or a lampshade or a plant? Or the way the person next to you is sitting or smiling or the way he has just walked out the door? Set up a little clear area and ask a friend to place things there at thirty-second intervals: a flower, a theater ticket, a sandwich, himself. When you have completed a series, place the forms before you and look at them carefully. Often they are like little dances. Sometimes they seem to portend little, but if we behold them with *care*, if we can withhold judgment and actually see what has happened, perhaps we will discover a seed, a gesture, a movement, a touch or look of the clay that will move us into a new or refreshed way with our clay.

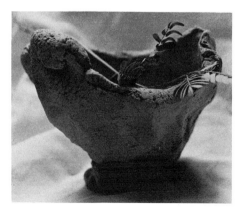

Recently I have begun to lead a very exciting and important exercise in my workshops that developed out of the above. Without much

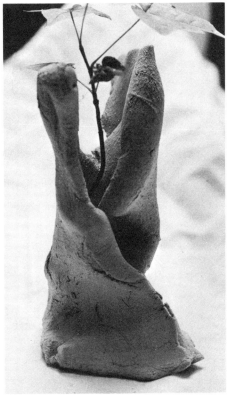

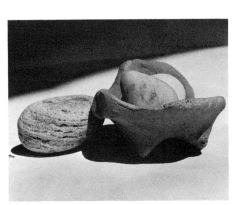

Pages 86-89: *Thirty- to sixty-second pinch pots by Tamar Griggs, Natalie Serving, Howard Yana Shapiro, and Robert Sherman*

advance explanation I ask the workshop members to bring in ten small objects, like a twig or a button, a bottle cap or a buttercup, a key or a ring or a key ring, a leaf, an acorn, a matchstick, a lock of hair, a stone.

When we are all assembled with about twenty-five pounds of clay or more each, I ask everyone to make ten little gesture pots, giving them one minute for each pot. Each pot is to make use of one of the objects they have collected. The pot is to be either a container for the object or a clay marriage with that object. I don't give the participants much—if any—time to think about it, but start in immediately, keeping the time with my stopwatch. Usually after they have made two or three pots I give them a ten-second "breathing" time between each pot, with their eyes closed. So as not to think in these rest periods and to relieve tension that may have built up, I ask the participants to bring all their concentration down into their stomachs. In order to get them to consciously let go of all the tight muscles there, I often suggest the image of a bowl of loose Jell-O. When the ten pots have been made, I call time, have everyone close his eyes for a minute of deep breathing, and then ask everyone to look at his own work carefully and choose the one piece that seems most interesting. I give them about three minutes to do this and then give them eight minutes to make eight variations of, or departures from, that chosen form without using the object, only clay. I start in immediately calling off the time: a minute to work; ten seconds to concentrate on letting the stomach muscles relax with one's eyes closed. At the end of eight minutes I give them another three minutes for rest with their eyes closed and then ask them once again to choose one of the eight to take off on and develop. This time I give them six minutes to make six forms. Often these forms are small, but occasionally someone has used more and more clay with each development. One man ended up using twenty-five pounds each for his last two pieces.

When these last six minutes are up I ask everyone to rise and I lead a brief stretching exercise to help relax them and then give them five to ten minutes (depending upon how many people there are) to walk about the room silently and look at each other's work. Then I have them choose one form by one of their colleagues in the workshop that especially interests them and I ask them to do four one-minute departures from it. I give them only two or three minutes to make their choice (to look carefully at the piece but not take it back to their working place) and then four minutes to make the pots.

Although I dislike having to keep time and to pressure people, in this way it proves worthwhile, because if I give them an explanation beforehand many people say, "Oh I can't do that." And yet they can, and in every instance, when the exercise finally comes to an end, there is a great burst of spontaneous chatter and joy. What happens is almost always thrilling to us all, even if we have not enjoyed the pressure. Sometimes as I watch them working I swear I can see light bulbs of inspiration flashing around the room. When we talk about it

afterward many people express their enjoyment and interest at being "allowed" to work from someone else's work. I, too, like that, and it is almost immediately clear from this exercise how people, when their imaginations are opened, are able quickly to make someone else's idea into their own—another example of the richness of working in fellowship. Imitation is one of the tools of learning. Initiation with clay is not the precious belonging of any one individual. We can and do ignite and incite each other.

I find these gesture pots a helpful way of finding one's way into a theme or getting out of a bind. It makes me realize again that I know more and have more going for me than I think. It is, in fact, a way of thinking with clay, a way of practice. And a way to take risks. Leading this exercise I have witnessed leaps of the imagination that have taken my breath away. I've seen people move from repetition into development, from tightness to boldness, from the general to the specific. It is an exercise to take you out of your head and into your body. If you stop to look at and judge what you have done, it stops the activity of imagination. Just do it; allow it to be whatever your body makes it. We need as artists to make the judgeless act in the dark if we are to reach for light.

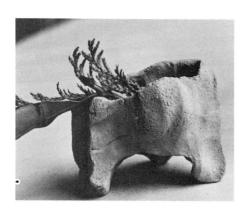

After completing this group exercise, people often will develop an idea or ideas that may have come alive for them perhaps by enlarging a piece, now taking all the time they may need. Or you may want to continue doing variations on variations, developments of developments. One of my students has done several hundred small pinch-pot variations of a pot she first made while doing this exercise. Every once in a while she will sit down with clay and one pot she has selected from her previous work and give herself thirty to sixty seconds each to do ten to twenty variations.

Usually themes develop that call for slow and attentive work now that an idea has opened up. Some days you will be freer with this exercise than you may be on other days. Some people hate this exercise on first encounter but are usually thankful to know about it and prefer to go home and try it on their own.

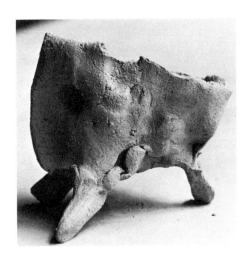

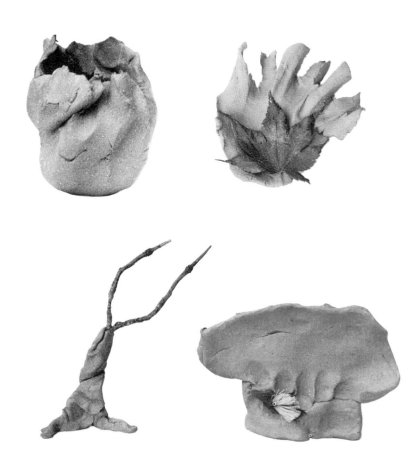

See if you can develop a variation of this exercise that will help you specifically to open up in the ways you may feel the need to.

### THREE VARIATIONS THAT MAY INTEREST YOU ARE:

*1* Doing this exercise with extremely personal objects, or objects belonging to a person you are closely connected to.

*2* (if you can afford it) After choosing one pot to depart from, do a variation and then immediately take a close-up photograph of it with a Polaroid camera. While the photograph is developing, destroy the pot and reuse the clay to do another variation and photo. Put the photos aside and don't look at them until you have completed this rhythm of work. Start the next day from your favorite photo and keep going as long as you can . . .

*3* Say you want to design a new soap dish. Gather several bars of soap (or reuse one unwrapped bar again and again) and do this exercise using the bars of soap instead of the found objects. It can be a helpful way into a "design problem."

## What If I Were to Ask the Question . . .

I HAD something as a child that I lost. That capacity I lost made paper into a million things; things I could cut out, paste up, fold, tear, wrap and fly. It made leaves into forests and the people in the books I read into close personal and private friends. As with many of the rest of you, this gift of being able to make images, to express wishes, to not as yet separate reality from fantasy, was educated out of me. But here we are back again, given a second and third chance to play with our clay in our own way. What if we were to use this clay in that way again? What if we were to close our eyes, find ourselves on a very nice (or difficult) day when we were still very young and knew how to play and to give this child our clay? What would he or she do with it? I'm really not joking, it *is* something you can do—quite seriously!

The most important lesson I have been learning from my own little boy is to relearn to ask the question "What if?" What if I were to make this bigger? What if I were to add a feather to it? What if I were to roll it in ashes? What if I were to write "I love you" on it? If I like doing this so much, what if I were to keep doing it? What if I were to stop and go to lunch? I ask the "what if" question a lot. Sometimes, especially when I'm teaching children, I start a chorus of "what if's" and am soon joined in and drowned out in these musical questions. The thing is, I'm learning that if you ask "What if?" often enough, you begin not only to believe it but to know that it is possible to play again ("playing" can be very serious indeed), to make things that aren't happening for you, happen. That you can turn yourself on or in by asking yourself and your clay, or your husband, or your child, or your yarn, or your paint, or the day, "What if I were to put a cherry on top of it? What if I were to take away all the decorations and let you stand naked? What if I made lists of 'what if's' in my journal?" The thing is, our clay can take and support the shape of our questions. The fact is, it needs them.

## Pinching Assignments

AT THIS POINT, if you have done all or some of the exercises in this book you should have at least some ability in handling clay using the pinch method. It's now time, perhaps, for you to set off on your own to see if you can find your own way. When I reach this point in a workshop, I generally do two things. First I ask everyone to make pinched clay spoons. I say little else, but I remind them that it is clay they are working with, that it's pinching, not coiling or throwing, that is the method, and that it's helpful to know what the spoon will be used for: to eat soup? to spoon-feed a beloved with? Try it!

The second thing I do is to give the class the choice of either picking one or two of the following assignments or being given one by a chance method. The assignments are worded simply and in some cases ambiguously. What matters is how *you* read or hear them and where it leads you. There is no right solution or even a wrong one. If you set about to pinch a candleholder and it turns into a goblet, the shift may be an important discovery or the result of laziness, or lack

of control. Only you can know this. And it's even possible that your very lack of control may bear fruit: by moving you from one vision to another, by not moving you where you wanted to go, or by inspiring in you the need to set about finally to gain the control you now want. You *may do the same thing over and over again in behalf of something very REAL that wants to be worked out.*

There are times when we seem to be working deaf to everything— our feelings, our intuitions, and even our clay. There are times when we have done something we feel to be fine only to lose it the very next day. (But as my friend David Hart says, "Whatever is real must be built anew again and again.") And there are times when we are open and the images and intuitions and connections flow. It's all part of it. It's all in the rhythm of life and death and rebirth. It's in the rhythm of our work and our growth. It's not clear; it's hard work. Only *we* know if we are fooling ourselves and *that's* something to know. It's our "trip," our journey, the "self-shaping of our own privacy."

Pinch a goblet

Pinch a footed bowl

What if you were to make a pinch pot with more than one opening? Say two or eight or fifteen openings?

Combine two or more pinch pots vertically or horizontally

Pinch a teapot

What if you were to pinch out from the outside walls of the pot as well as out from the inside?

Pinch a covered pot

Pinch a plate

Make a pinch pot in response to a sound. Say a clock ticking, your own heartbeat, a hum, a wavelike sound, or whatever.

Make a pinch pot in response to a piece of music (rock, folk, Bach, blues, Mozart, Cage, etc.)

Make a pinch pot while walking in a circle, connecting to the rhythm of your feet. Or make one with a different rhythm in your hands and your feet.

Pinch a cream and sugar set

Draw leaves and then pinch a pot based on a departure, an imitation or an abstraction of these drawings

Pinch a clay letter to a friend

Pinch a pot based on a "meditation" or "concentration" or one of the following words: cave, pool, self. Keep repeating the word over and over in your head and body as you work.

Pinch a pot from which to eat your favorite food

Pinch a napkin ring

Pinch a box

Pinch a pot and write a message of importance on it, or a confession or a secret

Pinch an object not ordinarily associated with clay; say a lunch box or a chair or window curtains or . . .

Pinch a painting

Pinch a candleholder

Pinch a container for light

Pinch a thick-walled heavy pot

Pinch a flower

Pinch a valentine

Pinch salt and pepper shakers

Pinch a table setting

Pinch a story

Pinch an explosion

Pinch a wallet

*Note:* Should you have difficulty getting into these assignments, one possible way to open it up for yourself would be to choose one, and before starting on a finished piece, do the "Exercise for the Imagination" on page 86 using the assignment as your point of departure, *e.g.*, pinch ten to twenty miniature goblets and variations from them.

# II
# The Color of Clay

## An Exploration of Color:
### Toward a New Design Relationship

I HAVE always loved color, from the time I was a child and decorated all my classroom assignments with colored pencil underlinings and drawings, to my later concern as a dancer for the color of the lights and the costumes that illuminated and clothed the movements. So it was natural for me when I began working with clay and glazes to be drawn to the rich colors and hues of the glazed forms. My early work was heavy with color: I loved the earthy tones of high-fired reduction stoneware glazes as well as the glossy rich colors I was able to achieve in my electric oxidation firings. The forms themselves were made with certain glaze colorations in mind and depended on this surface enrichment for their liveliness. I made blue-speckled goblets and yellow-covered pots and tended to think of them in those terms. At the time my glazing techniques were limited: I poured and dipped and overlapped and splashed. I tried everything I read about or saw. I admired the restrained and elegant overlappings of Karen Karnes' and Byron Temple's work; the poetic abstract-painterly pours of Toshiko Takaesu; the beautiful brush drawings of Cynthia Bringle; the bold and sure strokes of slip and glaze on the pots of Kit-yin Snyder; and especially the freedom, depth, and original personality of Mary Caroline Richards' work. And many others. What I admired most in all these artists' work was the naturalness with which their glazing complemented their forms. I learned by making a lot of pots and glazing and firing and sharing and looking and receiving help.

When I began hand building a few years ago, I produced much less work because I took more time with each piece I made and my pieces were more individual. I was therefore unable to glaze and fire as often as I had. Sometimes it would take me up to two months to make enough pots to fill my kiln. I would line up the bisque pots before me, their pink porous surfaces waiting to drink up the glazes I was preparing to cover them with. Some of the pieces I had made weeks before, and I found it difficult, if not sometimes impossible, to reenter the special nature of each piece. The forming and the coloring seemed separate acts. I was displeased and became aware of the need to find a new way of coloring my pieces, of unifying the forming and the coloring processes.

One summer my friend Natalie Murphy returned from taking a pottery course in California, bringing me a gift of some of the clay she had used there. The clay, called Sandstone buff, was an earthenware body, naturally dug in Nevada, with an unusually wide firing range of cones 4 to 12. In the wet state it was a beautiful mustard yellow color; it fired in a reduction atmosphere to a dark red brown and in oxidation to a sandy yellow buff. Up until that point I had been using gray clay bodies that fired buff to toast to light brown. This new yellow clay excited me and I immediately set about to make pots with it. Soon I had very little of this clay left, and though I had ordered some more clay sent from California, the new shipment had not arrived. So I tried appliquéing and pressing fine coils of the yellow clay into the surface of my gray clay, using it sparingly in an

effort to make the little I had left last. I liked the result of these dark lines on the toasty backdrop and especially the way the clays joined together when pressed and stretched. It wasn't very long before I started adding three or four other clays that I gathered from friends, making pieces with pressed appliquéd designs in various shades of toast to brown to gray to near-black. What I liked most of all was having even this limited color to work with from the very beginning of a piece. Using color at the start was an experience of color as form and form as an experience of color. It helped me feel more connected with the whole piece from start to finish. It wasn't long before I started wedging these clays together, inlaying them and experimenting with adding oxides to various clays to increase the range of my palette. That palette is now quite extensive, and I take a great deal of pleasure in using these clays and watching them change from the wet clay state, through the drying, the bisquing and finally the high firing. The color of clay is an altogether different visual and tactile experience from the color of glaze. The textured surfaces of the colored clays remind me of vegetable-dyed yarns in their dappled inconsistency. The use of colored clay has by no means lessened or substituted for my interest in achieving color by glaze; having both to draw upon separately and in concert enlarges the possibility of expressiveness.

But it is more than the colors themselves that has been of principal importance to me, for this exploration with color has helped me move into a new relationship with design that has to do with my attitude to the whole process of forming. It has helped me to experience design as emerging form that involves color: not design as an afterthought, or a pre-thought, but design as a cooperative, mutually dependent activity of form and color.

## Using Multiple Clay Bodies

### CLAY BLENDS

I found that the simplest way to begin the exploration of clay color was to use several clay bodies of varying color. Usually potters work with more than one clay body, or other bodies are available to them in test batches from clay suppliers, potter friends or local pottery schools. If you are a student, or have access to a well-equipped pottery studio supplied with various dry clays, it is possible to make up, test, and work with one or two auxiliary bodies.

The largest problem with using more than one clay body for a piece is the fact that each clay has its own drying and shrinking characteristics; this may make the two or more clay bodies you wish to combine seem incompatible—they may crack away from each other in the drying or firing. Yet it is possible, I have found, to use clays with considerably differing characteristics safely together in special ways. One way that I have so far found to be very successful with all the clays I have tested is to "blend" two clays together.

For example: You start with two balls of clay of different color (to see it clearly the first time, use two clays of contrasting color in both

unfired and fired states) and wedge equal amounts of each ball together until they are completely mixed. Do this with small amounts of clay and wedge the clays together in your hand by folding and squeezing. Keep doing this until there is no sign of streaking, but rather a clear, uniform color. This then gives you three colors of clay from two. If you then mix equal amounts of the half-and-half mixture with equal amounts of the two original clays, you will have five shades: Full strength of clay A; ¾ A plus ¼ B; ½ A plus ½ B; ¾ B plus ¼ A—and full-strength B. You can further subdivide and mix the clays to get nine shades, and so on, if you wish. You can then use these mixed shades individually or use all of the shades decoratively, or you can use gradations of color structurally. What if we were to make a pinch pot in this way? I could take a small ball of two clays, blend them in five or nine steps, pile these steps one upon another and pinch a pot or coil a pot or throw a pot.

Whenever I come across a new clay I test-blend it with the other clays I use, and often instead of adding one clay body color to the range of color I have available, I, in fact, am adding several. I've even blended stoneware both with a white stoneware and with porcelain successfully.

If you should have only one clay available, it is possible to try clay-blending by first adding a large percentage of, say, ocher, or manganese dioxide or red iron oxide (*see* page 98 for suggested amounts) to one ball of your clay. Then, using another ball of the same but uncolored clay, blend the two together.

## WEDGING VARIOUS CLAYS TOGETHER

Despite the fact that we are justly warned to be cautious about using two or more clay bodies together because each clay has its own shrinking characteristics, my experience has demonstrated to me that 95

it is very possible to do so. I did find it true that in some cases the clays would shrink away from each other when drying, so I test all the clays I use carefully. It is worth the effort. So far I have been using multiple clay bodies wedged together in two ways. The first has been for pinch pots. I wedge the clays in a controlled fashion (*see* page 108), wedging briefly and varying the pressure and the way I put the various clays together. I keep looking to see what's happening and am learning how to repeat what interests me by choice or to set about in alternative rhythms. When I have completed the wedging, I cut the ball of wedged clay in half to expose the design made by the rotary action of the wedging. I can then either make two pinch pots or put these two halves together again, back to back, and make one larger pot. Since I pinch fairly thin, and since the act of pinching has a way of "locking" the clays together, I rarely have cracking that seems due to the presence of several clays. The other way that I've been using multiple clay wedging has been to make heavy slab weed rocks that are often an inch or more thick. Here, it is necessary to choose and test the clays carefully, dry the pieces slowly and make sure that they are not fired too fast in the early stages of the firing. I have discovered that if I wedge these clays in advance and then wrap and store the clay for a couple of weeks before making the pieces, there is considerably less tendency to cracking.

And then on the other hand, I've become more interested in cracking than I once was. When a piece would crack in the firing, I used to automatically judge it a failure. Now that I am beginning to learn to withhold automatic judgments, I've noticed myself responding to just the way clays *do separate* from each other, and the design possibilities opened up by this. It's almost as if the clay were saying, "I'm only human and can't always stand firm. One of the things that happen to me—being clay—is that I crack. It may be a sign of my weakness, but it is also a sign of my uniqueness. My cracks are real; they can be beautiful—look at me."

## Adding Oxides to Clay

BY FAR the easiest way to achieve color variation with the least danger of cracking is to add oxides to the clays you already use. The color of every clay I know of can be altered by additions of oxides; and with some clays you can achieve a great variety of shades and hues. Some clay bodies that are dark-firing in a reduction atmosphere can sometimes be altered by only one or two oxides; however, in oxidation these same bodies may be colored by several oxides successfully, because the body itself, being unreduced, will fire a much lighter color in oxidation.

In preparation for this book I have, over the past two years, tested several clay bodies in well over one thousand individual tests. I test each clay with various amounts of each oxide at four temperatures; bisque (cone 012), cones 4 to 5, cone 9 in oxidation and cones 9 to 11

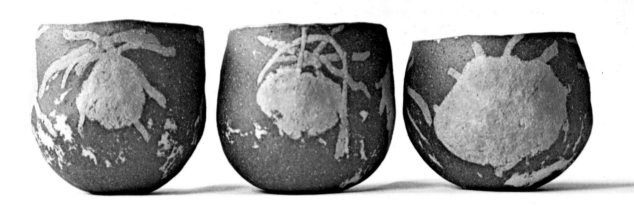

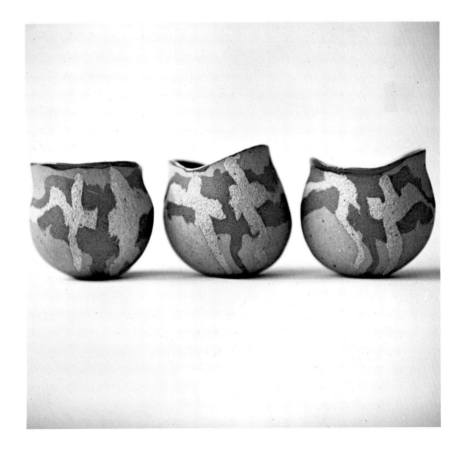

Above: *Set of bowls, "Astral Ripening," appliquéd colored clays applied before each ball is opened and pinched; original balls of stoneware wrapped in AP Green Fireclay plus oxides*
Right: *Set of beloved bowls, inlaid clays, made for Ron and Melissa Garfinkel and the author*

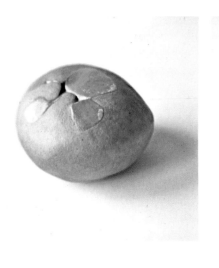
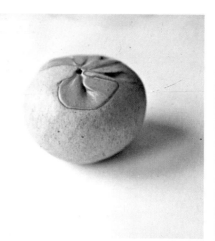
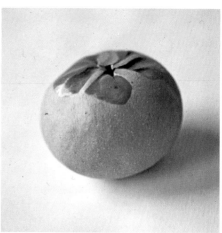

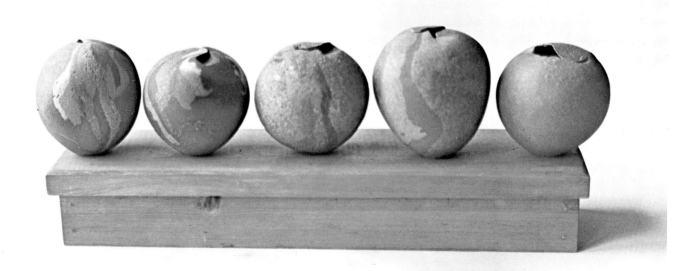

Top: *Three paddled, closed forms*    Middle: *"Primordial Eggs"; the same inlaid colored clays fired in oxidation temperatures ranging from cone 012 to cone 9*    Bottom left: *Glazed bowl, "City Dream of a Country Night"*    Bottom right: *Pinched, glazed bowl, "Afternoon"*

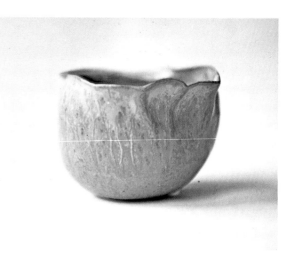

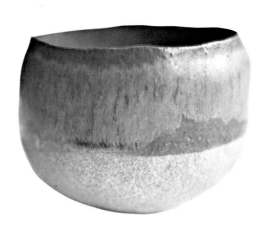

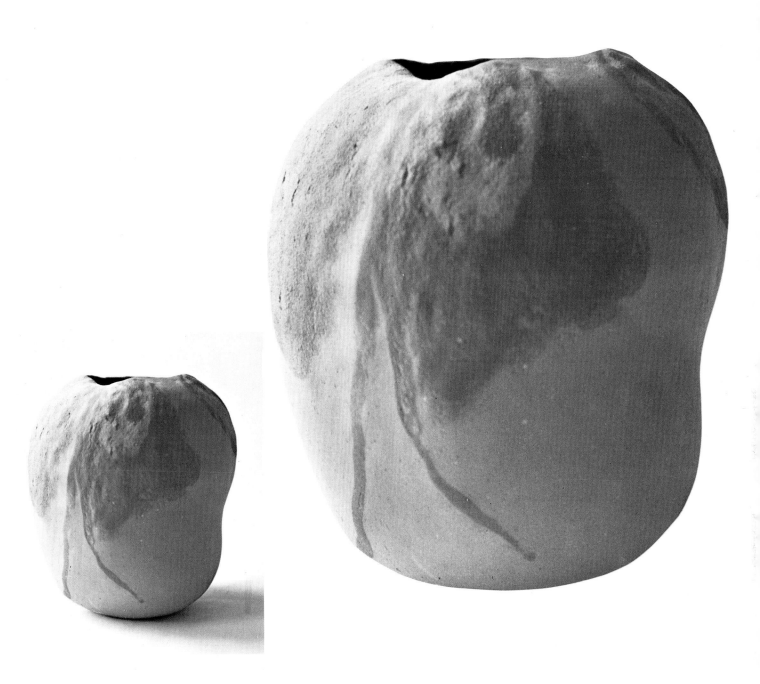

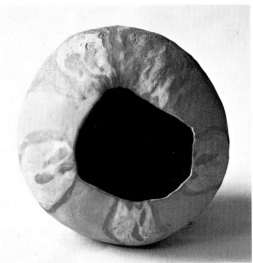

*Three views of large pinched form decorated with colored clays applied before the ball of clay was opened, slapped, and pinched*

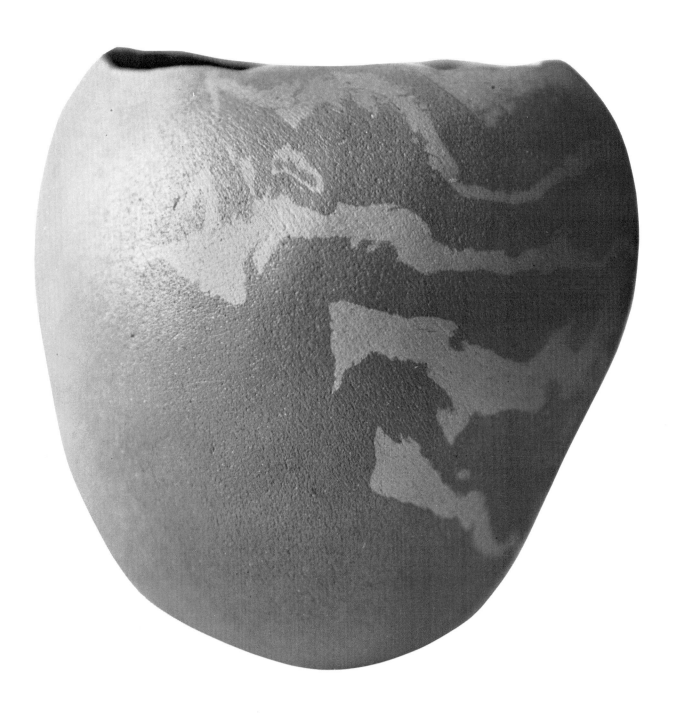

*"Spirit" bowl, porcelain inlaid in stoneware clay, fired to cone 012*

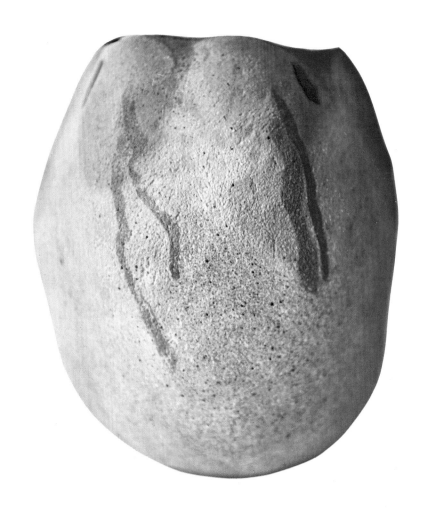

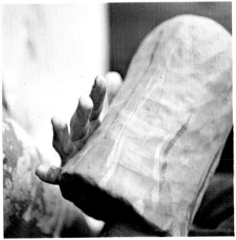

*Three steps in making stoneware pinched pot shown above*

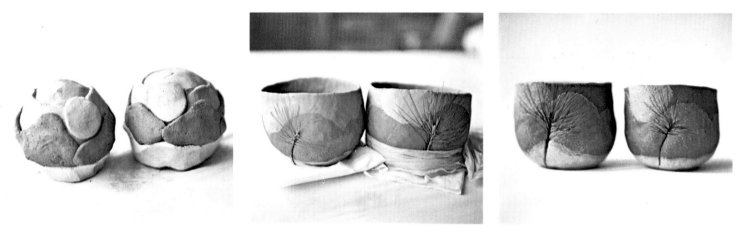

*Steps in making two landscape bowls, made for Bill and Jane Brown; finished pots at right*

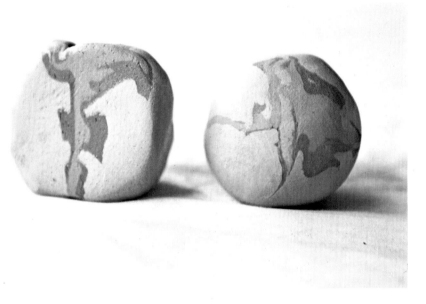

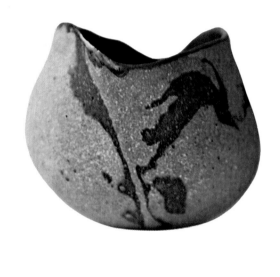

*Ball of clay prepared and inlaid for making pot* (right)

*Ball of clay prepared and inlaid for making pot* (right)

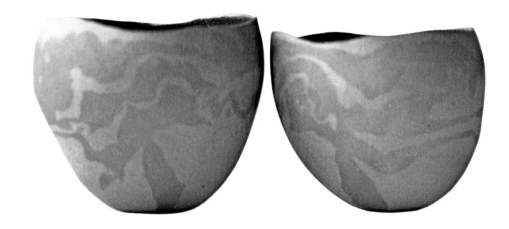

*Two of a set of beloved bowls
made on the occasion of a death
in the family*

*Steps in making reduction-fired cone 9 pot* (right)

*Steps in making oxidation cone 9 pot* (right)

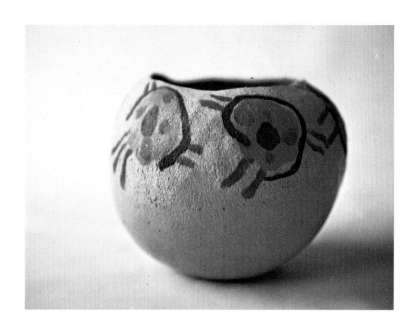

Top: "Child's Play," appliquéd colored clay   Middle: Pinched plate with slip and glaze and traces of bracken fern that were placed on plate as it was set in the kiln, by Mary Caroline Richards Bottom left: Footed bowl, slip decorated and glazed by Cynthia Bringle   Bottom right: High-fired Albany slip-glazed pot

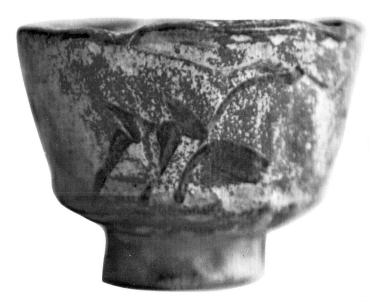

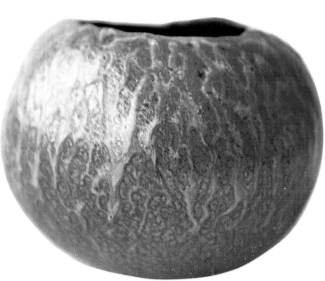

in a reduction atmosphere. I have had many exciting results, some of which I have listed below. However, since each kiln will vary the resulting colors, especially in the case of a reduction atmosphere, I would advise you to use my results as guidelines with which to test *your* own clays in *your* own kilns. Of the four clay bodies given below, two are available, and the other two are easily preparable. However, here, too, I would urge you to test these clays before you attempt to use them. If you test them and keep your tests you can use them as a color guide, for in most cases the color of the wet clay you will be working with is quite different from the resulting fired-clay color.

When I first began coloring my clays I used an extremely unreliable and imprecise method of doing so. It was, however, a method well suited to my situation and my person. I would take a ball of clay of any size, sink a well with my thumb and add oxide. I would then add a few drops of water and make a paste of the oxide, which I would then wedge into the clay thoroughly by squeezing, rolling and overlapping the clay. I would pinch out a little round disc of this clay and put it in the next firing. If the fired test looked as if it had too much oxide, I would add more clay to the remaining ball of clay and oxide that I had wrapped and stored. If the color looked too pale I would add more oxide and retest. When I finally achieved the color I liked I would separate a small amount from the original ball of clay, still in its damp state, wrap it well and file it away as a color guide for making up a new batch of the colored clay when needed. This worked fine when I was using only a few colors in small amounts.

When the range of colored clays I used increased and I began to share the results of this work in my workshops, it became necessary to use a more precise and more communicable method. In the case of adding dry oxides to a wet clay body I now use teaspoon measurements to pound measurements of clay. When adding dry oxides to dry clay I work by percentage.

## ADDING OXIDES TO WET CLAY

Using exactly one pound of wet clay and a *level* teaspoon measure of oxide as my standard, I may, for instance, spoon six teaspoons of iron chromate into a well sunk in the one-pound ball of clay. I then continue as I did before, adding enough drops of water to make a paste of the oxide and wedging it into the clay by using my hand to mix, roll and work the oxide in well. (I don't wedge on a bat or on any surface, but rather do up to two pounds at a time in my hands.) I then make a test of a pinched-out circle of the clay and wrap and store and label the remaining ball of wet clay. Once I have established a color in my firing atmosphere, I no longer need to test the clay but can make new batches by referring to my records. I mark each test "cookie" with a number or the name and amount of the oxide. I record all tests in a special section of my pottery journal for future reference.

## ADDING OXIDES TO DRY CLAY

When I mix my own clays I test them in small batches of one hundred grams. I weigh out the various clay ingredients into small cups and add the oxides by percentages, anywhere from one-half of 1 percent to 20 percent, depending on the oxide. I then pour the dry clay and oxide into an empty coffee can (the kind of coffee can that has a tight-fitting plastic cover), cover it and shake well. I pour the mixed clay back into the cup that I have filled about one-third with water. I let the clay settle, stir very well making sure the oxide is completely mixed into the liquid clay, let it settle once again and pour off any excess water, and end by spooning the tests onto a plaster bat or a clean and dry board. I then mark the "cookie" samples and fire them. When I find a color I want to use, I generally weigh out and mix about 2,000 grams of this clay-oxide combination, which I store in a liquid state in covered plastic containers. Shortly before I want to use this clay I dry it to workable consistency in the amount I need on small plaster slabs. If you don't have enough plaster slabs to use, it is possible to leave the buckets uncovered until the excess moisture has evaporated to the point where the clay is a workable consistency; then cover the clay in an airtight container or wrap well in several sheets of plastic.

I tested all the oxides generally available, and found the following to give the best results generally:

Red iron oxide
Black iron oxide
Iron chromate
Cobalt oxide
Cobalt carbonate
Copper carbonate
Manganese dioxide
Green chrome oxide
Yellow ocher
Black nickel oxide
Vanadium pentoxide

I have only recently begun to try mixing two oxides together. Several of these combinations are listed in the first clay test (*see* Table for Clay I with oxides, pages 100-101). I would imagine these or similar combinations would work for other clays as well. There are also commercially prepared "body stains" that are available, generally sold for coloring low-fire (earthenware) clays. I have tested a few and so far found that most of the colorants "burn out" at high temperature, but did find two listed below that work well. They are Hommel body stains (available through Standard Ceramic Supply Company, P.O. Box 4435, Pittsburgh, Pennsylvania 15205, and probably from other suppliers). You might check pottery supply catalogs to see whether you could order "body stains" in small amounts to test-try, especially if you work at low temperatures.

What follows is detailed information about four clay bodies that I've used in combination with oxides: how much oxide to use, how to mix, where to get the clays, costs, etc. It's not my intention to get you to use these specific clay bodies and oxides; I rather share them as examples of my experience and ways of working so that you will have a good idea of the processes and methods involved. A note of caution also: these very clays and oxides might work very differently for you depending on your working conditions and the way you fire. It might be far more valuable for you to start by asking, "What if I were to add ocher to my clay?" and go on from there, using what follows as a guide.

## CLAY I

This clay body, Imacco high-fire sculpture mix, is a commercially available clay body with a firing range of cone 4 to cone 12. I do not throw with this clay nor do I glaze it (used by itself, I find this clay cracks when glazed). I use this clay body sometimes as is, but specifically for its great capacity to take on the color of added oxides for appliquéing. I also build unglazed coil, slab, or sculptural forms with it. I generally use it affixed onto another body when I make a form that needs to be glazed on the inside for functional use. I often blend this clay half and half with sandstone buff for a glazable clay of very warm color with excellent building and throwing strength. Imacco sculpture clay is a very plastic, heavily grogged (14-gauge mesh size) body that comes in two twenty-five-pound plastic bags per fifty-pound carton. It fires to white at cone 4, off-white at cone 9 in oxidation and to a sunny toast color in a reduction atmosphere.

As clays go, this is a reasonably priced body. I have it shipped (in 500- or 1,000-pound loads) from Southern California to my home in Northeastern Pennsylvania for under fifteen cents per pound prepared—almost three-quarters of this price being for shipping (it is also available dry for about 25 percent less per pound). It can be ordered from Art-Pak Products, P.O. Box 17356, Portland, Oregon 97217 (for the states of Washington, Oregon, Idaho and Colorado); from Leslie Ceramic Supply Company, 1212 San Pablo Avenue, Berkeley, California 94706 (for Northern California). All other inquiries should be made directly to the manufacturer: The Industrial Minerals Company, 1057 Commercial Street, San Carlos, California 94070, Attention: Robert L. Irwine.

Note that the grog in this clay is not always colored by the oxide so that the fired-clay color has a speckled-textured quality of light spots. Also, in reducing atmospheres, there will be a light random speckling of dark carbon specks. Oxides in this clay produce colors of depth and texture that resemble vegetable-dyed wool colors.

## Clay I
*(Imacco High-fire Sculpture Mix) with Various Oxides*

(All figures denote the number of level teaspoon measures per *one* pound of moist clay.)

| Oxide | Cone 4 | Oxidation Cone 9 | Reduction Cone 9–11 |
|---|---|---|---|
| Iron chromate | 1½–7 tsp. light gray to bluish gray | 1½–7 tsp. light gray to mid-tone gray | 1½–7 tsp. warm texture gray, lt. to near-dark |
| Red iron oxide | 1–9 tsp. lt. pink to brick red | 4–9 tsp. lt. yellow-brown to dk. red-brown | 1–4 tsp. yellow-tan to sunny brown |
| Black iron oxide | * | 6 tsp. red-brown | 1 tsp. warm toast 3 tsp. yellowish red-brown |
| Manganese dioxide | 1–7 tsp. lt. brown-gray to dark brown | 1–6 tsp. mid-gray-brown to dark brown | 1-6 tsp. mid-gray-brown to dark brown |
| Cobalt oxide | 1–5 tsp. pale blue to bright blue | 2½–5 tsp. dark blue to midnight blue | 1–5 tsp. dark gray-blue to midnight blue |
| Cobalt carbonate | 2–7 tsp. pale blue to bright pastel blue | 2–7 tsp. warm gray-blue to dark blue | 2–7 tsp. light gray-blue to brilliant blue |
| Copper carbonate | 2–5 tsp. light green to olive | 1–3 tsp. lichenish greens | 2–5 tsp. lichenish, off-gray-green |
| Black nickel oxide | | 3 tsp. greenish brown | 3 tsp. greenish brown |
| Vanadium pentoxide | 3–7 tsp. light to brilliant yellow | 5–7 tsp. textured coral-yellow | 5–7 tsp. yellow to coral-saffron |
| Cobalt oxide and green chrome oxide | ½–1 tsp. each light blue-green | 1 tsp. each bluish green | ½–1 tsp. each very warm gray-blue to warm blue |
| Green chrome oxide | 7 tsp. mid-gray-green | 7 tsp. dark gray-green | 7 tsp. dark gray-green |
| Vanadium pentoxide and red iron oxide | 6 tsp. van. pent. & 1 r.i. oxide yellow-pink coral | 6 tsp. van. pent. & 1 r.i. oxide bright mustard-yellow | 6 tsp. van. pent. and 1 r.i. ox. dark coral |
| | | 5 tsp. van. pent. & 2 tsp. r.i. oxide greenish yellow | |

| Oxide | Oxidation Cone 4 | Oxidation Cone 9 | Reduction Cone 9–11 |
|---|---|---|---|
| Vanadium pentoxide and yellow ocher | 5 tsp. van. pent. & 2 tsp. ocher corals | 5 tsp. van. pent. & 2 tsp. ocher bright yellow<br><br>6 tsp. van. pent. & 1 tsp. ocher warm mustard | 5 tsp. van pent. and 2 tsp. ocher dark olive |
| Vanadium pentoxide and cobalt carbonate | 5 tsp. van. pent. & 3 tsp. cobalt car. spotted coral | 5 tsp. van. pent. & 3 tsp. cobalt carb. bright mid-green | 5 tsp. van. pent. & 3 tsp. cobalt carb. warm green-coral |
| Vanadium pentoxide and copper carbonate | | 5 tsp. van. pent. & 2 tsp. copp. car. warm gold | 5 tsp. van. pent. & 2 tsp. copp. car. muted olive |
| Iron chromate and cobalt carbonate | | | 2½ tsp. each warm gray-green<br><br>5 tsp. each dk. blue-gray |
| Iron chromate and vanadium pent. | 4 tsp. i.c. and 5 tsp. van. pent. dark olive | 4 tsp. i.c. and 5 tsp. van. pent. coral green | 4 tsp. i.c. and 5 tsp. van. pent. coral green |
| H-10 Blue-green body stain | 4 tsp. lt. blue-green | 3–4 tsp. lt. blue-green | 3–4 tsp. lt. blue-green |
| H-49 Royal turquoise body stain | | | 1½–5 tsp. lt. green to bright blue-green |
| Yellow ocher | 3–7 tsp. lavender | | 1–7 tsp. yellow-tan to yellow-brown |

* Blanks in the Table indicate that nothing of interest happened for these particular tests.

Two Notes:

(*1*) *Manganese dioxide:* Note that manganese dioxide comes in three forms that I know of: granulated, fractionated, and powdered. The fractionated and granular forms will not color the clay but give you black spots which can be very useful. If you are interested in this, I would recommend that you try 80-mesh fractionated manganese dioxide, using about one-fourth of a teaspoon per pound of clay to start, or "to taste." For the colors noted above and below, use powdered manganese dioxide.

(*2*) *Vanadium pentoxide:* I did not know of this oxide until the summer of 1970 when teaching a workshop at Penland. I suggested to a student that she try yellow vanadium stain in her clay. Unfortunately there was no vanadium stain on the shelves but there was vanadium pentoxide. So we decided to try it ("what if?"). I have since tested this oxide extensively. It is a very unstable coloring oxide in that it always comes out differently, but generally produces either a very warm yellow to green to red to coral, or a mixture of some or all of these. It is unusual and very usable.

Vanadium pentoxide is slightly soluble in water. If you wash your piece after firing, the yellow color may possibly bleed and become more intense after several hours of air-drying. There is no danger of poisoning from this slight solubility, but I would advise you against using it on the inside or rims of pots that are to be used for food. I use clays colored with vanadium pentoxide appliquéd to the clay. I wash the piece after firing, and to insure against "running" further, spray it with one coat of clear acrylic spray or Karylon Matt-Clear Fixative.

## CLAY II

A. P. Green Missouri plastic fire clay is available all over this country and in Canada from the various A. P. Green refractory outlets and is stocked by many lumberyards that carry fire clays for fireplace mortar. It comes in 100-pound sacks dry and is comparatively inexpensive. It is possible, with a good deal of aging, to use this clay for throwing and hand building by itself, as it's unusually plastic for a fire clay. A. P. Green Missouri takes oxides well and in a totally different way from the Imacco sculpture clay; it tends to be deeper in color—more "earthy."

I have recently been using a clay body for throwing and hand building formulated by Cynthia Bringle, a dear friend and a fine potter in residence at the Penland School. I use this body when I am working with the A. P. Green fire clay plus oxides, as the Bringle body itself has A. P. Green as its major ingredient. I am assured then of similar drying, shrinking, and firing characteristics of the colored clay and the body clay. I sometimes add the oxide to the A. P. Green plus the sagger clay (*see* formula below) for added plasticity, and in some cases add the oxides directly into the clay body formula itself (cobalt carbonate and vanadium pentoxide). The formula of this clay is as follows:

*Bringle Body*
100 A. P. Green plastic Missouri fire clay
75 xx Sagger clay *(fire clay)*
25 Ocmulgee red
10 A-3 Kona Feldspar *Kingman*

The double x Sagger clay is available through the Kentucky-Tennessee Clay Mines, Gleason, Tennessee or Mayfield, Kentucky. It is used because it is an inexpensive substitute for ball clay (if xx Sagger is not available to you, ball clay can be used). The Ocmulgee red is a very dark firing clay and is available from the Burns Brick Company, 711 Tenth Steet, P.O. Box 4787, Macon, Georgia, but this too can be substituted. It is used for color (you can use less or more "to taste"). However, you may know of more locally available clays such as Ohio Red Art, or Dalton clay, or A. P. Green Valentine fire clay, but in these cases you should test to determine how much to use.

## Clay II (A.P. Green Missouri Plastic Fire Clay) with Various Oxides

(Based on dry percentages.)

| Oxide | Oxidation | | Reduction |
| | Cone 4 | Cone 9 | Cone 9–11 |
| --- | --- | --- | --- |
| Red iron oxide | 20% medium red-brown | 15–20% brick red | 2% warm toast up to 8% dk. metallic brown |
| Green chrome oxide | 5–10% pale to mid-green | 5–10% pale green to olive | 5% gray-green 10% grayish forest green |
| Cobalt oxide | 4–8% medium to dark blue | 4% bright blue 8% dk. blue | 4–8% midnight blue |
| Cobalt carbonate | 8–12% bright blue | 6% bright blue 12% dk. blue | 6% dk. gray-blue 12% dk. bright blue |
| Copper carbonate | 5% green 10% brown-green | 5% dark gray-green | 5% light gray-green |
| Manganese dioxide | * | 4–10% light to dk. brown | 2–8% light to dark brown |
| Rutile (light tone) | 15–20% flesh | 15–20% sunny toast | 12–20% sunny toast |
| Iron chromate | 15% gray | 4–15% shades of gray | 4–15% greenish grays from lt. to dk. |
| Yellow ocher | 2–8% pink to pale red | 8% red | 2% bright mustard yellow 8% dk. yellow-brown |
| Vanadium pentoxide | 8–10% coral 12–20% greenish yellow-browns | 6–15% green-gold | 8–20% green to gold-mustard |

* Blanks in the Table indicate that nothing of interest or use happened with these particular tests.

(Based on dry percentages.)

| Oxide | Oxidation | | Reduction |
| | Cone 4 | Cone 9 | Cone 9–11 |
| --- | --- | --- | --- |
| Iron chromate | * | 10% gray | 10% gray |
| Vanadium pentoxide | | 20% dark red | 10% red-green |
| Cobalt carbonate | | 8% dark blue | 8% black |

* Blanks in the Table indicate that nothing of interest happened with these particular tests.

Another clay body that will work well with A. P. Green Missouri fire clay and oxides is the following:

| | |
| --- | --- |
| A. P. Green Missouri plastic fire clay | 40 |
| Cedar Heights–Gold Art bonding clay | 40 |
| A. P. Green Valentine fire clay | 20 |

Note that the Valentine clay is a coloring agent for this clay and that you can use it up to 30 percent and perhaps more for a dark clay, and eliminate it altogether for a very light-firing clay. You can test oxides in the clay as is, or with the clay minus the Valentine clay, or with the A. P. Green Missouri, and/or the Cedar Heights (I've been able to get a real green clay with the Cedar Heights and green chrome oxide in a reduction atmosphere). Just this body with the opportunities it has for variation could produce quite a range of color and be less likely to have problems of drying and shrinking incompatibility.

## CLAY III

This clay, a white stoneware, takes only a few oxides, but has a clarity of color and clear texture with those it does. It is finer in visual and tactile quality than the sculpture clay and the A. P. Green fire clay. I often use it, especially with 2 percent cobalt carbonate, on pinch pots, and combine it with other colored clays of less intensity. I have had no difficulty with the difference in shrinking rate.

The formula is as follows:

*White Stoneware*

| | |
| --- | --- |
| Edgar Plastic Kaolin | 40 |
| Ball Clay | 8.88 |
| A-3 Kona Feldspar | 31.11 |
| Flint | 17.77 |
| Bentonite | 2.22 |

## Clay III (*White Stoneware*) with Various Oxides

(Dry amounts in percentages of oxide.)

| Oxide | Oxidation Cone 4 | Oxidation Cone 9 | Reduction Cone 9–11 |
|---|---|---|---|
| Copper carbonate | 5% dark gray-green | 2% pale pink | 5% smoky pink |
| Red iron oxide | * | 2–8% pink to dark red | |
| Iron chromate | 15% light gray | 8–15% gray | 8–15% gray |
| Rutile | | 12%–16% tannish yellow | |
| Cobalt carbonate | 1–6% pale to dark blue | 2–6% pale to dark blue | 1–6% pale to dark blue |
| Cobalt oxide | 1–4% pale to dark blue | 1–4% light to dark blue | 1–4% mid- to dark blue |
| Cobalt carbonate and green chrome oxide | 1–1½% of each blue-green | ½–1½% of each blue-green | ½–1½% of each blue-green |
| Cobalt oxide and green chrome oxide | | ½–1½% of each blue-green | ½–1½% of each blue-green |
| Vanadium pentoxide | 8–20% green to mottled red | 12% green | 12% bright olive |
| Ocher | 2% peach 8% bright red | | |

\* Blanks in the Table indicate that nothing of interest happened with these particular tests.

## CLAY IV

Sandstone buff is produced by and available from Quyle Kilns, Murphys, California. Unusual care is taken in the preparation of this clay—it is extremely plastic and velvety to the touch: a joy to pinch. It is a very dark red-brown when fired in a reducing fire, and a sand-colored and sandy-textured clay in oxidation. Quyle Kilns describes this clay as having a firing range of cones 4 to 12 and says it is an earthenware clay. The latter interested me as I had heretofore thought of earthenware clays as low-firing. Some investigation has now altered this view; I've come around to the idea that the classification "earthenware" refers not so much to the temperature at which a clay matures, as to the fact that it is a porous body—it does not become vitrified when fired to maturity. (According to this view, porcelains are truly vitrified bodies and stonewares nearly vitrified bodies.)

Sandstone buff contains ocher, making it yellow in the wet state and therefore a special pleasure for me to use. When you add an oxide to this clay you are adding an oxide to the already present ocher, which in most cases cancels out the additive. However, where it does work, it does so excellently.

In reduction I can turn this already dark clay black by adding powdered manganese dioxide or cobalt carbonate. The cobalt does a better job, but as it is pink in its powdered form, there is no color change when you wedge it into the wet clay. The manganese is visible and therefore easier to use. The amount you use will depend greatly on how heavy a reduction atmosphere you create in the fire. I would suggest testing both with one to three teaspoons per moist pound. Vanadium pentoxide, four to eight teaspoons per pound, added to the Sandstone buff in reduction is never the same twice: from a mottled strawberry to yellow mustard. In oxidation the vanadium produces golds, mustards and greens and is especially fine at cone 4. Strong and deep reds can be achieved by adding one to five teaspoons of red iron oxide. These colors at various temperatures in oxidation are the most vivid in my palette.

I would again urge you to test your own clays first before seeking out others or ordering the ones I've given. To make a sample test with your own clay, try two level teaspoons of cobalt carbonate in one-half pound of your wet clay, or 4 percent to your dry body. Try iron chromate at two and a half to three teaspoons per half pound or 10 percent to dry clay. Try vanadium pentoxide at two and a half teaspoons per half pound or 10 to 15 percent in dry clay. If you have both oxidizing and reducing atmospheric kilns, test these samples in both. I'm certain you'll get something you'll want to follow. If you are interested and feel the need and test with care and range, you will begin to have several colors to use. It's a lot of work, but worth it for the added pleasures, tactile and visual, and the added joy of working with design and color from the very start.

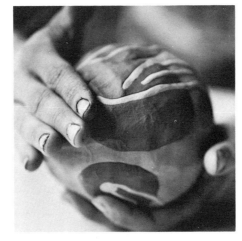

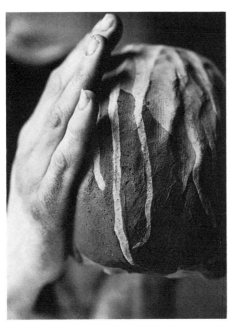
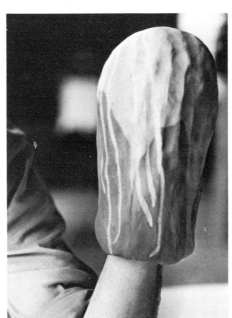

## Appliquéing the Colored Clay

MY INTEREST in appliquéing colored clays to my pieces is largely due to what happens to those clays when they are affixed to an unopened ball of clay that is then pinched, and I am especially interested when it is to be a larger piece that I first slap before pinching. Slapping the appliquéd clays alters whatever design I have made in ways that are exciting to me. It spreads them, extends them, integrates them, elongates them. With some pre-planning and a good deal of experimentation I can often know in advance how they will change. I can apply a linear design with the majority of the lines running vertically up and down the ball of clay and know that when I slap out the ball of clay with my arm held up in front of me, the design will elongate. Or if I put uneven coils of color horizontally around the ball, I'll know that the uneven lines will spread out and appear to be layers of earth color. Or I can apply a design and watch what happens and exercise control by the direction of my slapping. Should I want a clear and precise design I could slap out the ball of clay before adding the colored clay design. I can apply the clay in thick or thin coils or sheets: a very thin disc of color clay, for instance, when slapped out will break up into open lacelike or dry earthlike patterns, whereas a thicker disc would more likely hold a solid color.

107

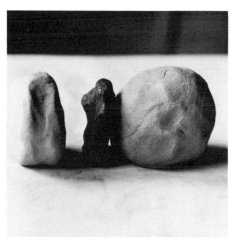 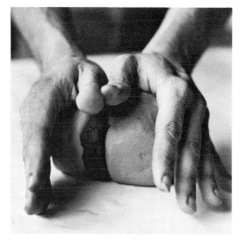 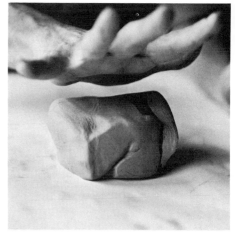

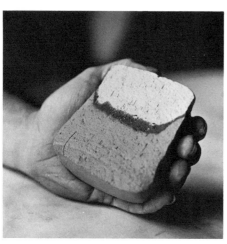 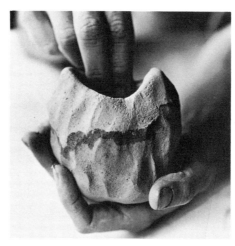 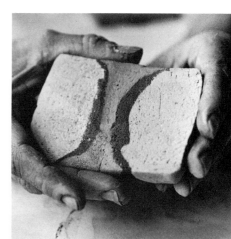

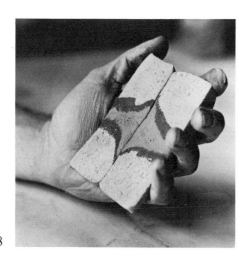

## Wedging Colored Clays Together

I HAVE found wedging various clays together to be a matter of experimentation and restraint. By restraint I mean not wedging too much too soon. There is a certain point in the wedging of two or more clays together when they begin to mix too well and a marble-cake pattern begins to form. If you wedge still more you begin to lose the differentiation between the clays altogether. So I begin by wedging, say, four counts before I cut the ball to see how the clay is mixing. I can then slam the ball together again and continue wedging further: how many counts or in what direction will be determined by what I have noticed.

To a large extent the way you place the clays together before you start and the direction or directions you wedge will determine the resulting flow of one clay through another or beside another. You can place three balls of clay (or rectangles, or hunks) next to each other and wedge them four counts in one direction or, say, three counts in

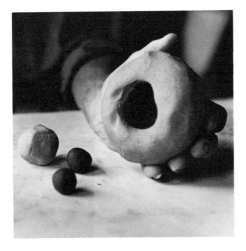

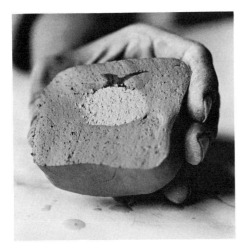

one direction and three counts in the opposite direction, or you could wedge them on the spiral. It is necessary to cut the ball in half to really see what is going on. Then you can put the two halves back together again so that they match or so that they are mismatched or turned, as it were, inside out. You can start out with one ball of clay wrapped in a slab of a second color, and in a third or fourth as well, and then begin to wedge. Or you could sink a well in a ball and drop a small bead or beads of colored clay in, close up the hole and wedge.

The thing to do is to keep trying until you arrive at something of interest. It is not necessary to discard uninteresting attempts. Just keep wedging the clays until they are completely mixed to make a ball of a darker clay.

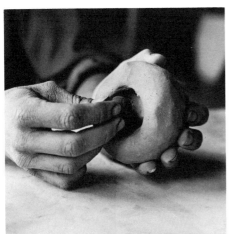

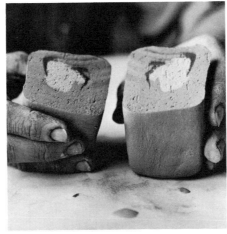

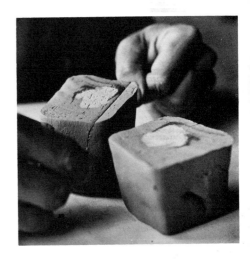

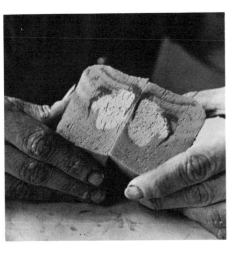

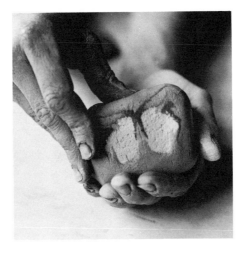

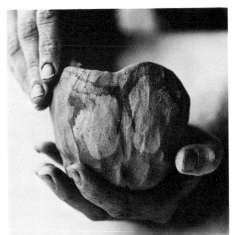

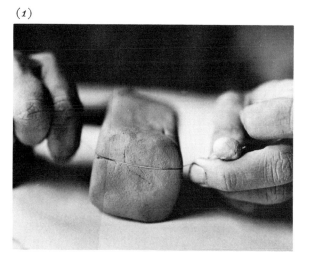

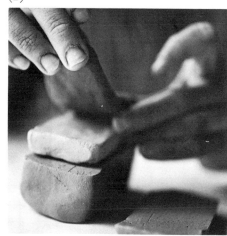

## Inlaying Colored Clays:
### An Example

I START by wedging and pounding my base clay into a rectangular shape. Then with a fine untwisted wire I slice off a layer at the top A-B (*see* diagram) and set this slice aside. I place one or two sheets or coils of colored clay on top of the remaining rectangle, cover it with the slice and pound it on all sides trying to reestablish the rectangle and to work the clay close together. I then could cut again along lines C-D and/or G-H and E-F and add more clay sheets or coils or whatever. I can check how the design is building up at any point by cutting off an end, L-M. I can either discard this test slice or make something from it or reattach it to the body of the parent rectangle before continuing. When I have arrived at the design I want I cut along line J-K to have two squares with the same design to work with or I can cut off at line L-M and the opposite side for one ball with the same design at both ends. Or I can put my two squares together with the designs adjacent to each other, like an ink-blot design. Once I have arrived at a design I can go further with it by wedging it in much the way described on the previous pages. There is no end to the possibilities here: you can inlay a checkerboard pattern or zebra stripes or star patterns.

Below: *Inlaying of colored bars and beginning of wedging to change design of inlay* Last photo, facing page: *Progressive wedging from beginning of simple inlay demonstration*

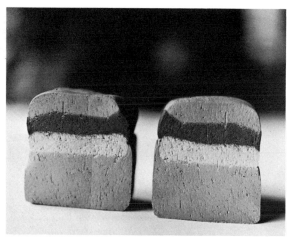

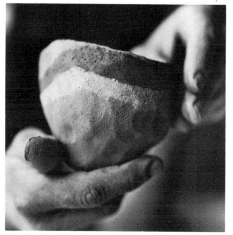

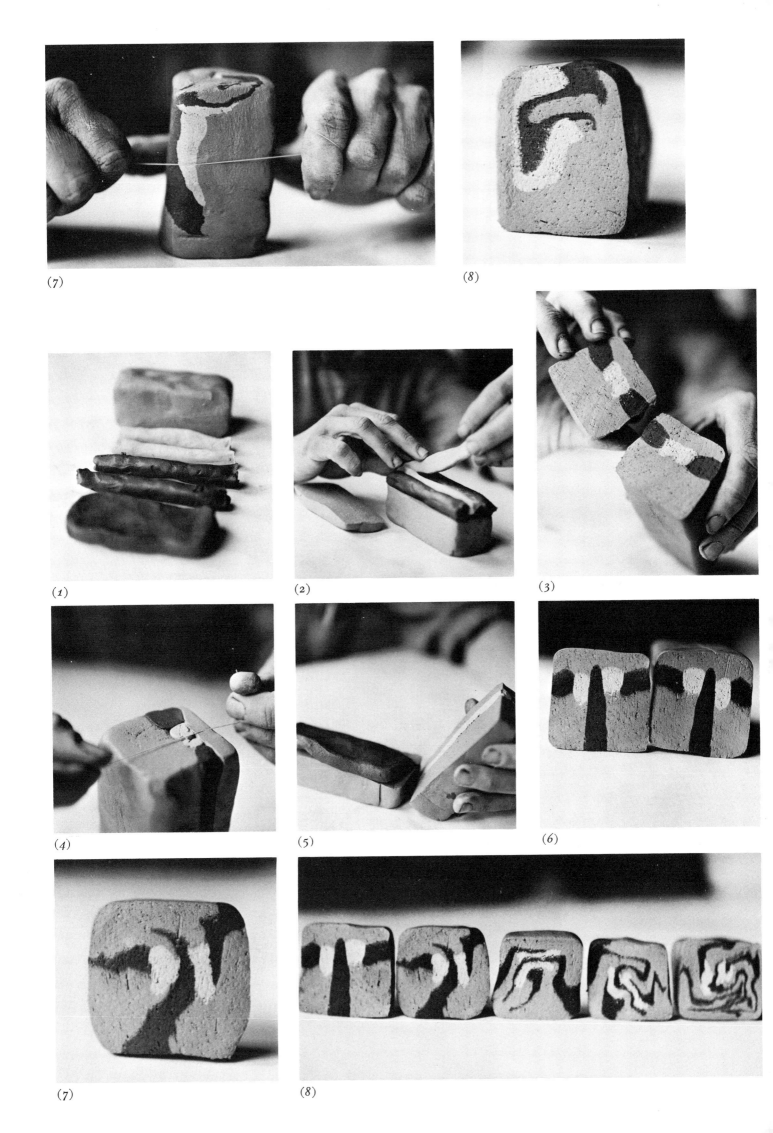

(7)

(8)

(1)

(2)

(3)

(4)

(5)

(6)

(7)

(8)

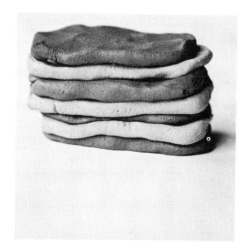 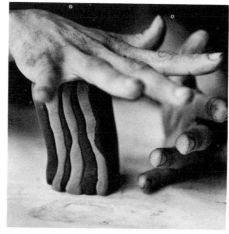 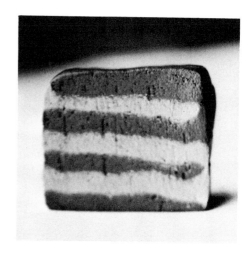

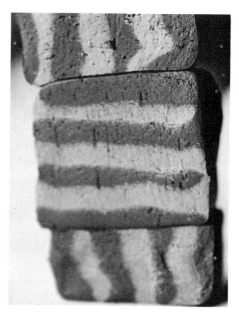

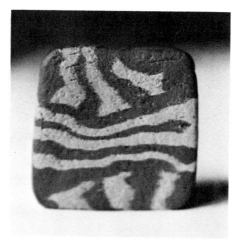

*Example of Sandstone buff layered with Sandstone buff plus red iron oxide, cut, repositioned, and wedged slightly*

I use this inlaying method for pinch pots generally; however it clearly has numerous possible uses. If you know your clays to be compatible you could slice off the ends of a rectangle into pieces one-half inch or more in thickness to make tiles (roll or pound clay down at least another one-fourth inch to insure good binding of the various colors), or to build slab boxes, or to make clay medallions. To be sure of fewer complications, start by using only two clays or several colored clay variations of the same body.

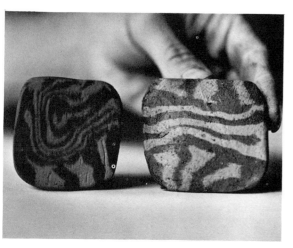

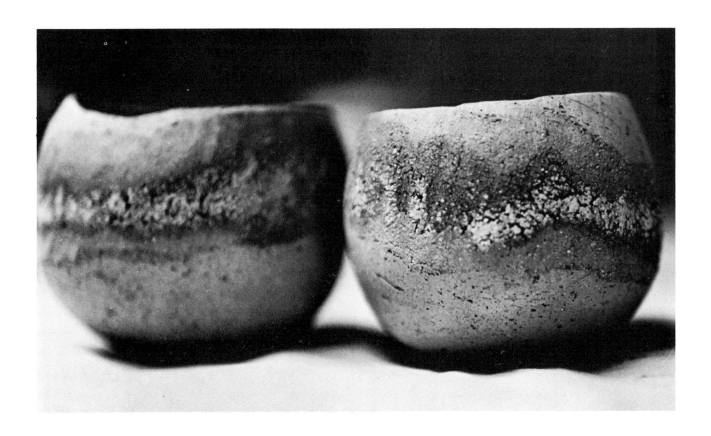

## Beloved Bowls

THE INLAYING technique illustrated on pages 110–111 was born out of necessity. I wanted to make sets of pinch bowls that were deeply related. I wanted the same emblem or symbol to appear on each bowl, not as an attachment, but as if coming out from the inside. And I wanted the bowls to come, as it were, from the very same ball of clay.

I started by wedging the clay as shown on pages 108–109, but soon needed more specific control to be able to make this emblem a specific sign. Eventually I began to prepare the clay much the way I had seen wood craftsmen laminating layers of wood. Then finally I began cutting bars of clay and inlaying the colored clays; like making clay sandwiches. It was especially exciting to come upon this method out of the need I had to form from a specific impulse.

Since then I have discovered that by no means is the use of two or more colors of clay together unprecedented. Herbert Sanders, in *The World of Japanese Ceramics,* shows an old technique called "neriage" in which the potter sandwiches a flattened-out coil of a white clay between two flattened coils of a dark clay. The coil is then folded and pressed together. When ready to use it is cut into clay mosaics that are then pressed together into a mold to make the pot. Also, a friend sent me a clay shard from Vallauris of intricate design in colored clays, covered with a clear glaze; it could only have been achieved by what seems to be some related method.

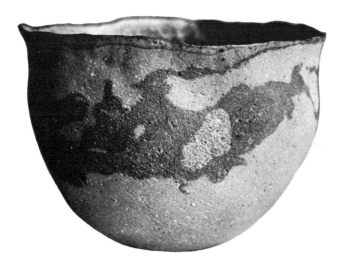
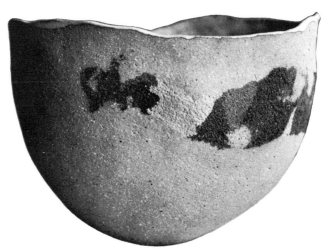
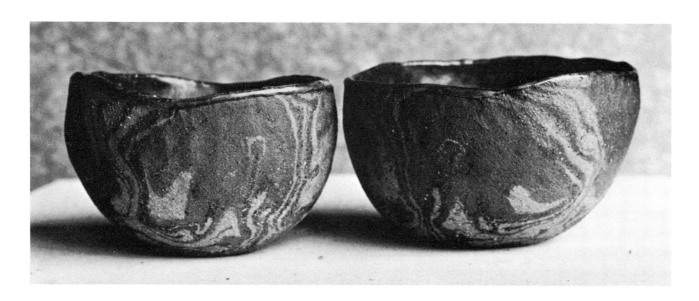

Top left: *One of a set of three beloved bowls*   Top right: *One of a set of two beloved bowls made for the author and Carol Tefft*   Bottom: *Two of a set of three beloved bowls made for Richard Chalfin, Mary Caroline Richards and the author*

One could easily become seduced by this technique and the possibilities of all this color. You could make all kinds of exciting pots using these colored clays and handling them in these ways. But how do we go beyond the technique of it all, the flash of it? How do we bring ourselves into a state of being and working in which we use these techniques out of necessity; technical necessity, yes, but also inner necessity? We need to use *this* color to feel or say *this* about clay, about working, about our world, about our life. Can I use yellow

clay, today, to express my joy at the smell of spring in the air? Or what about those bluebirds that came to my feeder this morning, can I celebrate them? And what about my despair and my nervousness and my irritability. Can I sing in color of them?

When I come to the point in a workshop where I might demonstrate this method of inlaying clays, I have found it more meaningful to share the impulse of the way I work with it, rather than centering the focus on the technique itself. So we make beloved bowls together.

Beloved or "greeting" bowls are two or more pinch bowls made from the same bar of prepared and inlaid clay. The bowls are made with a specific person or persons in mind. If there are two bowls, one is for a friend, the other for myself. On occasion there have been four or six bowls for a whole network of friends. When I pinch out the bowl for my friend, I do so in quiet and with the name and being of this person as my "meditation" focus. I say his or her name over and over. When making the bowl for myself I concentrate on our relationship, my feelings for this person and our connection. When the bowls are finished I give or send my friend his bowl and keep my own to use. It never fails that when I pick up my bowl to use, the name and face of my friend become present as I make the greeting. I would like to say that my need to feel this kind of connection with my friends gave birth to the technique which makes it possible for me to do so.

One summer I spent two weeks at the Penland School teaching with Cynthia Bringle. At the same time Ted Hallman was teaching weaving and my friend Marsha Feinhandler was in his class. I felt full of love for the three of them those two weeks. I wanted to make a sacrament of how I felt, so I made four bowls out of one ball of clay with a quiet river of color flowing through them and green pools of glaze in them. When the bowls came out of the kiln on the last day, the four of us drank tea together from our bowls. Now when I use my bowl in Pennsylvania, I think of Ted in California, Cynthia in North Carolina and Marsha in New York. I greet them and feel the connection.

My mother died after a long and difficult illness. Soon after her funeral, I made a set of mourning bowls to speak from some part of me of her pain, of my father's pain, my brother's pain and of my own pain and confusion. How I wish I could have given her the bowl that was for her.

I make beloved bowls a great deal. I have made them for many of my friends. I have three friends who are so important to me that I have yet to be able to make beloved bowls for them. But I feel certain the moment will come when I shall. I wait upon that moment. If I had my choice of only one area to pursue, this would be it. For I can already feel the next step taking shape in these bowls. I am beginning to feel the connection of these bowls I have been telling you about and the begging bowls that started it all. This voyage of discovery! *To uncover, to confess—that's the technique, that's the skill.*

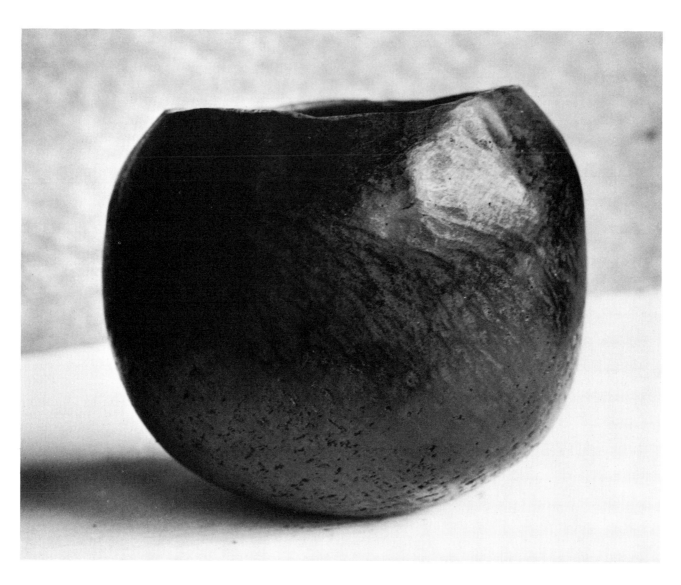

*Burnished, sawdust-fired bowl*

# III
# A Method of Firing: Sawdust Kilns

## A Grace-full Fire

IN FRENCH the art of pottery is often referred to as *"L'art du grand feu"* (the art of the large fire). I like this name, for it contains in it an intuition of the awe, the fate and even the fear that potters develop as they work with this element in the final stage of forming an object. When it comes to firing our work we are no longer (if we ever were) singly in control. Although we may come to know our kilns and their fuels well, learn to speak to them, to use their unique potentials, we can never seem to learn it all; the mystery continues and adds color to the act. We are both the victims and the gift receivers of the fire's own course.

There are many types of kilns and a variety of fuels available to the contemporary potter. Some of these kilns and their fuels are quite simple and direct and allow for a great deal of near-predictability, while others almost depend on their unpredictability and variety of result for their interest. Whereas in the past a potter was limited to the fuels and clays available in his location, contemporary potters have the option of choice. We can work in stoneware, earthenware or porcelain, and fire our ware in electric kilns, wood-fired kilns, gas kilns, oil kilns. We can work in oxidation or reduction atmospheres; at high temperatures or lower temperatures. We can build primitive kilns fired with cow dung or straw or peat moss. We can work in the raku spirit, or with salt glaze at high temperatures, or with china paints at low temperatures. Or in several of these spirits. It is not unusual, in recent years, to come across potters working within a larger range; having more than one kiln and using a variety of fuels and clays; even firing an individual piece at two or more temperatures.

There is a lot of information available, in books and articles, on kiln construction and firing. I do not intend to repeat such information here. I would recommend as especially useful the three books by Daniel Rhodes (*see* Bibliography). Yet no information can be a substitute for tending a fire oneself. Conceptual knowledge of what is supposed to happen rarely prepares us to act in response to what actually happens. Every fire and firing is a unique event to be listened to and spoken with. We learn by doing it again and again and prepare ourselves to be able to behold the unexpected. It is a fine paradox: on the one hand we have a vision and work for control and articulation that may allow that vision to come to life; on the other hand we have the events of the fire that are unique, most often unpredictable and that have the grace of revealing visions beyond our own. So the fire can become collaborator, enemy, teacher or obedient tool; we make our choices or they are made for us. We form this relationship based on where we are and what we need.

My own relationship with fire is still timid, in awe, full of fear and changing shape. Nevertheless I do feel that pottery is an art of fire and that timidity is one real response to it. I have become interested recently in new beginnings, in beginning again, in being a beginner. So let me tell you here about one first step you can take with me as a beginning.

Sawdust firing is the gentlest of fires: a flameless fire. It is based upon what has been learned from primitive fires—a simplification of them—that when there is not sufficient oxygen, the fuel, needing oxygen to burn, will combine with the oxides in the clay and leave, as a result of this combination, a carbonaceous "reduced" black surface on the fired clay. Pottery fired in sawdust is extremely low-fired; just past the point where the pot would not dissolve back into workable clay if it were soaked. It will not hold water, nor can it be glazed. The limitation (I should say "privilege") of this palette is blackness. And yet within this limitation is a gentle and soft range of possibility. You can do a sawdust firing in your back yard at little or no cost. It has a special grace and takes its own time.

*Brushed and incised decoration on top of burnished pot; sawdust-fired*

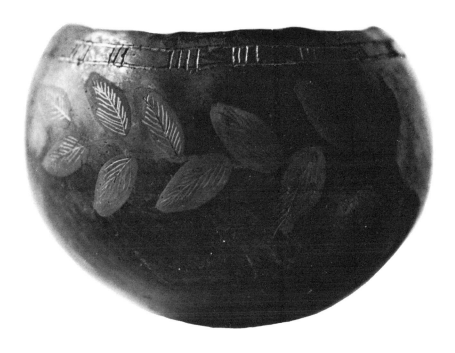

# The Pots and the Clay

POTTERY pieces to be fired in a sawdust kiln can be made of any kind of fireable clay. By any accounts, work fired in this manner is fragile and non-functional (in that it will not hold water, nor can it be eaten from) so it does not make much difference if you use a high-fired clay or a lower-maturing clay. I often add a considerable amount of grog or sand to the clay to retard shrinking as well as to strengthen the ware, especially in the case of boxes where I want the cover and the box itself to shrink compatibly (for a description of how to add grog or sand to the clay *see* Appendix). Should you find a source of natural clay near your home or on a trip and be uncertain to what temperatures this clay or these clays will fire, you *can* be certain that they will not go beyond their point of maturation and are eminently suitable for firing in a sawdust kiln.

Often when one does find a vein of natural clay in the earth or beside a stream it is usable just as it is dug from its source. If, however, it is full of twigs and stones and its moisture is uneven, you can prepare the clay for use in the following manner:

*1* Dig the clay and cut and pound it into fairly small pieces—the smaller the better (say, no larger than one square inch).

*2* Allow the pieces to dry in the sun or air uncovered until you are certain the clay is dry through and through. This can take a few hours or several days, depending on the size of the clay pieces.

*3* Fill a tub or pail one-third full of water and sprinkle the dry pieces into the tub—do not mix yet—allow to slake. The dry clay will drink up as much water as it needs and the pieces will disintegrate.

*4* After it has stood for several hours, mix the clay with your hands or a big stick and then allow the clay to settle.

*5* Siphon off as much of the water on the top as possible. Do this until little or no excess water settles on top. Use a cup if there is a lot of water. Use a turkey baster when there is just a little.

*6* Mix the clay slip again and screen it through a coarse house screen to remove small stones, twigs and other foreign matter.

*7* Let stand until water evaporates or dry out excess water on plaster bats or sheets of asbestos board or on planks of wood in the sun until only enough water is left to wedge the clay for use.

A former student and friend of mine, Ray Blumenfeld, has worked quite a bit with sawdust firings and was concerned about producing less fragile ware by lowering the maturing point of her clay. She wrote to tell me that she used earthenware clay and while still in the slip state added up to 40 percent of talc (if your clay is already in a workable state you can add the talc in the same manner as you could add grog and sand as described in the Appendix). She also suggests that a very small amount of soda ash may be used as well ("one tablespoon to a bucket of slip"). She added a further note of interest: "Some clays, especially if polished, dry with a white gypsum film on the surface. To prevent this, add a small amount (one tablespoon to a small bucket of slip) of barium carbonate, commercially used and called anti-gyp by brickyards."

119

There is no right or wrong form of pot to make for a sawdust firing. That's totally up to you. You may be concerned with the fact that the pieces are not usable in the sense that they will not hold water and cannot be used for eating purposes. The consideration that most affects me is the blackness of the finished pieces. So I have made dark bowls and especially dark boxes. I would suggest that you begin by making fairly small pieces and work your way up to the possibility of quite large forms.

It is not necessary to pre-fire the pots (bisque fire), and as a matter of fact, one is more assured of a deep black if the pieces are fired raw. If the pots are bisqued they will be stronger and in the case of a low-fire clay, mature. And the bisquing of the ware often produces pieces that are only partially black: they may have areas of grayness or reveal the pink of the bisque. By all means try this—it can be very special.

The pots can be formed by any method: they can be pinched, coiled, made from slabs, and even thrown on the potter's wheel. If the pots are dried and fired as is, the result will be matte-blacks, grays, and smoky pinks. However it is possible, and highly desirable, to polish the raw ware so that the resulting fired pieces will have a high ebony-like shine.

Polishing or burnishing is usually done when the pots are somewhere between the leather-hard and dry stages. Numerous smooth objects can be used to rub the clay until it produces a shine—a smooth piece of glass, or a smooth pebble, the curves of which can reach into small surfaces you want to burnish. Generally, I use the back of a spoon, and Ray writes that a silver spoon will give additional luster "as the silver wears onto the pot." The more you polish, the higher the shine. I often will burnish a piece once, put it aside and reburnish it again later. You can burnish it so that no marks of your tool are visible or you can burnish in planned directions so that you make a pattern with your strokes. The fired outcome can be like black damask. Burnishing can be slow and painstaking and you can press too hard and break your piece; nevertheless it is one of those slowing-down steps that can be very satisfying—giving you the opportunity, as it were, to make a bond with this particular piece at this particular time.

Another possibility open to us is to work further on top of the burnished surface. For a matte-black design on a burnished ground you can use a slip made by watering down (to a cream consistency) some of the very clay you have been using, or another clay, and brushing it on. On several occasions I have used a sharp pencil to draw and scratch through the burnish with words or designs. I've used colored slips, which most often turn black, but I have had several pieces turn a rich iron-red where I have brushed on a design in a mixture of red iron oxide and water. Burnishing the red iron will insure its permanence.

## Building the Kiln

IT IS not necessary to build a permanent sawdust kiln. It is far more flexible to build and rebuild the kiln for each firing, letting the number of pots and the size of the pots determine the size and shape of the kiln. The kiln can be made of common house brick (clay or even shale brick). If you happen to have some around you can build it of cinder block or old pieces of insulating or hard brick or a mixture of all of these. It is also possible to make the kiln out of an old metal garbage pail if you were to punch nail holes all about it for ventilation.

Start the kiln by making the floor. Clear a fairly level spot of rocks and branches and lay your bricks or cinder blocks until you have a large enough platform to contain the inside dimensions of the kiln plus the width of the walls. No mortar is necessary. Build the walls of the kiln up loosely. It is important that there be a slight space between most of the bricks so that the kiln can breathe when it is being fired. Ray says she likes to leave as much as an inch of space between 121

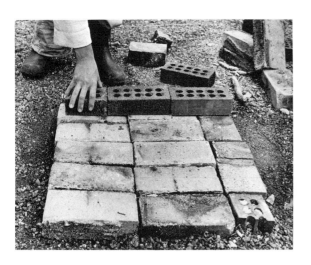 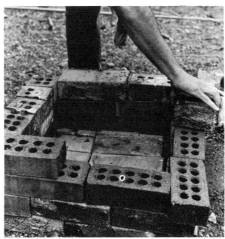 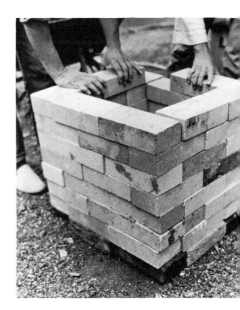

each brick except on windy days, when she places the bricks closer together. I generally start with the bricks fairly close together, prying them more open with a screwdriver should I seem to need more oxygen while firing.

The kiln looks like a chimney and goes up very fast. On the top layer of brick, place four small chips of brick (about one to two inches high), one on each side, to support the cover, leaving an air space between cover and kiln. The cover can be a garbage-can cover, a piece of metal, an old kiln shelf, a sheet of transite, or anything that you are certain is non-combustible.

## The Fuel

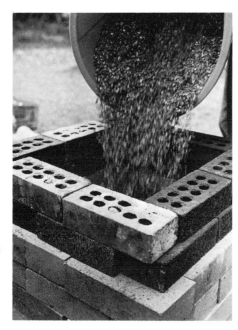

THERE IS sawdust and there is sawdust; or so I've been discovering. There is hardwood sawdust and softwood sawdust. The strongest firing I've had so far was with a hardwood sawdust, but we can't always choose. Softwood sawdust has worked well too and in one case the sawdust of a resinous pine left a sap-like stain on one or two of the pots. In any case, the sawdust should be fairly fine and free of twigs and splinters of wood. (You can sieve it through very coarse screening or fine fencing.) It is also important that at least half your sawdust be dry. If you can get only fresh sawdust, try to prepare in advance so that you can spread the sawdust out in thin layers in the sun for a day or two to dry it out. Coarse sawdust and wood shavings tend to burn too fast. I tried using very dry wood shavings for one firing and it burst into flame, as the shaved curlicues were large and loose and housed too much oxygen.

A good source of sawdust is either a sawmill, if you live in the country, or a lumberyard. Usually they will give you as much as you need free; occasionally they'll charge a nominal fee. The most I've had to pay so far was ten cents for a plastic bag about garbage-can size. Go prepared with your own bags or boxes for transporting the sawdust. Sawdust obtained from a carpentry shop is often especially

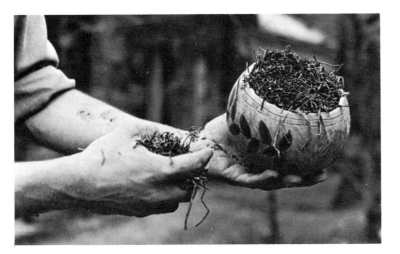
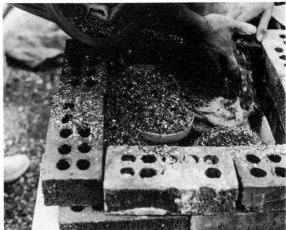

propitious: fine and very dry. I often mix dry carpenter's sawdust half and half with the fresher sawmill sawdust.

## Stacking the Kiln

START stacking your kiln by pouring four to six inches of sawdust onto the floor of the kiln to act as a bed for the first layer of bone-dry pots. Fill each bowl with sawdust and make sure to uncover and fill all covered pieces, firing the pieces either unattached or attached. Place the pots three to four inches away from the walls of the kiln and leave as much as two inches between each piece. Fill in all the spaces between the pots with more sawdust and then cover the entire first layer with three to four inches of sawdust before stacking another layer of pots. As the pots will settle while firing, it is a good idea to place the larger and heavier pots at the bottom of the kiln. After the last layer of pots, place another five to seven inches of sawdust and your kiln is stacked.

To make stacking easier you can build the kiln up only a few bricks high before you start loading, adding bricks, pots, and sawdust as you go. This is especially helpful when you cannot foresee how tall your kiln should be.

## Firing

WHEN YOU have completed the stacking of the kiln, place a few sheets of crumpled newspaper all over the top layer of sawdust and cover this with a few dry twigs or splinters of wood. Light the paper and cover the kiln. From here on each firing is a new experience. You have to watch and respond to what happens. *What you aim for is a slow and even smoldering of the sawdust from top to bottom. It can take anywhere from eight to forty-eight hours or longer.* It appears that the longer the firing takes, the more heat is transmitted into the ware. It does not require your being with the kiln all that time. Once you establish that the firing is going along fairly smoothly you need only check it once every few hours.

123

In the beginning check it often. Once the initial paper and twig fire has burnt out you want to be sure that the top of the sawdust has caught and is burning evenly, especially in the corners. If it seems to have gone out, start again with paper and twigs (if it is a very still day try removing the cover until the firing is well established). Sometimes it takes two or three or more starts to get it going. If all else fails, try dribbling a bit of oil or lighter fuel over the top to try to get it started.

You should never see flames once the paper and twig fire has burnt out. The top layer of sawdust should appear black all over, possibly with occasional sparks, and you should see either heat waves or smoke coming out from under the cover. The smoke lets you know that the fire has not gone out. If the sawdust is burning too fast, add more sawdust to smother it and to slow it down. If one corner is burning faster, add more sawdust to that area only. If all else fails and you seem unable to hold back the firing, you might try dribbling some water onto the top of the firing.

At the outset check the kiln every ten minutes and make whatever alterations seem to be needed. If the firing is slow and seems to need more air, use a screwdriver-like tool to enlarge the openings between the bricks. Once the firing is established, let it be; check only now and again.

The danger of fire from this kiln is highly improbable. Just make sure to keep the cover on when you are not around and to clear the nearby area free of combustibles. (You might keep a bucket of water nearby, just in case.) Let the firing continue on its own during the night. When, after several hours or on the following day, the top layer or layers of pots are visible and seem to be done, you can lift out the finished ware so that there is less chance of these pots cracking those below as they settle. (Should you have cracking problems because of settling pots, you can try putting a layer of chicken wire in the sawdust between each layer of pots. For an especially delicate piece you could build a chicken-wire cage to house your piece and stuff it with sawdust.) Lift the pots out with raku tongs if you have them, or use asbestos gloves, and place the pots on the edge of the kiln until they are cool to the touch. The pots will look gray with ash; you need only rub them for a short while with a soft rag to clean them and bring out the polish. Or wait until the entire firing is finished and cool to unload.

Further steps can be taken after firing to deepen the shine and/or the color of the ware. Because the ware is still porous, such things as boiled linseed oil, nose oil, paste or liquid wax can be applied, and rubbed in well. Recently a friend discovered that a jeweler's buffing wheel with a touch of black jeweler's rouge on it will deepen and bring out the burnished shine. It does so in a way I prefer, say, to using wax. The increased sheen seems to come more from the inside rather than appearing to be on the surface.

The finished pots will hopefully be black, and shiny black if they

were burnished. Yet sometimes the blackness is uneven and streaked with grays, or there is a luster-like oil slickness, or the pink of bisque. There is no *should*. Some people work for an even blackness, others look for the random irregularity of the smoky grays. The pots will be what they are and our appreciation may move beyond our expectations. Take time to behold them. You can always refire them to try for more even reduction. Or you can give up and fire them in a regular bisque firing which will re-oxidize them free of carbon and allow them to be glazed. A pot may break from too rapid firing or because another pot settled too heavily upon it. Or a pot may blow up because it was not totally dry when placed in the kiln. Respond to what happens and see where it takes you. I hope I have told you enough and not too much. On the very day I am writing this, my friend Judith Steinhauer showed me a poem she wrote called "thinking cooking doing being" in which the last lines are:

Note: the lack of an ingredient has
been known to lead to a new recipe.
NO BLAME.

If you own no kiln or do not attend a class and live in an area where the very small amount of smoke from a sawdust firing will not be an annoyance to your neighbors, try a sawdust firing. Invite a small friend to work with you. If you work with children let me highly recommend this way of firing. I first learned about sawdust kilns from two British potters, Ann Stannard and Helen Penny, who worked with teachers of crafts in British schools. They tell me that such firings are widely practiced by grade school children in England.

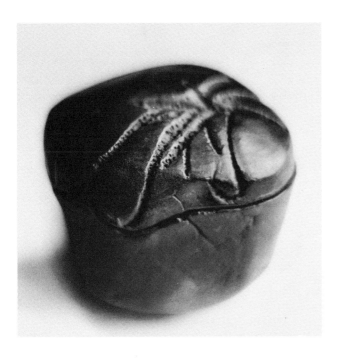
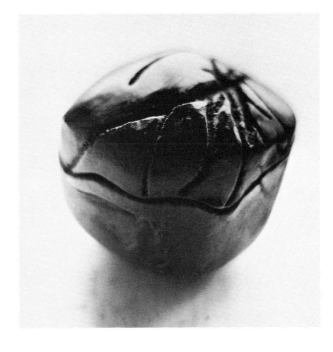

*Burnished, sawdust-fired box by Peter Lombardi*

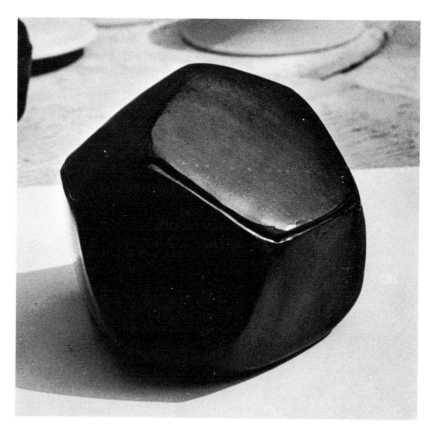

During the summer of 1971 I did sawdust firings in Tennessee, North Carolina and Maine. One of the firings in North Carolina burned too fast and we lost most of the pieces, but all the others had exciting results. In Maine, at the Haystack Mountain School of Crafts, many of the members of the workshop became excited by the results and Jan Sadowski, who was the shop monitor, came up with some interesting questions. "What if" we were to make a sagger and place a raw pot and sawdust in it and fire it up in a regular gas bisque firing? He did so and the results were excellent: a shiny black pot fired to bisque temperature. He then asked, "What if" we fired another piece in a sagger in a cone 10 gas firing. Would the sawdust turn into an ash glaze and coat the pot? He tried it and discovered that the ash did not become a glaze but that his pot was mature black and gray stoneware with only a little of the polish lost. Many "What if's" followed, and Jan returned to Detroit at the end of the workshop determined to build a large sagger to put in his gas kiln so that he could make large black-burnished stoneware pieces. These were exciting moments: It is terribly thrilling in teaching when a fresh and open imagination picks up on what has been introduced and proceeds to find its own way. The journey need not be alone at all moments. We can and do spark one another, and carry each other on.

# IV
# An Album

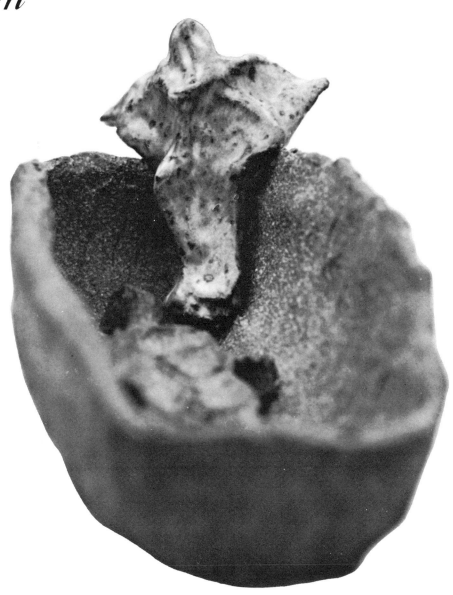

*"Easter Morning," stoneware by Mary Caroline Richards*

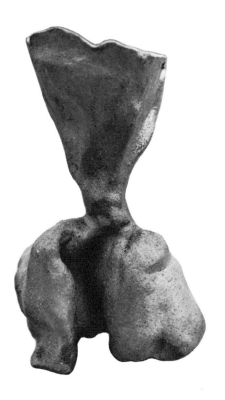

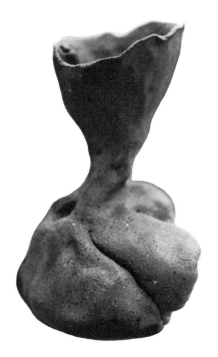

*Two views of Form Number One, "Root/Shoot," from the series "Emerging Form" and one view of Form Number Six, "Towards the Inner Ear," also from the series "Emerging Form," unglazed, wood-fired to cone 9, by Mary Caroline Richards*

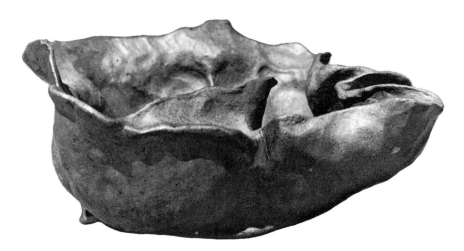

Opposite, top: *Pinched porcelain with raku earrings, 6 inches high, by Ruth Duckworth* Bottom: *Pinched porcelain bowl, 6 inches in diameter, by Ruth*

*Duckworth*

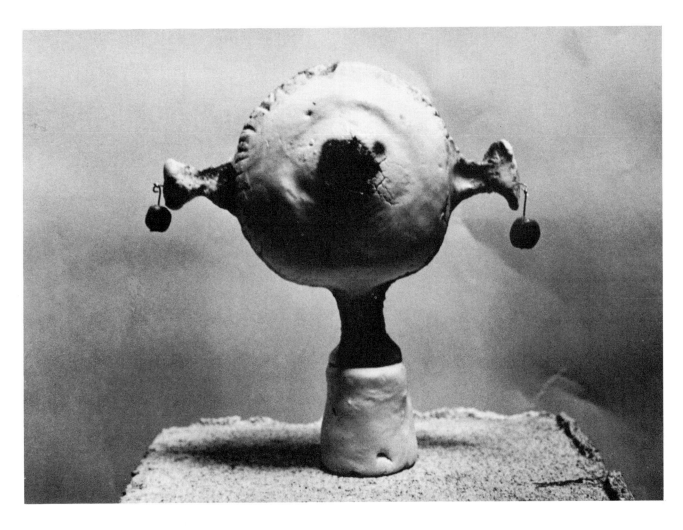

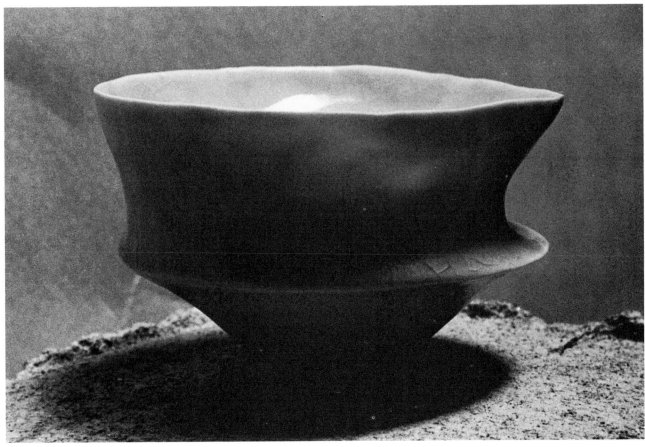

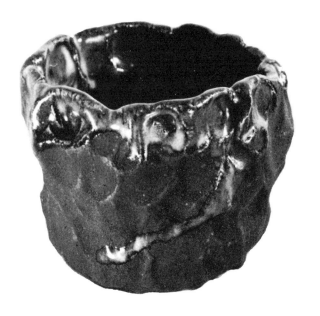

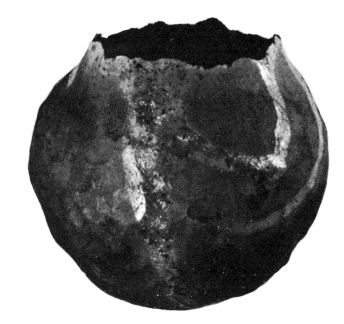

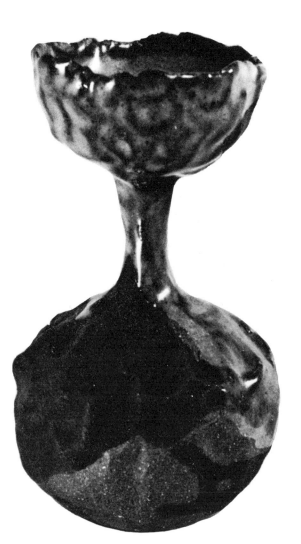

*Three pieces on this page by George
Cummings,* Top left: *One-minute pinch
pot, 2½ inches high, stoneware glaze*
Top right: *Raku piece, 3¼ inches high*
Bottom: *5-inch high stoneware piece*
Facing page: *Three pieces by Ken
Goldstrom, paddled and assembled
pinch pots of brickyard clay, "pit-fired,"*
130  *from 10 inches to 20 inches high*

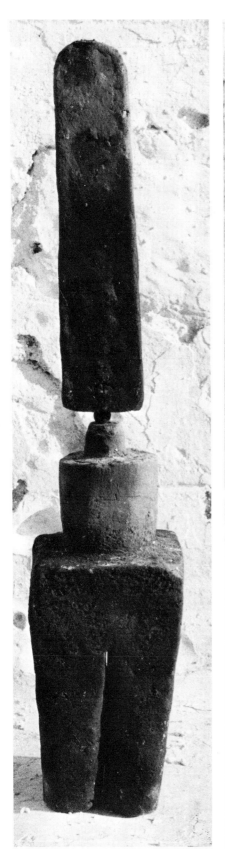
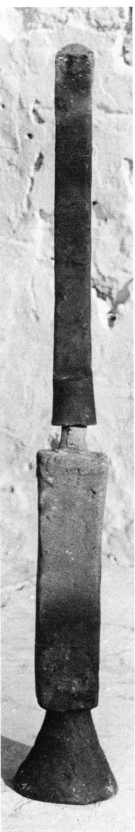
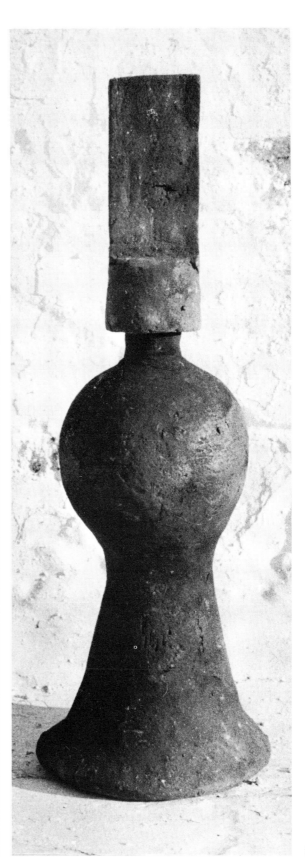

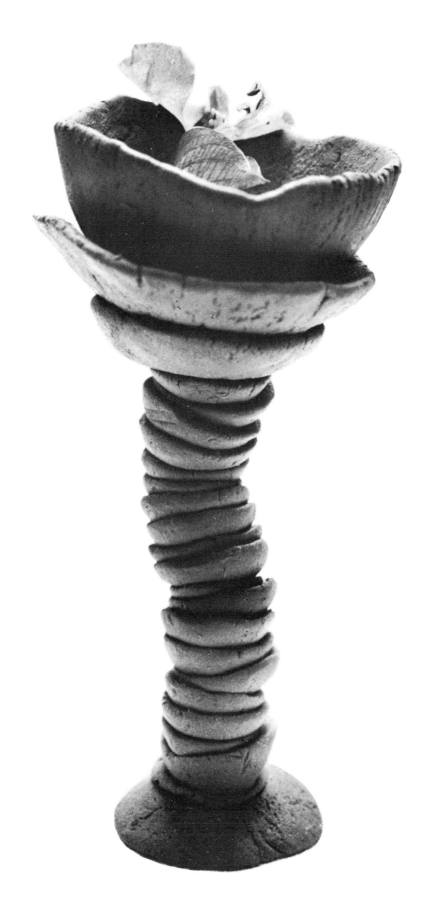

*Four goblet forms.* This page: *Unfired goblet by Natalie Serving* Facing page, top: *Fired stoneware goblet by Howard Yana Shapiro* Bottom: *Goblet by Amy Hart* Extreme right: *Goblet by Shirley Tassencourt*

132

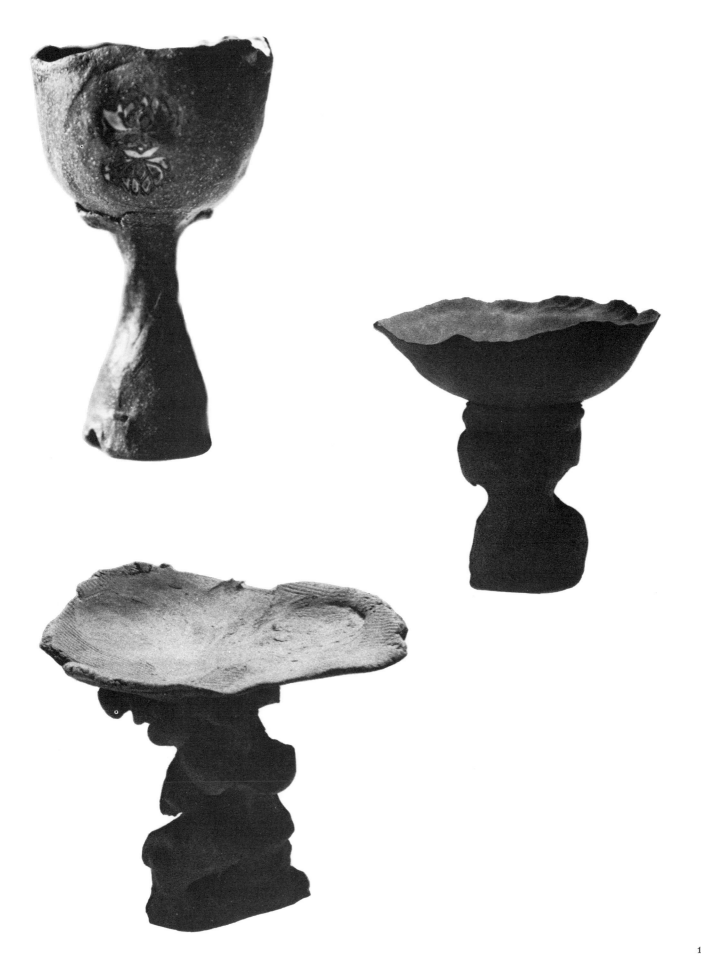

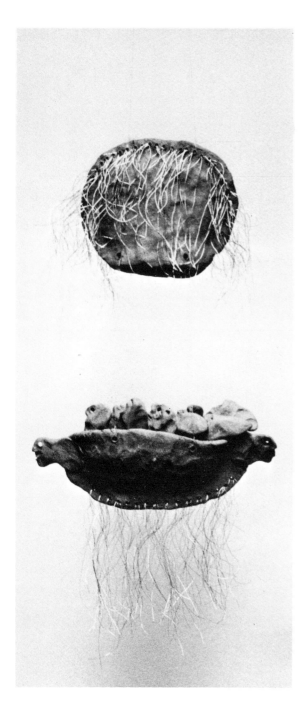

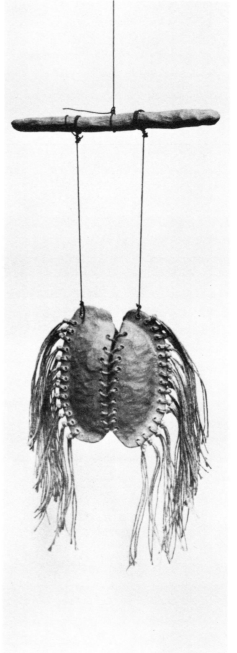

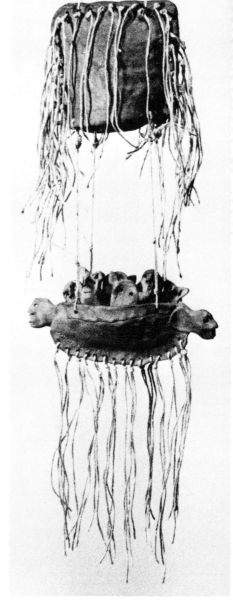

*Three pieces by Tom Suomalinen,*
Left: *"The Silver Cloud," 12 inches*
*high, pinched stoneware and metallic*
*thread* Middle: *"Bivalve," 18 inches*
*high, pinched stoneware and linen*
Right: *"The Milk and Honey Cloud,"*
*12 inches high, pinched stoneware*
134 *and linen*

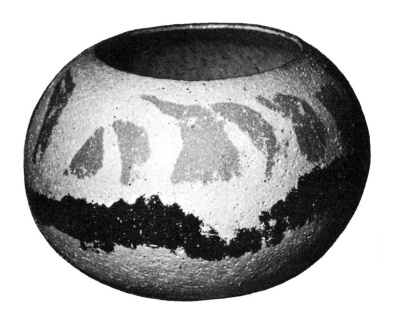

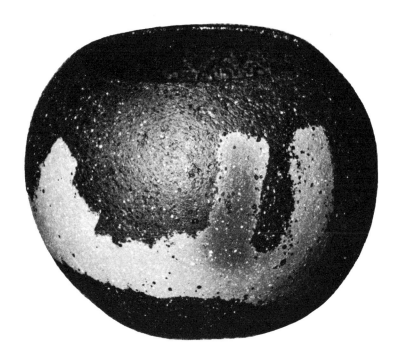

*Two pinched bowls by Walter Hall, appliquéd colored clays fired in oxidation atmosphere*

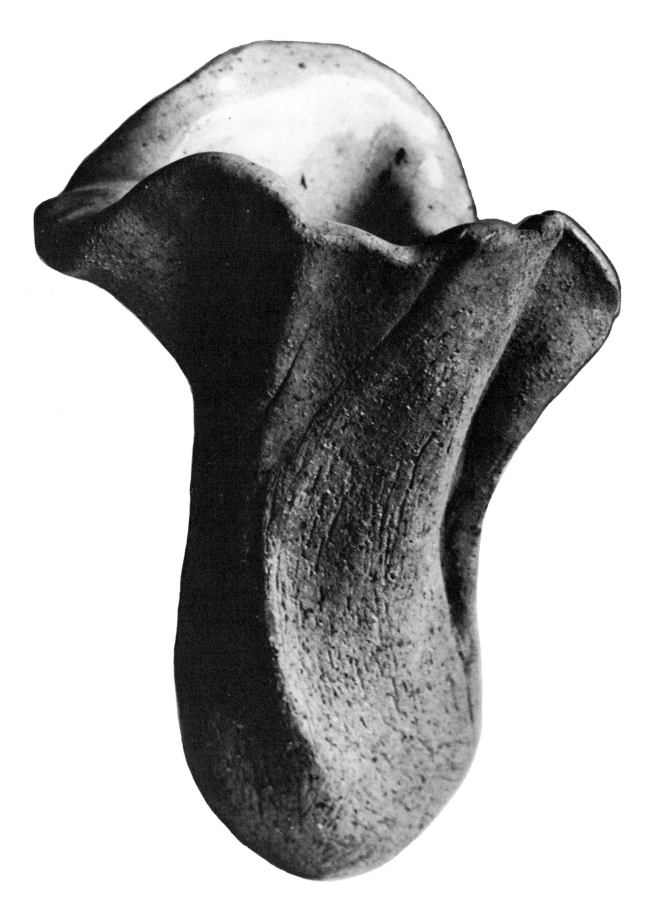

*Vase by Susan Griffing, stoneware reduction, 10 inches high, made by paddling on the fist, as demonstrated in "Making a Large Pinch Pot"* (see pages 55-56)

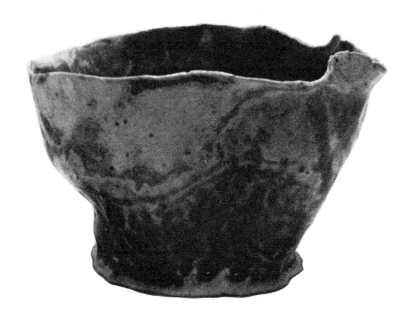

*Glazed stoneware forms;* Above: *by Shirley Tassencourt*  Below: *by Kathy Damback*

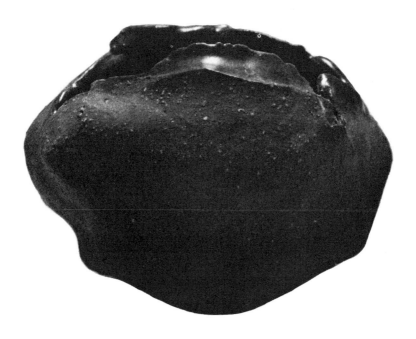

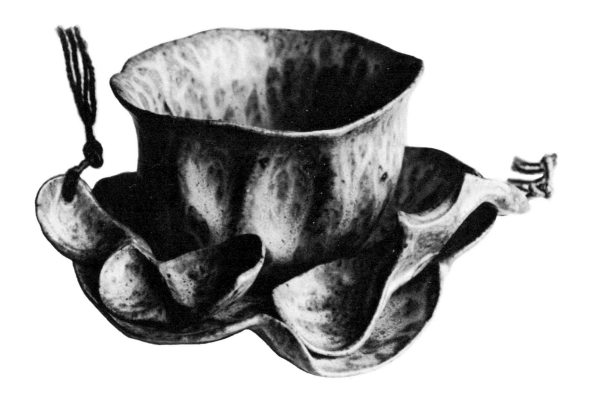

*Glazed pinched bowl, spoons, and saucer from the series "Communitas," by the author*

*Pinched torso form, 10 inches high, by Barbara Sexton*

*Two views of raku-fired pinch bowl by Howard Yana Shapiro*

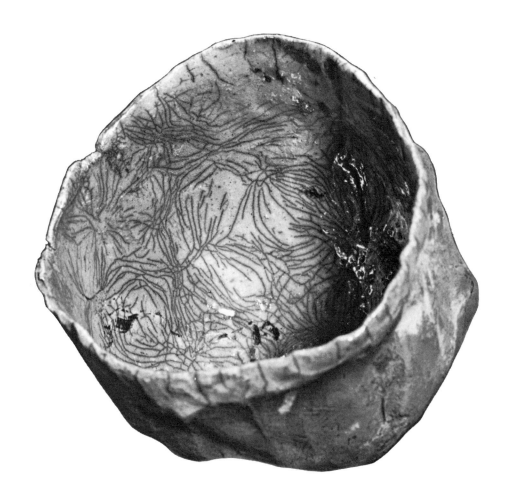

# V
# An Aesthetic of Humanness

## Notes, Stories and Quotes from My Journal

FINDING one's way with clay is a technical question: in what way, *i.e.*, method, do I want to work? It is also a question of style: how do I want this piece to look? And it is a spiritual question as well: how do I relate, connect to what is unknowable or as yet unknown in myself and in the materials I work with? Yet fundamentally it is an observation: that the clay is the material, the companion, the faithful John, the teacher, the child, the sparring partner, the beloved with which I'm finding my way through and into my life.

"If the designer is to make/a deliberate contribution to society,/he must be able to integrate/all he can learn about/behavior and resources,/ecology and human needs;/taste and style just aren't enough."

—From a poster announcing the opening of
THE SCHOOL OF DESIGN OF THE CALIFORNIA INSTITUTE OF ARTS

Just now they played Beethoven's Ninth on the radio and during the scherzo I threw a bowl. I am alone in the shop for the first time all day. The door is open—it's spring. Moments ago I watched two little buds push out of a twig. I felt "how wonderful to work, to work to Beethoven, to work to Beethoven in the spring." The pot is before me; beautiful, alive and new in its wet state. Why does a newly thrown pot never again look so alive to me?

*Air*, you dry my pot and change it. Today, now, at this moment, I say you can *take it*: I've had my share. I stand aside and let you and the fire do what you will with it.

Not techniques, but equipment for the journey.

We had our first sale at the Pottery Co-op. I had no idea how many people would respond to our mailing. I was not very hopeful, as handmade stoneware had not sold well in local stores and I believed it would take a long time to build up a clientele. I was overwhelmed by the constant stream of people who came all day and cheerfully examined and purchased our wares. Everybody, craftsman and customer, was having a good time. I asked a friend, "Why here and not in the stores?" Her reply was: "That's the difference between a commercial act and a human one."

143

"It's not a matter of having taste but rather of being able to taste what is present. To behold."

—M. C. Richards

Students of dance, of musical instruments and of the potter's wheel seem to understand that there is a lot of work to be done before they can attempt to dance *Swan Lake*, play Chopin and make teapots. Somehow, in hand forming with clay, too many people, in their attempt to produce, become stuck in the same place for too long. One can easily become seduced by the pattern of turning raw clay into a usable object, and turn out one after another piece to give away or sell. What I understand now from my own experience is that this can be a great danger for some of us, a kind of cheating of one's potential. I think it is possible for the hand builder to work with a sense of *practice*, to take one form, or forms, and explore each form daily. And one's practice need not be limited only to technical problems; it can be concerned with theme and/or expression. I can practice how to pinch a pot with a small unwobbly foot. I can practice pinching handled mugs where the handle is the continuation of the gesture of the object, or I can practice my need to show in my work what it is I'm feeling. I aspire to practice where I am most vulnerable—with clay and with the events of my life.

This morning I finally learned how to pinch a cylinder with a small- to medium-sized ball of clay. I've been trying to learn to do this for the past three years and have recently been really practicing to that end. In a workshop not long ago, one potter kept coming up repeatedly with cylindrical shapes. She could not say why, but thought it possibly had to do with the way she held the pot in her left hand as she pinched with her right hand. With the image in my mind this morning of this woman holding her ball of clay on its side in her hand, I discovered that after opening the ball of clay it was necessary to resist strongly with the holding hand as the pinching hand gently pinched and firmly pulled up, pinched and pulled up. It reminded me very much of the way one "collars in" the clay when throwing a cylinder or a necked or closed form on the potter's wheel. I repeated this step twice, then pinched the pot, opening it just wide enough to get my whole hand in so that I could "drop" the extra clay I had left at the bottom later, when the top had dried.

It seems so obvious now, so simple. I'm certain I will be able to teach this to anyone who pinches in just a few minutes. I am amazed by how long it took me, yet how worthwhile all that practice now seems. And it brings everything else I know about pinching into

clearer perspective. I wonder if this is the way a scientist feels when he finally discovers a basic law of his work: as if everything has suddenly reopened with new light shining.

The sculptor Giacometti was commissioned by the French Government to design a coin in commemoration of the artist Henri Matisse. He spent five full days in Matisse's bedroom sketching and sketching the old artist. Drawing after drawing displeased Giacometti and finally he shouted in despair. "Oh Master, I cannot draw" and Matisse replied, "None of us can."

In one sense this book I'm making is very technical. I've spent a long time attempting to demonstrate "how to" pinch clay and how to color clay and ways to use this color. But in another sense this is a book about my feelings about aesthetics and about art and about being a teacher and about being a person. Is there any difference?

Yesterday the white crocuses bloomed and in the morning were covered with dew—by afternoon they had opened wide, white, wind-choreographed. At dinner, Roopan wore them in her black hair: born and adorn in one day. Today they wilt listlessly in the humid sun.

Oh why do I rage so against such short blooming in myself when I am so accepting of how it is with the crocus? Why can't I let go in the way of nature—in that rhythm of blossom, burial and rebirth, of earning and re-earning? It's not the *way* I seek, but rather a skill at and courage for finding and re-finding.

A good many of the people I work with are either adults or young people not connected to a university. They have not, or do not attend an art school and often they worry about it. My own experience was in dance, and although that has been helpful and proving increasingly so recently, I, too, have limited formal training in art and craft. Or so I thought. My work with clay has been demonstrating that everything that's happened, everything I've experienced and felt were part of my real formal education as an artist.

"My gift is my song and this one's for you"

—a line from a song by Elton John   145

A friend has pointed out that what I do is "more therapy than it is art." I was, at first, quite confused about this, for the word "therapy" is a complex word often misused and occasionally used as a put-down; especially when used with the word "art." I began to relax about this when I discovered that the root of the word "therapy" is "to cure." To cure, not in the sense of making well something that is sick, but to cure in the sense of to ripen. To ripen as the seed ripens into the fruit, as the child ripens into the adult, as our voice ripens into our song. If this is what it means to be a therapist, to aid in the process of ripening, then it is something to work for.

Several years ago I had a student who was by profession a skilled carpenter. He worked predominantly on the wheel. For a long while I struggled hard to teach him how to throw. I would tell him time and time again that his pots were too heavy at the bottom and too thin at the top. He would watch the technical demonstrations I gave only to return to his wheel and work the way he had previously. He did more trimming than throwing; spending hours cutting away the clay like a woodworker turning on a lathe. He would glaze these pots, almost always cylindrical covered pots, with a transparent gray glaze over blue slip bands. I didn't understand what he was doing or how to help him develop skill. Finally I gave up and left him alone. He is a fine person and I loved having him in the shop; he came often, worked hard and was very helpful with shop chores. About a year later, unstacking a kiln early one morning, I came upon a shelf of his pots; they were the same heavy-bottomed, thin-topped, gray-colored forms with blue bands. Only something had happened. They sat there proud and dignified and glowing with the breath of his life. They appeared, now, to be the real work of a person. Thank heavens, at least some of my students know when not to pay attention to me.

To be open to the needs of my own growth: to ripen as clay ripens, through geology and the weathering of the storms.

"It's not one trip, but a whole journey."

—IRA PROGOFF

I once had a terrific argument with M. C. Richards over the placement of the compost heap at the farm. She was for placing it conveniently between the house and the garden. I was for concealing it unseeable at some distance, for I wanted to keep the front yard beautiful. Well, the argument was important and we went on with it for some time. I remember feeling, when it was over, that we had somehow come closer together. Sometime later she wrote me a letter when I was off teaching somewhere in which she spoke of her annoyance over my view of beauty. "You describe something as beautiful only when you feel it to be attractive," she wrote. "For me, beauty is that which is revealed."

I cannot remember what it was to dance—it seems such a miracle that the body can move. I can remember only the ecstasy that at moments, four or five times a year, I would experience in a class or more rarely in a performance. When I move now it is in such a different way. The outer form of my body no longer remotely resembles the instrument it was, nor has it the same facility, yet the inner body, my skeletal self, is ready to dance; yes, more ready now than it ever was. And how incredible that it is clay that is my dancing partner now. What fantastic and new choreographies we will make, are making. I shall always be a dancer!

*A Fantasy:* What if I were asked to design a curriculum for a new school of pottery? These are some of the courses I would offer—

What is clay?—The geology of clay and the preparation of clay bodies;
Body movement and breathing;
How to build a wheel;
Throwing on the potter's wheel;
The techniques of hand forming;
Design course #1: How to keep a journal;
Design course #2: On being a person;
How to build and fire kilns;
Design course #3: Clay and meditation;
Design course #4: Working the imagination;
Design course #5: The myths and legends of man;
How to read, write, listen and hear;                    147

How to care for one's automobile;
Marketing and exhibiting one's wares;
Carpentry;
Life styles and man's religious experience;
Glaze and glazing—the chemistry of intuition;
How to bear leisure;
Cooking;
Senior thesis—the theater of experience.

This morning I read Seonaid Robertson's chapter "On Being a Potter" in her book *Craft and Contemporary Culture*. What an amazingly gifted woman she is. She is so articulate about her feeling for clay. But what was special for me is the way she talks about what it means to be a craftsman and that the tradition of the crafts "enshrines the knowledge and the satisfactions of generations of a community. It is 'more than one man deep.' " More than one man deep!

I have just made a drawing in my journal of a pot I would like to make someday. It would be large and like a totem pole. At the base would be a heavy mud-textured bowl that I would make by pressing very wet clay into a crude basket. It would be the root of the pot. Out of it would rise a terra-cotta-and-black reduced triangular vase form; like the Egyptian blacktop pottery that I saw in the British Museum. And so on, it would rise through all the traditions that nourish me and would not end. There would be room at the top.

This morning I felt full of life, full of wonder and after doing yoga with her I told Phyllis Yacopino that the pots themselves are the least of it. That I felt one could be a potter without making pots. She looked at me very strangely and said that the other morning Jim had told her of a dream he had had.

In the dream Jim discovered that he wanted to study pottery with me. He heard that I was to give a demonstration and decided to attend. When he arrived he noticed that it was not a pottery studio but a lecture hall and that it was very crowded. He said that I gave a talk in which I said, "You can be a potter without making pots."

The molecules of clay are flat and thin. When they are wet they become sticky with plasticity and hold together as in a chain. A connecting chain. I like picturing that connection in my head.

I am making my connection with clay. Clay turns me on and in. It seems clearer and clearer that I was drawn to clay by its plasticity. For it is plasticity that I seek in my life. To be able to move into new

and deeper forms as well as make them. Making the connection and being plastic.

A life of increasing plasticity in which I make the connection between the life I'm living and the objects I'm forming.

In a workshop I led recently, we spent part of a morning exploring various ways that coils could be added one to another. Ideas were shared and spoken aloud as we each made several little test cups. Later one student stopped by where I was working and mentioned how one of the ways we had come upon excited her very much. "It would be an excellent way to make owls," she said. My immediate reaction was to say, "Please don't make owls; ceramic owls are so trite and cute!" Mercifully, I for once held my tongue. I took a deep breath and then started talking with her about owls. I suggested that most pottery owls one sees are humorous and that it seemed to me that there was more to owls than humor; certainly they are a symbolic bird; of wisdom, of the night. I suggested that she do a little research in just what owls were symbolic of and that she could also read about the various owls and their habits. I also asked her if she had ever had a personal experience with an owl. It turned out she had been scared when a hooting owl with outstretched wings had startled her while on a walk.

Later that afternoon I had an opportunity to talk with this woman for some time. She had an advanced degree in ceramic education and had studied and taught at many schools and studios. She thanked me for the workshop and said, "For many years now, I've wanted to make owls, but I've hesitated to do so because all my teachers said that owls were trite and cute. You make me feel that not only is it okay to make owls, but that since I want to, I should." It was a simple encounter, but it etched itself deep into me. If I am going to tell my students that they have to make what they need to make, then I am going to have to celebrate their owls and their rosebuds or whatever they make, when what they create is born of the necessity of their needs as *they* feel them.

A while ago M. C. told me something she had been told by one of her teachers, Francis Edmonds. "You have to learn to ask the questions," he said, "before you can grow to the answers." It's one of the most exciting and helpful ideas I've ever heard.

If dance is life at its most glorious moments, as Pearl Lang says in today's *New York Times*, then is being an artist to have a life so lived that these moments take expression in acts? Does it have to be dance? Can't it also be planting a garden, painting a picture, smiling directly into the eyes and being of another, or forming a clay vessel?

Art as an ongoing process of experiencing one's experiences—not peripherally, but right there in the thick of it? And it's not only those glorious moments, if by glorious one were to mean moments of ecstasy; it's clearer how to use those moments. But what about the times of despair, when all seems lost and meaningless? Isn't celebrating these times in acts art too? I feel now that if I can develop the same ability to speak of my despair and my doubts as I seem able to speak of my joy and my connection, my work will be truer; truly more expressive—more with what *is*. And by embracing what is, will I be making room for what may be? Opening the doors of possibility? I keep hearing the voices at the end of Martha Graham's *Clytemnestra* singing from the Oresteia, "Rebirth, rebirth—a sprout both red and green." Red with the blood of our experience? Green with the shoots of hope of our newborn lives?

"The Japanese potter who finds an unexpectedly beautiful effect of glaze bows to the kiln and says 'Thank you.'"

—From *Craft and Contemporary Culture* by SEONAID ROBERTSON

In times like these when so many of us can choose with almost total freedom in what areas we wish to work, why are so many of us drawn as if by a magnet to clay and yarn and glass and metal? Could it be that all the "glitter and the gold" that our parents worked so terribly hard for has polluted our senses? That we are satiated and drunk and confused by the richness of it all and need to reconnect ourselves to basic things? I don't feel the need as strongly as I once did to make more beautiful objects. But I do feel that I need to make a bowl for *you* to eat your rice from. *I* need to do that for *us*.

I received a letter from Ruth Jo in Des Moines, Iowa. She wrote that she had liked working with clay this past summer at Pendle Hill and had been looking locally for a workshop where she could continue the work. She finally found one and was informed by the instructor that she would have to work with earthenware for two years before he would allow her to use stoneware. "Stoneware," he told her, "is a privilege." "What do you think of this?" she asked. I replied, "Dear Ruth, nice to hear from you. Your teacher is right, stoneware is a privilege—so is the air we breathe. They are privileges we are all entitled to participate in, NOW!"

I am trying to learn how, when leading a workshop, to speak from the artist in me to the artist in each one of the people present. I do not mean by this anything to do with good artist or bad, better artist or best. I find such distinctions meaningless and unhelpful. My experience is demonstrating that there is an artistic voice in each one of us that is not helped by any comparisons except with our own deepening growth. In each of us there is *our* pinch pot, as there is *our* dance, *our* poem and *our* song. What it looks or sounds like is less important than the artistic journey we take to discover it.

I toast and greet the artist in you from the artist in me.

A source of design in my own humanness? My own experience as decoration and motivation and shape? My feelings and my needs and my longings as my true palette?

What else! Am I about?

What else! Is this book I've been making really about?

# VI
# Appendixes

## A Note to the Inexperienced

ALTHOUGH this book starts at a beginning, it makes the basic assumption that the reader-user is familiar with clay; its preparation, uses and how to fire it. If, however, you have not heretofore had such experience, I think it very possible for you to make a good and serious start with the material in this book plus some supplementary help.

There is a lot to learn in the beginning. Just where and how to dig clay or purchase some; how to prepare and wedge it ready for use; how to store, dry, glaze, and fire your pieces. By far the most propitious way to learn all about this would be to take a course or workshop with a responsible teacher in a well-equipped school or studio, using this book and others as a supplementary text and to help with your practice at home.

In recent years more and more courses in pottery have become available, through university and college extension departments, at Y's, craft schools, summer short-term resident workshops and classes offered by potters in their own studios. Should you be unfamiliar with the availability of such courses, the research and education department of the American Crafts Council, 29 West 53rd Street, New York, New York 10019, publishes a directory of craft courses ($2.50) that brings its extensive listings up to date annually. For summer workshops, *Craft Horizons* and *Ceramics Monthly* (*see* Bibliography) publish complete listings in their April or May issues. Just a few years ago those lists were brief. In April of 1971, however, *Craft Horizons* listed 194 places that offered summer instruction in this country plus additional listings for Canada and abroad.

Should you need further advice, most counties, states and large universities have extension service departments (usually under "Home Economics"—call your local county extension service) with staffs that should be familiar with craft courses offered in their areas. If all other investigation fails you could write the American Crafts Council for the name or names of your state's representatives to the regional assembly of the Council. These people are professional craftsmen themselves and may know to whom to direct you.

One note of caution: There are many studios around the country that sell greenware already cast from molds and offer classes in what is called "China Painting," *i.e.*, the application of low-fire glaze decoration. While this is by no means without interest, I would encourage you to find a class where you would begin with the clay itself and experience forming your own pieces, no matter how crude or hesitant a beginning it may represent; it is important, I believe, to get a feeling for the whole story. Sometimes, however, these studios do sell clay and equipment and offer firing services for a fee. It could be a way of starting if you were to use the clay and firing service they offer and begin at home with this book and others to guide you.

Should no class be possible or available or should you want to try it out on your own before making a commitment of time and money to a class, it is possible, I think, to make a start on your own if you are willing and able to learn by trial and error. Kilns are expensive to

buy or build (anywhere from two hundred dollars to thousands of dollars—depending on size and type), but you could start modestly with a sawdust kiln (*see* page 121) or be fortunate enough to find someone who would be agreeable to firing your work or better still letting you participate in one of his or her firings. I would definitely suggest that you read at least one other pottery book before beginning. I would recommend *Clay and Glazes for the Potter* by Daniel Rhodes and/or *Ceramics* by Glen C. Nelson (*see* Bibliography), as they are highly readable and interesting and full of important information.

You would have to find a place in your home to do your work and purchase or make the basic tools you would need. You can start with very little, especially if you follow the exercises in this book. You will, however, need clay, and finding some may take some investigation. Local schools may be agreeable to selling you some or a local potter might be able to tell you of a supply source. Look in your Yellow Pages under "Ceramic Supplies" or "Pottery." Check the ads in *Ceramics Monthly* for the addresses of supply companies that are in your area or within reasonable shipping distance. Occasionally a hobby store will stock potter's clay (make sure it is a water-base clay for firing and not a sculptor's clay meant for casting). Or you may know of or have heard about a local source of natural clay that you could dig and prepare yourself (*see* page 119).

In any case, if you have not worked with clay before, I do hope you get the opportunity to at least try it, especially under the guidance of a gifted teacher. I encourage you to seek out a teacher from convictions I hold strongly. Although there are a few highly accomplished self-taught potters, they are the exception. Most potters I know or know of studied and/or served long apprenticeships. It is the rare dancer who is self-taught; I don't believe I've ever heard of a pianist or violinist who did not study long and hard. There are basics to be learned and mastered if we are to develop the skills that will allow us our freedom. If we work alone, we are in danger of limiting ourselves to what we know only from instinct. And it is not only the teacher that is important, but the atmosphere of the studio and our interaction with our fellow students as well. If you are unable to find a suitable class, try to see as many exhibits of contemporary and historical pottery as possible, seek out other potters in your area for fellowship and dialogue, go to craft fairs, read as many books and periodicals as you can.

To form something with clay, whether to use or look at, is one of the most basic human experiences available to all of us. In an age of ready-mades, where we are not given an opportunity for full participation in the objects of our lives, the highly plastic material of clay offers us that now rare experience of seeing something through from the very beginning.

# A Note on Wedging In Additives to Your Clay

ADDING a material to already prepared clay can be difficult and/or time consuming, yet it is often important to do so; for example, when making boxes, sculptural forms, or when you need a clay with more texture. Following is a method for adding grog or fire clay or sand or talc to a clay body, which I find not much more difficult than wedging clay.

*1* Prepare a bucket of whatever material you need to add and a bucket of water next to your wedging area.

*2* Pound your clay into a long rectangular bar under six inches in height and width and as long as it needs to be.

*3* Using a cutting wire, slice the clay into one-inch lengths.

*4* Dunk each of these pancakes of clay, one at a time, into the water and then lay it down flat in your bucket of grog or fire clay or whatever.

*5* Lift it and place the second side down into the grog, pressing it down a bit before lifting it and placing it aside. Both sides of your pancake should now be coated or "breaded" with the grog.

*6* Do this with each pancake of clay until all are coated with your grog.

*7* Then wedge the clay, by kneading, until the grog is well worked in. As the grog is already somewhat evenly spaced in your clay, the wedging should take only a little more time than usual.

## Notes

(1) Should this coating and wedging not have added as much grog to the clay as you need, wedge the clay just a bit until the clay feels as if it is accepting the grog with ease. Then re-pound your clay into a rectangle and repeat the slicing, dunking, coating and wedging.

(2) If your clay is already very moist to begin with, you can eliminate the water-dunking step.

(3) Should the clay be quite dry you can press both thumbs into the center of the pancake so that it creates a well that will capture extra water when you dunk it; then when it is placed on its back in the grog, you can sprinkle extra grog into the well until you are sure the water is trapped.

(4) In a case where you need to add a specific percentage of a material to your clay, weigh the clay and figure out the weight of added material you need to wedge in. It is important to note that the clay contains water and the material to be added does not, so that you must figure on this differential when weighing. If, for instance, I have ten pounds of wet clay into which I want to add 40 percent of fire clay, I would deduct the weight of the water from the clay before figuring my 40 percent. Usually I figure the water weight to be just under one-third the weight of the prepared clay: so I would, in this case, figure 40 percent of seven pounds to be approximately correct, which would make for an addition of two and a half pounds of fire clay. I'd place this two and a half pounds in a bucket and cut, dunk, coat and wedge until the bucket of fire clay was empty.

# Glossary

BALL CLAY: A white or near-white firing clay that is highly plastic. Used as the clay ingredient in glazes and added to clay bodies to increase their plasticity, most often in porcelain.

BISQUE: Once-fired but unglazed clay. Derives from the French *"bisquet"* meaning half-baked.

BISQUE FIRE: First firing of ware usually at a low temperature (012–04) to drive off water and harden ware so as to facilitate glazing.

CLAY: A natural, fine-grained earthlike material, the product of the geological weathering or aging of the surface of the earth. The root of the word "clay" is "sticky": sticky soil.

CLAY BODY: Generally refers to a combination of clay ingredients calculated to mature at a desired temperature and to have desired working characteristics.

COILING: A method of hand-building pottery in which the clay is rolled out into long, narrow ropes of clay that are placed one on top of another and joined to build up the form. Either the coils are left visible or the joints are smoothed over.

CONES (PYROMETRIC): Made of ceramic materials, these cones are placed in a kiln where they can be viewed by the potter through spy- or peepholes in the walls or door of the kiln. They are calculated to measure the heat work of the firing (temperature and duration) and are graded to soften and melt to indicate to the potter that his clay and glazes have reached their maturity. Final temperature is designated by cone number, *e.g.*, cone 4, cone 9.

EARTHENWARE: Generally refers to a low-fired clay. More specifically, it is a non-vitreous clay with an absorbency of from 5 to 20 percent.

ENGOBE: A slip, usually with colorants added, that is halfway between a clay and a glaze. It is usually brushed over the surface of a pot to harden the surface, change the texture, or alter the color of the clay. It can be fired as is or glazed.

FIRE CLAY: A refractory clay used in the manufacture of bricks, muffles, saggers, etc. It is often plastic enough to be used by potters as an ingredient in stoneware clay bodies.

FLUX: The melting agent in a glaze.

GLAZE: A liquid suspension of fine mineral particles that is applied to pottery and fired to its maturity to form a glassy surface that seals the clay and decorates the piece.

GREENWARE: Unfired pottery; also called raw-ware.

GROG: Clay that has been fired and crushed in a variety of mesh sizes. It is added to clay to reduce shrinkage and to add texture and/or tooth.

KILN: A furnace for firing pottery made of refractory and insulating materials.

LEATHER-HARD: Refers to that state in the drying of a raw pot when enough moisture has air-dried so that the piece can be lifted without distortion and yet is damp enough to be worked further: carved, burnished, joined, etc.

MATURITY: That point in a firing where the clay has reached its maximum non-porosity and hardness and when the glaze has flowed and formed a strong bond with the clay.

OXIDE: A compound containing oxygen and one or more elements.

OXIDATION FIRE: A firing condition when the fire has sufficient oxygen to cause complete combustion free of carbon or carbonaceous gases.

PLASTICITY: Refers to that quality in a clay that allows it to be worked and reshaped without cracking or crumbling.

PORCELAIN: A hard, totally vitreous clay, generally fired at high temperatures. It is usually white or gray and free of impurities. In some cases, when thin, the clay will be translucent.

RAW-WARE: Refers to unfired and dry pottery.

RECONSTITUTED OR RECYCLED CLAY: Used but unfired clay that has been allowed to dry and is then reliquefied for reuse.

REDUCTION FIRE: A firing condition in which the amount of oxygen mixing with the fuel is reduced so that the carbon in the fuel must seek out and combine with the oxides in the clay and glazes to combust. This causes changes in color and texture of the clay and glaze.

SAGGERS: Boxlike containers made of a highly refractory fire clay used to house pots in firings so that they will be protected from direct contact with the flame.

SALT GLAZE: A glaze surface that forms on pots by introducing rock salt into the kiln at a high temperature. The salt volatilizes and combines with the silica in the clay to form sodium silicate.

SLAB: A method of hand building with a great variety of uses in which the clay is either rolled out with a rolling pin or sliced with a wire or tossed into sheets that are then used to construct a form.

SLIP: A clay in liquid suspension used decoratively or as a binding agent. Clay slips often have oxides added to them for decorative purposes.

STONEWARE: High-firing clay with little or no rate of absorbency. Closer to porcelain than earthenware, it is more plastic and depends upon its impurities for its color and texture.

THROWING: The act of forming clay on the potter's wheel.

VITREOUS: Refers to the non-absorbency of a clay or a glaze.

WEDGING: Freeing a clay of air and working a clay into a state of textural and moisture uniformity by an action of the heel of the hands and/or by cutting and pounding.

# Bibliography*

## BOOKS

Birks, Tony. *The Art of the Modern Potter*. Country Life Limited, London.

Cardew, Michael. *Pioneer Pottery*, St. Martin's Press, New York, 1971.

Colbeck, John. *Pottery: The Techniques of Throwing*, Watson-Guptill Publications, New York, 1969.

Erikson, Joan. *The Universal Bead*, Norton Press, New York, 1969.

Leach, Bernard, *A Potter's Book*, Transatlantic Arts, Inc., New York.

Nelson, Glen C. *Ceramics: A Potter's Handbook*, Holt, Rinehart & Winston, New York, 1971.

Rhodes, Daniel. *Clay and Glazes for the Potter*, Chilton Press, Philadelphia, 1957.

————. *Kilns: Design, Construction and Operation*, Chilton Press, Philadelphia, 1968.

————. *Stoneware and Porcelain: The Art of High-Fired Pottery*, Chilton Press, Philadelphia, 1959.

Richards, Dr. Mary Caroline. *Centering in Pottery, Poetry and the Person*, Wesleyan University Press, 1970.

Robertson, Seaonaid Maini. *Craft and Contemporary Culture*, George G. Harrap & Co., Ltd., London.

————. *Rosegarden and Labyrinth*, Routledge & Kegan Paul, London.†

————. *Beginning at the Beginning with Clay* (pamphlet). Society for Education Through Art, 29 Great James Street, London.

## PERIODICALS

*Ceramics Monthly*. 4175 North High Street, Columbus, Ohio 43214.

*Craft Horizons*. 16 East 52nd Street, New York, New York 10022.

---

* Some of these titles may be unavailable except at special libraries.

† Available from U.S. office of Routledge & Kegan Paul, 9 Park Street, Boston, Massachusetts 02108. The author urges everyone to read this book, especially those who work with children.

PAULUS BERENSOHN, potter and teacher, has taught at Swarthmore College, The Penland School of Crafts, Haystack Mountain School of Crafts and The Arrowmont School of Crafts. He was founding director of the Wallingford Potters' Guild and, in recent years, has led workshops all over the country. When he is not traveling, he lives on a farm in northeastern Pennsylvania, which he shares with friends.

TRUE KELLY was born on a farm in the Hudson Valley of New York State. She has led workshops in various artistic media for students of all ages, for the retarded, and for American Indians. In recent years, she has been artist-in-residence at The Penland School of Crafts in North Carolina, where she has given courses in photography.